WASHINGTON, D.C.

THEN & NOW

Thunder Bay Press
An imprint of the Baker & Taylor Publishing Group
10350 Barnes Canyon Road, San Diego, CA 92121
www.thunderbaybooks.com

Produced by Salamander Books,
an imprint of Anova Books Ltd.
10 Southcombe Street, London W14 0RA, UK

Washington Then and Now is a revision of the book first published in 2000.
"Then and Now" is a registered trademark of Anova Books Ltd.
© 2013 Salamander Books

All notations of errors or omissions should be addressed to Thunder Bay Press,
Editorial Department, at the above address. All other correspondence (author
inquiries, permissions) concerning the content of this book should be addressed
to Salamander Books, 10 Southcombe Street, London W14 0RA, UK.

Library of Congress Cataloging-in-Publication Data

Mitchell, Alexander D.
 Washington D.C. then & now / Alexander D. Mitchell IV. -- Second edition.
 pages cm
 ISBN-13: 978-1-60710-755-2
 ISBN-10: 1-60710-755-4
1. Washington (D.C.)--Pictorial works. 2. Washington (D.C.)--History--Pictorial
works. 3. Historic buildings--Washington (D.C.)--Pictorial works. 4. Historic
sites--Washington (D.C.)--Pictorial works. 5. Washington (D.C.)--Buildings,
structures, etc.--Pictorial works. 6. Repeat photography--Washington (D.C.) I.
Title. II. Title: Washington D.C. then and now. III. Title: Washington DC then &
now.
 F195.M58 2013
 975.3--dc23
 2012043131

Printed and bound in China

1 2 3 4 5 17 16 15 14 13

Acknowledgments
The black-and-white photography was supplied courtesy of the Prints and Photographs
Division of the Library of Congress, with the following exceptions:
Page 72, Corbis images.

The publisher wishes to thank Theo Hopkinson for taking all the "Now" photographs
for this book, with the exception of:
Corbis images, pages 11, 55, 71 (small), 73 (top), 73 (bottom), 75, 77, 131, 135, and 142.
Library of Congress, pages 13 (small) and 89 (small).
Simon Clay, pages 15, 21 (small), 23, 27, 83, 115 (small), 117, 119, 125, and 129.

Additional text by Colin Salter.

Anova Books is committed to respecting the intellectual property rights of others. We
have therefore taken all reasonable efforts to ensure that the reproduction of all content
on these pages is done with the full consent of copyright owners. If you are aware of any
unintentional omissions, please contact the company directly so that any necessary
corrections may be made for future editions.

WASHINGTON, D.C.

THEN & NOW

ALEXANDER D. MITCHELL IV

THUNDER BAY
P·R·E·S·S

San Diego, California

WASHINGTON, D.C.

THEN & NOW INTRODUCTION

Of all the major cities in the United States, Washington, D.C., must rate as the most untypical and unusual. It is the center of power in the United States, and even in Western civilization. It could qualify as the first "planned community" in the country, even if the plans were often disregarded and changed over the years. It merits nomination as the largest "company town," with the huge numbers of federal employees working in the city. The city's skyline is distinguished by what it doesn't have: skyscrapers rising out of the downtown district. And the District of Columbia is truly "monumental," with a memorial, monument, or grand building seemingly within sight or a stone's throw of any place in town.

The area now known as the District of Columbia had its origins in 1785 when, after years of a nomadic existence, the new government of the thirteen former British colonies voted to set up shop in a permanent "federal town." After much debate over whether to place the city on the Delaware River or the Potomac River, the government decided on the southern option. In 1790 George Washington selected the 100-square-mile diamond of land that would be named after him. It incorporated parts of Alexandria, Virginia (near his own home at Mount Vernon); Georgetown, Maryland; and both banks of the Potomac and Anacostia Rivers. The location would be derided in future years as one that was heavy on swamps and mosquitoes, hot and humid in the summer, and cold and icy in the winter.

Pierre Charles L'Enfant, a French engineer and architect who had served with Washington in the colonial army, offered his services to design a capital city worthy of a great nation and world recognition. No doubt inspired by the grandeur of Versailles and Paris, he and Andrew Ellicott laid out a visionary grid plan heavy with majestic avenues, a central mall, monumental circles, and spectacular public buildings—the basis of Washington's heart today.

L'Enfant's plan quickly outran the young nation's resources and the ability of economic development to match, and it would take until the late nineteenth century for the combination of a thriving economy and expanding government to raise the city from a backwater company town to a metropolis. By 1900, however, unplanned and haphazard development had so ignored L'Enfant's vision that a congressional committee headed by Senator James McMillan was organized to completely revamp and overhaul the future appearance of Washington. The end result of consultations with architects and artists was the *Report of the Senate Park Commission*, popularly referred to as the McMillan Plan. Released in 1902, it has influenced the appearance of the city for more than a century. Its major effects over the years were to restore and protect the open spaces of the National Mall and create other open plazas and monuments such as the Union Station Plaza, the Lincoln Memorial, and the Arlington Memorial Bridge. It also capped the height of

future buildings just as the skyscraper era began, producing the low-slung skyline that distinguishes Washington from almost every other metropolitan area in the United States today.

The next major plan for Washington arose from the Public Buildings Commission, created by Congress in 1916 to address the problems of housing an expanding bureaucracy. Their planning culminated in the Public Buildings Act of 1928, which directly resulted in the construction (during the Depression-ridden 1930s) of the group of massive federal buildings between Pennsylvania Avenue and the Mall now known as the Federal Triangle. It also resulted in the construction of the Supreme Court Building, the House Office Building, and the Jefferson Memorial.

In common with metropolitan areas in the rest of the nation after World War II, Washington shifted from a thriving residential metropolis to a central business city surrounded by suburban bedroom communities. In all this, the downtown shopping district and much of Pennsylvania Avenue, arguably the nation's showcase boulevard, remained neglected. In 1964 the President's Council on Pennsylvania Avenue, appointed by John F. Kennedy, submitted a report that guided the redesign of the southeastern end of Pennsylvania Avenue and the commercial district to the north between Sixth and Ninth Streets. The redevelopment continues to this day, with new purposes for buildings such as the Old Post Office.

Today, Washington endures as a thriving American city, although not without the ills that affect many other American cities—crime, suburbanization, and traffic congestion—and troubles unique to the District of Columbia, including endless political wrangling. As the twenty-first century approached, the district struggled to get aboard the economic boom that had swept the United States after the Cold War, and struggled anew to gain political autonomy in the form of home rule or statehood.

This book, just like the photographs on these pages, cannot be a definitive interpretation or history of the city. Rather, it is a collection of moments frozen in time, sometimes perilously. For every scene in the book that is seemingly preserved for the ages by planning and legislation, there is another where construction cranes hover and buildings are rising or falling as these words are written. For every scene that would take no effort for the first-time visitor to find, there were scenes that led to enormous perplexity and searching. Jonathan Swift noted that "there is nothing in this world constant but inconstancy," and that is particularly apt in the case of photographic histories. With that, I hope that you enjoy the small slice of the District of Columbia's historic panorama presented on these pages, and hope that readers in the future can also partake in the sense of discovery and exploration that we enjoyed while producing this book.

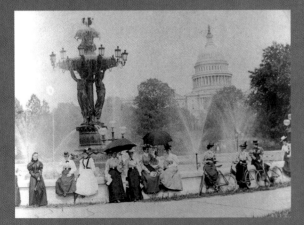

Bartholdi Fountain, c. 1905 p. 14

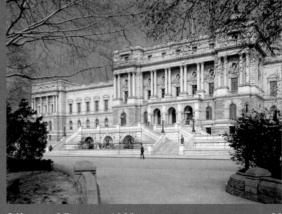

Library of Congress, 1902 p. 20

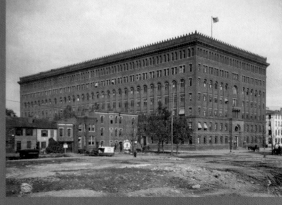

Government Printing Office, c. 1910 p. 30

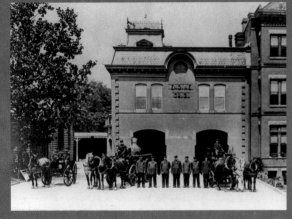

C Street and Delaware Avenue, c. 1875 p. 32

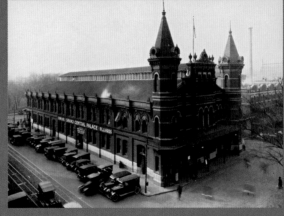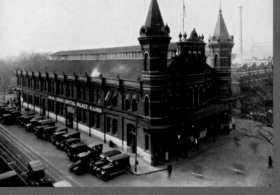

Seventh and B Streets, c. 1925 p. 48

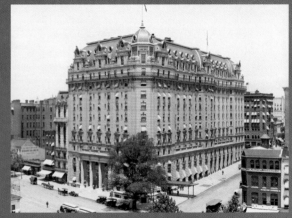

Willard Hotel, c. 1910 p. 50

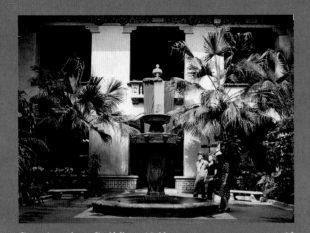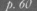

Pan-American Building, 1943 p. 60

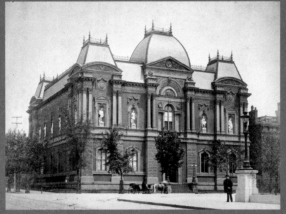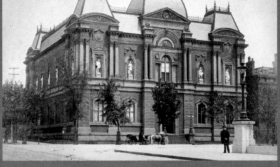

Corcoran Gallery, c. 1895 p. 66

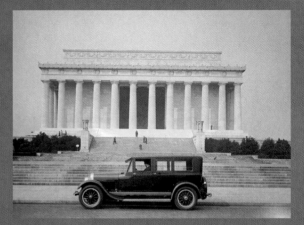

Lincoln Memorial, c. 1925 p. 74

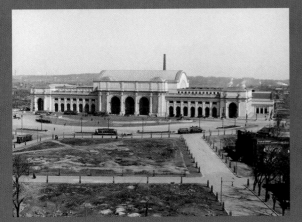

Union Station, c. 1910 — p. 82

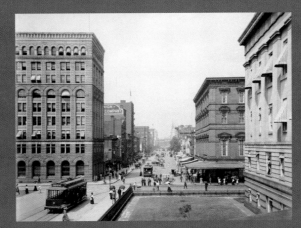

Ninth and F Streets, c. 1908 — p. 94

Ford's Theatre, c. 1875 — p. 98

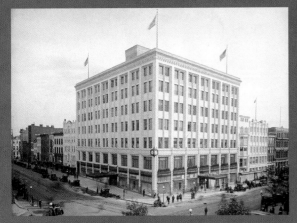

Hecht's Department Store, 1926 — p. 102

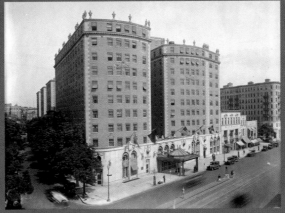

Mayflower Hotel, c. 1925 — p. 108

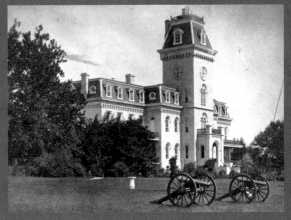

Scott Hall, 1868 — p. 118

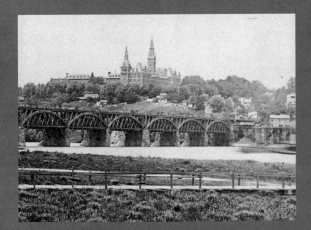

Potomac River, c. 1880 — p. 122

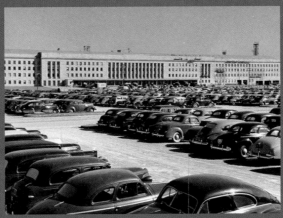

The Pentagon, 1942 — p. 131

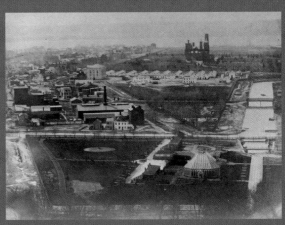

View from the Capitol, c. 1865 — p. 136

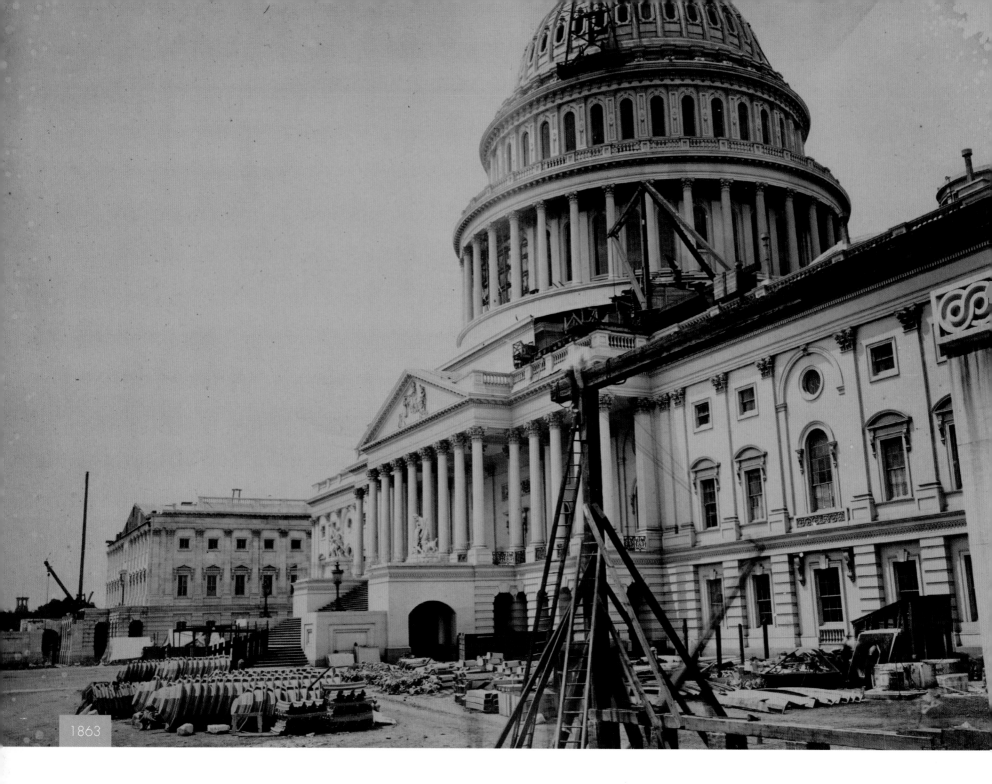

1863

THE CAPITOL
Historic seat of the United States Congress

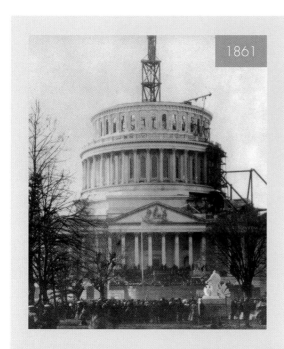

1861

AN ARCHITECTURAL MASTERPIECE

The completion of the new, larger dome in 1868 unbalanced the architectural proportions of the east front of the Capitol. In 1904 the portico, first erected after the devastation of the 1814 British attacks, was rebuilt to restore the classical harmony of the east front's appearance. The 1959–61 extension preserved the appearance of the facade with a reconstruction in marble, and the original sandstone Corinthian columns of 1828 were removed and put into storage. In 1984 landscape designer Russell Page created a permanent home for the old columns in meadowland within the National Arboretum.

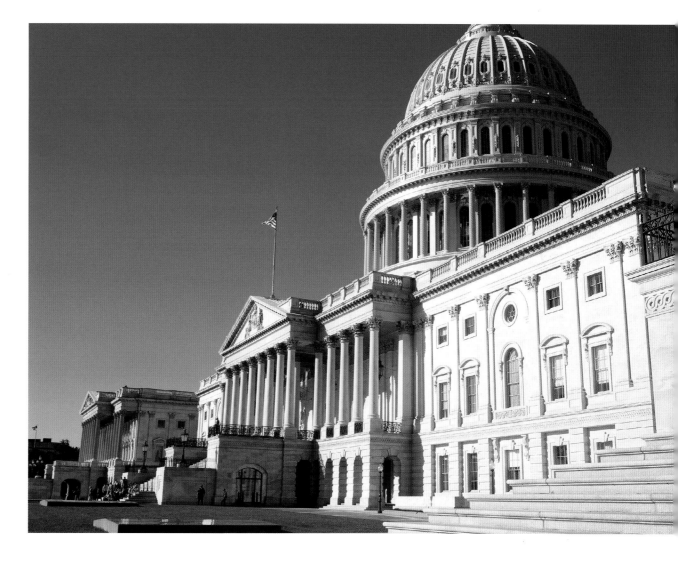

LEFT The original design for the U.S. Capitol Building was submitted in 1793 by William Thornton in response to a competition set up by Thomas Jefferson. Thornton's design was later modified by Benjamin Henry Latrobe and then Charles Bulfinch. The old Senate wing, begun in 1793 and completed in 1800, is to the right; the House wing is to the left. Both were torched by British troops in August 1814 during the War of 1812. After rebuilding the fire-devastated wings, Bulfinch began work on the center section in 1818, completing it in 1829. In 1850 the U.S. Congress (which had grown along with the nation) authorized a much-needed expansion of the Capitol, begun the following year. In 1855 Congress authorized a larger dome in keeping with the larger building. This was still under construction during President Abraham Lincoln's inauguration and throughout the Civil War.

ABOVE: The modern photo shows what appears to be the same portico and walls, but this is actually a new extension built thirty-four feet out from the old one in 1959–61. The extension added a hundred offices to the Capitol Building.

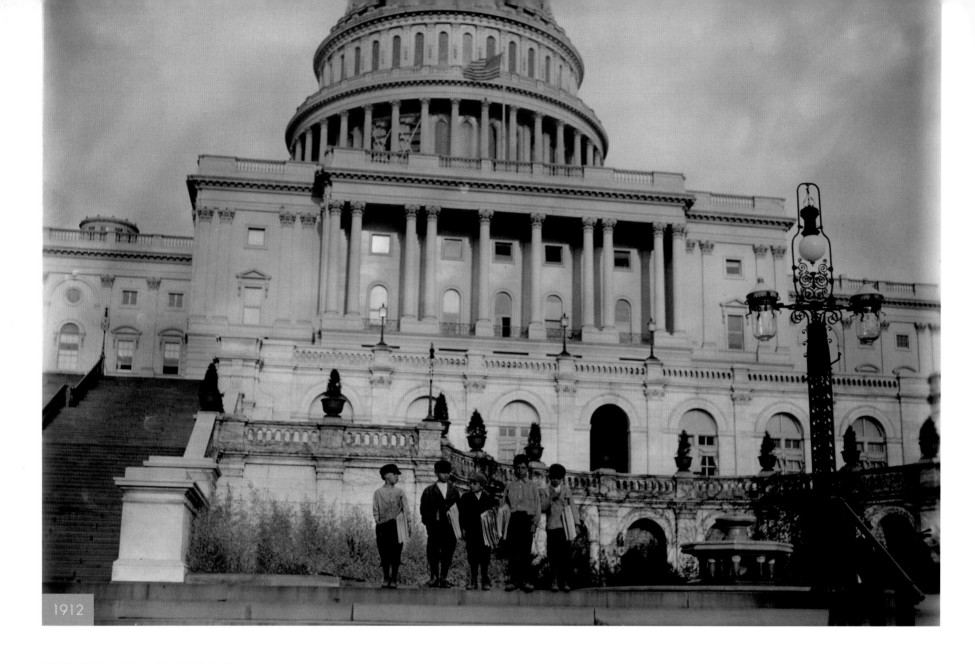

1912

THE CAPITOL

Former workplace for "newsies," the Capitol continues to make the news

ABOVE: Five "newsies" line up below the steps of the west front of the Capitol on April 12, 1912. When asked by the photographer how much money he'd made that day, one of the boys replied, "Eight cents." Being truant from school was not uncommon in the early twentieth century and, despite its status as the nation's seat of government, Washington has always had a large population of those affected by poverty. Four days later these boys are likely to have sold every newspaper they had, when news of the RMS *Titanic*'s sinking hit the front pages.

RIGHT: In the twenty-first century, news is still made on Capitol Hill, but newspapers are no longer sold on the steps of the west front. Since the introduction of electric floodlights, the seat of the U.S. government has been bathed in a spectacular blaze of glory each night, save for wartime blackouts.

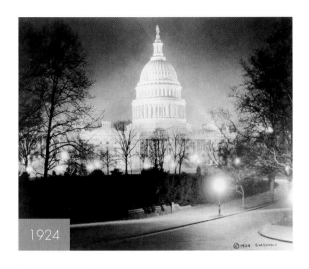

1924

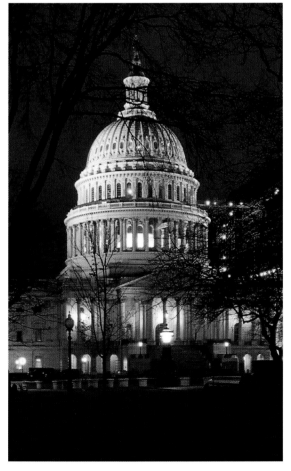

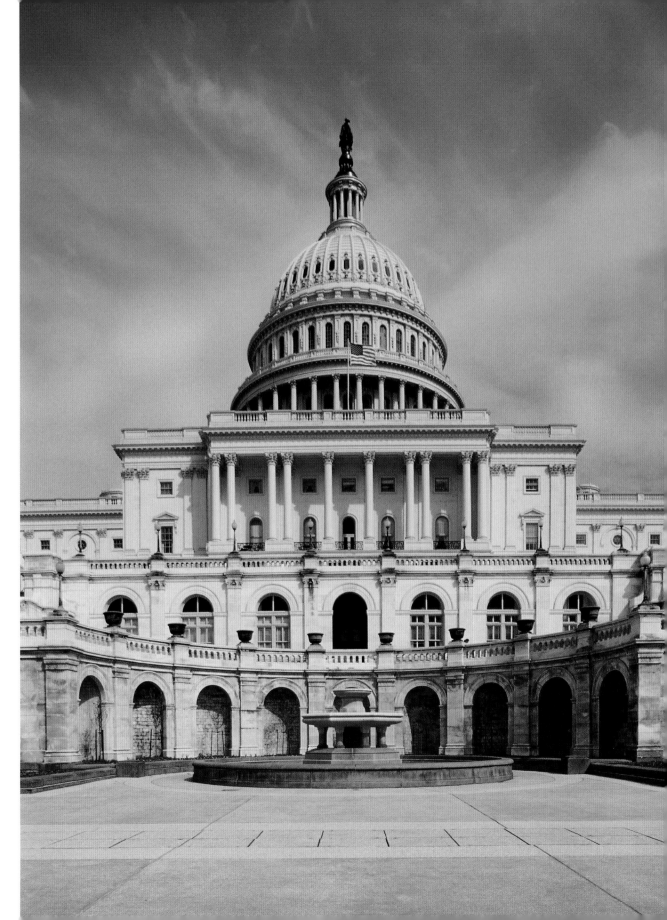

MARYLAND AVENUE
Featuring Washington, D.C.'s first steps toward an integrated transportation system

BELOW: This view looks southwest from the corner of B Street and Delaware Avenue NE toward the east front of the Capitol. Horse-drawn streetcars began operation in Washington in 1862 with the construction of the Washington and Georgetown Railroad. It was joined two years later by the Metropolitan Railroad Company. Three other companies served Washington before the first electric streetcars in the city began operation in 1880. Overhead wires were banned by Congress soon afterward, and a variety of mechanical and electrical systems were then adopted, including a conduit system that used an underground sliding shoe devised for the Metropolitan, seen here. This system gave the tracks the appearance of a cable-car system like that of San Francisco, and the slot for the conduit can clearly be identified between the tracks in the foreground of this 1910 photo.

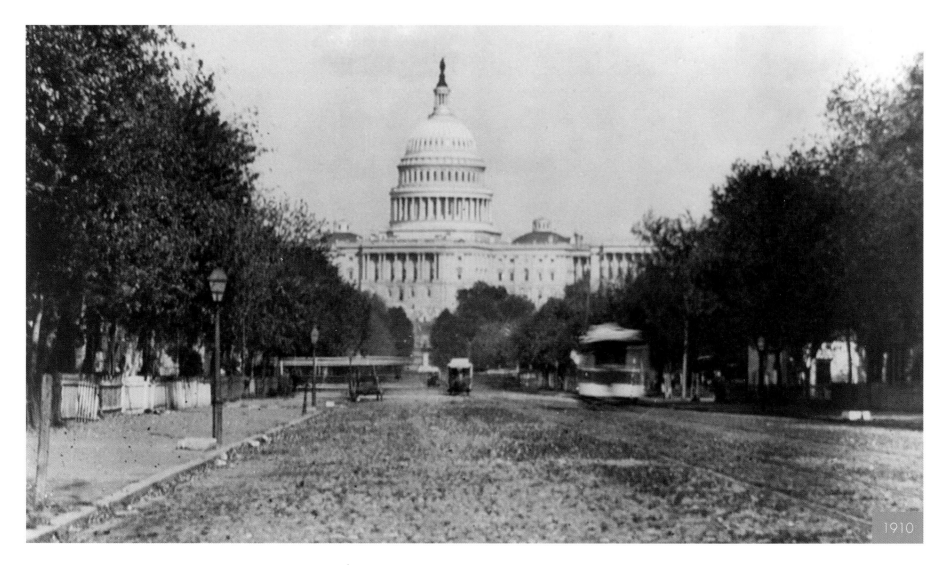

1910

RIGHT: The last D.C. Transit streetcars operated until January 1962; the Washington Metro subway system was begun in 1969 and opened in 1976. In the early twenty-first century, construction began throughout the city on the first of eight proposed light-rail surface lines, the modern-day successor to those horse-drawn cars of 1862. The nineteen-foot bronze statue atop the Capitol dome, *Freedom*, sculpted by Thomas Crawford, was removed from its perch by helicopter for a much-needed cleaning in 1993. A security presence on the approach to the Capitol controls vehicle access to the area, and the same security concerns rule out the return of streetcars on this particular route of the old Metropolitan Railroad.

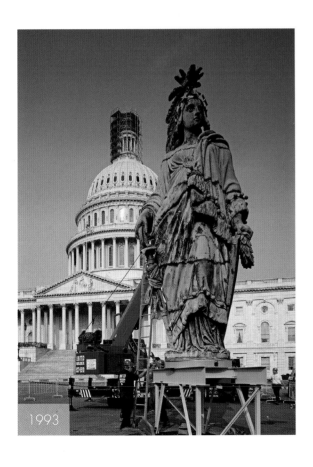

1993

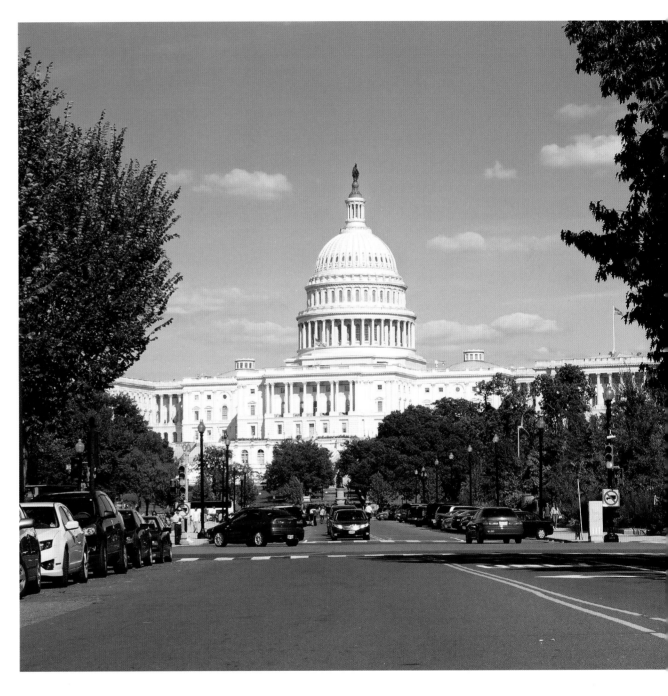

LEFT: This 1993 photograph shows Thomas Crawford's statue *Freedom* after it was removed from the Capitol dome for restoration.

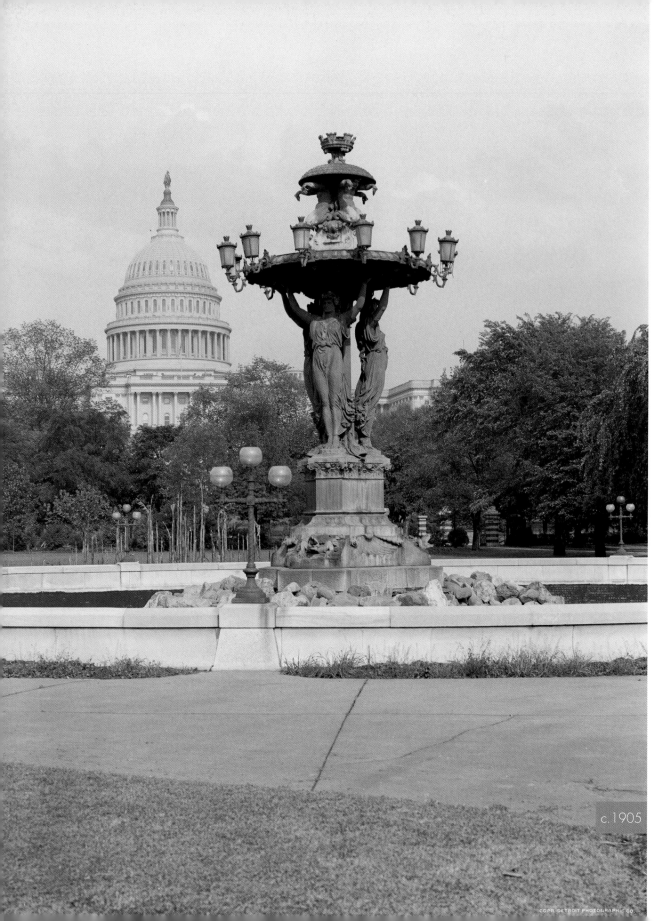

c.1905

BARTHOLDI FOUNTAIN

Designed by Frédéric-Auguste Bartholdi, creator of the Statue of Liberty

LEFT: French sculptor Frédéric-Auguste Bartholdi holds a special place in the history of Franco-American relations; he is the creator of perhaps the world's most famous sculpture, *Liberty Enlightening the World*, more popularly known as the Statue of Liberty, in New York Harbor. The statue was commissioned by the Union Franco-Americaine to express the strong bonds felt between the two countries that were both forged by revolution within a few years of each other in the late eighteenth century. Bartholdi first visited the United States in 1871 to select a site for the Statue of Liberty. He made frequent trips and even married his French wife in Newport, Rhode Island, in 1875. In 1876 he was a commissioner on the French delegation at the Philadelphia Centennial Exhibition, at which he exhibited this more modest sculpture. The U.S. government purchased the cast-iron fountain, a mere thirty feet high, the following year.

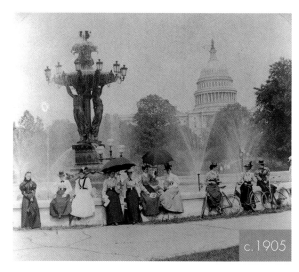

c.1905

RIGHT: The government got a bargain, offering Bartholdi only $6,000, which was about half of what the sculptor had hoped for. The fountain was first installed in the Botanic Garden across First Street SW from the Capitol. With its gas lanterns it was one of the first fountains to be illuminated at night, and it stood there for fifty-five years dispensing light and movement come rain or shine. It survived harsh winters like that of 1901 when it froze solid (below). In 1932 it was moved across Independence Avenue to the triangle of land formed with First Street and Washington Avenue SW. The area, now known as Bartholdi Park, faces a major exit ramp from the Southwest/Southeast Freeway (I-395). Thousands of drivers file past the Bartholdi Fountain daily, most of them unaware of the story behind it.

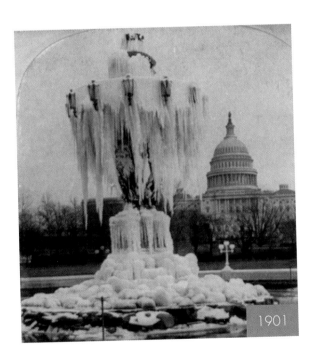

1901

ABOVE: The frozen waters of the Bartholdi Fountain during the winter of 1901, with the Capitol as a backdrop.

LEFT: A change of season: the fountain was a popular and cool meeting spot in the Botanic Garden during summer months.

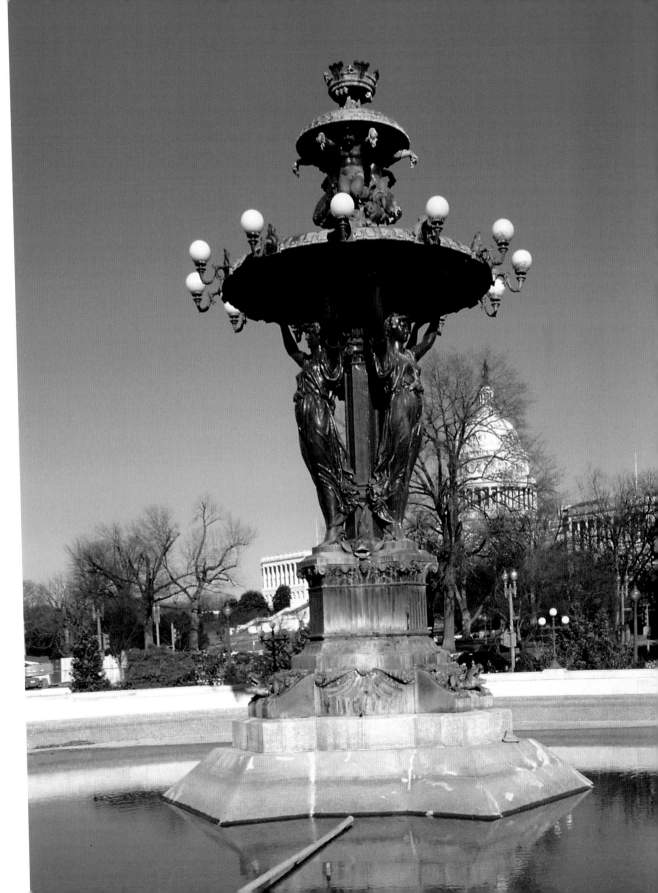

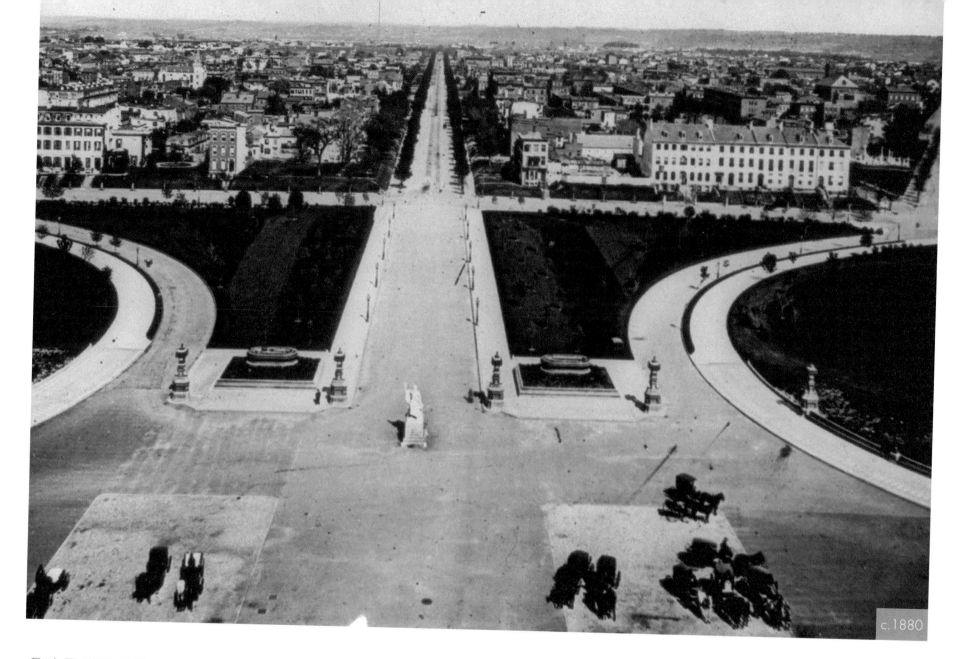

c.1880

CAPITOL STREET
The heart of congressional life

ABOVE: The view east from the Capitol dome circa 1880 depicts the largely residential neighborhood now referred to as Capitol Hill. The massive twenty-ton marble statue of George Washington in the foreground, created by Horatio Greenough, was commissioned by Congress in 1832 and delivered in 1841. It proved to be too heavy for the Capitol Rotunda—yet oddly too small for the interior—and it spent the next century being moved about the East Grounds and the city like a hapless chess pawn before taking up residence in the Smithsonian Museum of History and Technology in 1962. At the right center can be seen Carroll Row, the future site of the Library of Congress. Large numbers of newer Victorian homes can also be seen, as can the results of general public works and street regrading—many older buildings are now high above the streets, requiring long stair climbs to the front door.

16

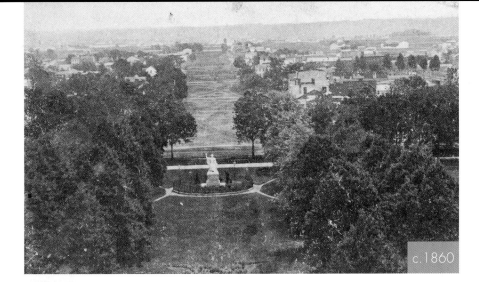

c.1860

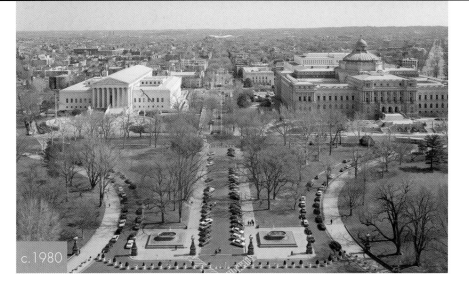

c.1980

ABOVE: Much of what appears in the old photograph is obscured by foliage in the modern view, with its lower elevation. To the right, behind the trees, can be glimpsed the Library of Congress (1897), and to the left the Supreme Court Building (1935). Other items in view are unchanged—the lanterns on their sandstone pedestals, and the giant ornamental basins in their marble-edged beds. For security reasons, cars are no longer permitted as close to the Capitol as they were the 1980s (top right). Other security precautions are less visible; tripods, once a necessity in early photography, are no longer allowed on the Capitol grounds without a permit.

TOP LEFT: This photograph, taken about 1860, shows the statue of George Washington in what looks like a pastoral location. In roughly twenty years the area around it was transformed into a much busier and distinctly urban environment. The contrast is heightened in the photo taken more than a century later (top right).

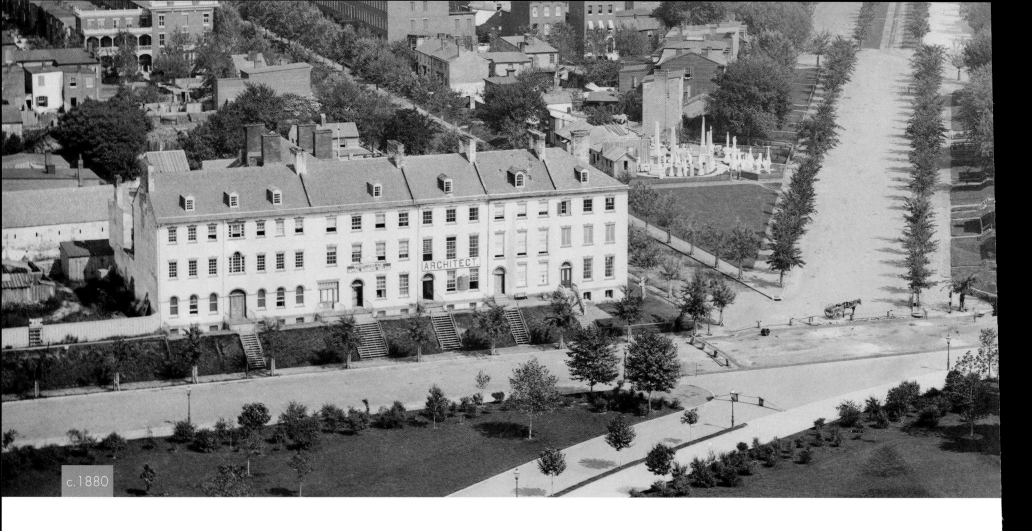

c.1880

CARROLL ROW / JEFFERSON BUILDING

From fashionable boardinghouses for members of Congress to the present site of the Library of Congress

ABOVE: A five-house block of buildings, Carroll Row was built around 1800 by Daniel Carroll, the principal landowner of Capitol Hill at the time. Located within walking distance of the Capitol, Carroll Row became famous for its fashionable boardinghouses for members of Congress prior to the Civil War. While serving in Congress from 1847 to 1849, Abraham Lincoln lived in Anna G. Sprigg's boardinghouse on Carroll Row. Another famous building in the row was Long's Hotel, where the 1809 inaugural ball was held for President James Madison. Throughout the nineteenth century, Carroll Row had many uses. The houses were used as headquarters by General Robert Ross and Admiral Sir George Cockburn, leaders of the invading British forces who burned the city in August 1814. They also turned the southernmost house into a hospital for wounded British soldiers. In the 1830s, this house served as the printing establishment of Duff Green, editor of the *United States Telegraph* and printer for the government. During the Civil War, Carroll Row was transformed into Carroll Prison and housed the government's political prisoners.

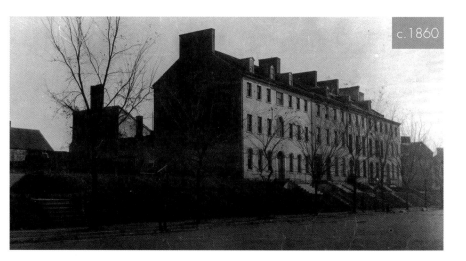

c.1860

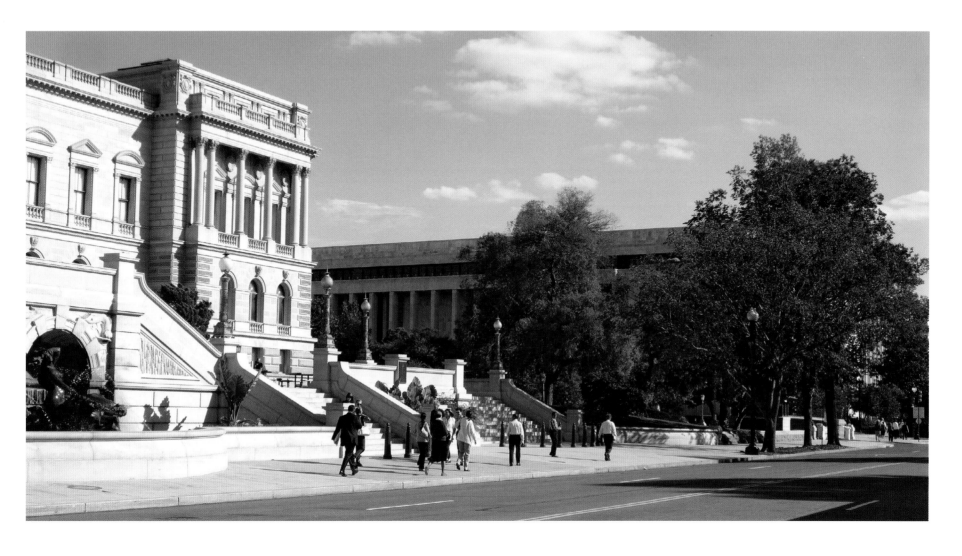

ABOVE: Facing a shortage of shelf space at its Capitol location, Congress authorized the construction of a new Library of Congress building in 1886. Designed in the style of the Italian Renaissance by architects John L. Smithmeyer and Paul J. Pelz, the building opened its doors to the public in 1897 and was hailed as a glorious national monument. Throughout the twentieth century, Congress endeavored to increase the building's cultural importance. In 1936 the Gertrude Clarke Whittall Foundation was established to support the art and scholarship of music. In 1941 Brazilian muralist Cândido

LEFT: This photograph from about 1860 shows the southernmost house of Carroll Row, which served as a military hospital and a printing establishment.

Portinari completed four large paintings depicting the succession of periods since the Spanish and Portuguese arrived in America, in the entrance to the Hispanic Room. The building was formally named the Thomas Jefferson Building in 1980. In 1984 Congress appropriated funds to restore it to its nineteenth-century splendor. The building reopened in 1997, on the hundredth anniversary of the Library of Congress. In 2008 it was physically reconnected to the Capitol for the first time since 1897 thanks to the construction of an underground passageway. The Madison Building, located across Pennsylvania Avenue, was inaugurated in 1980; it serves as an annex to the Thomas Jefferson Building and as a memorial to President James Madison. Ten quotations from Madison's writings adorn the exterior walls of the Madison Building.

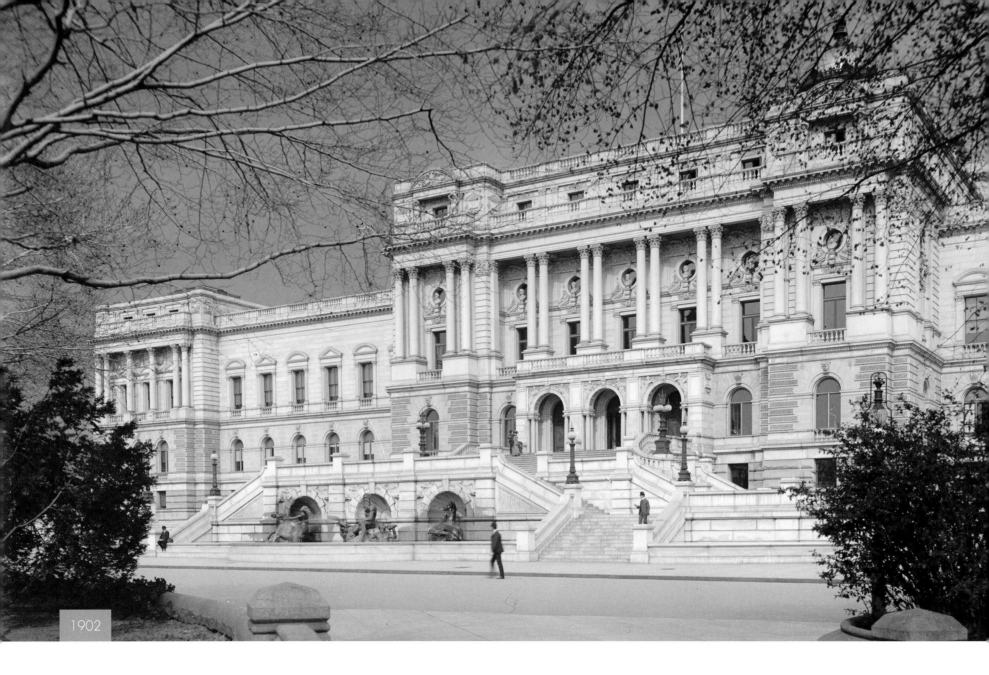

1902

LIBRARY OF CONGRESS

Home to the largest collection of published works in the United States

ABOVE: The Library of Congress was started as a legislative library in 1800 with the acquisition of 740 books from London, but was destroyed when the British burned Washington in 1814. Thomas Jefferson then sold his 6,437-volume personal library to the government for $23,950 to form the nucleus for a new library. Since then, the Library of Congress has become the de facto national library of virtually all works published in the United States.

A competition to design a more modern library building was launched in 1871. The winning architects, John L. Smithmeyer and Paul J. Pelz, were awarded the contract in 1873 but spent nine more years refining their design by visiting the great libraries of Europe. Construction began in 1886 and was completed in 1897. This photograph was taken in 1902.

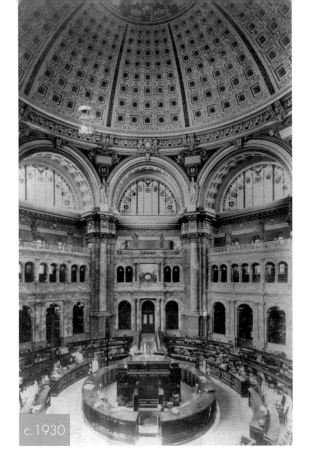

c.1930

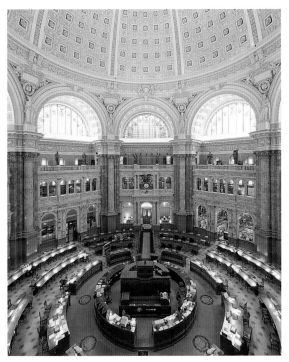

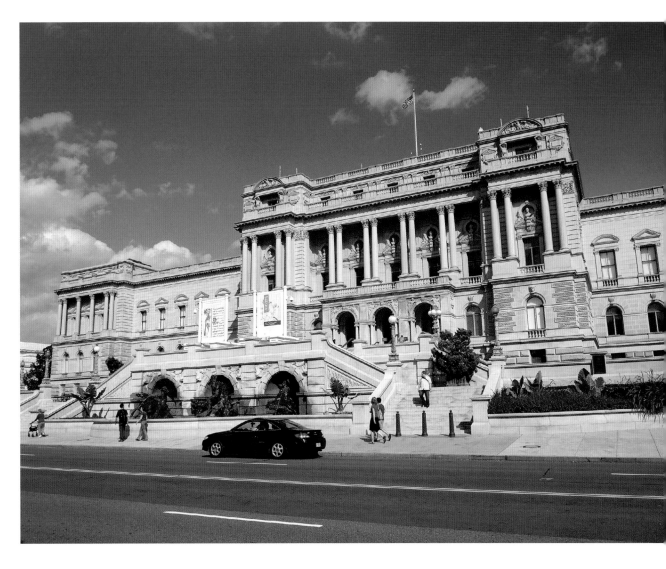

ABOVE: The Thomas Jefferson Building is in the Italian Renaissance style. It was originally planned to house three million volumes; the Library of Congress now holds around 147 million items in the adjoining Jefferson, Adams, and Madison Buildings, and at off-site storage centers. The relatively restrained exterior conceals one of the most elaborate interior decorative schemes in the country, and includes the work of over forty American artists. The photos at left show the Main Reading Room, an awe-inspiring space described as being like the inside of a giant Fabergé egg. Only the glow of laptop computers marks the difference of years in the octagonal mahogany-trimmed shrine to research.

LEFT: These two pictures show the magnificent Main Reading Room circa 1930 and today; it is a favorite of students in the humanities and social sciences.

21

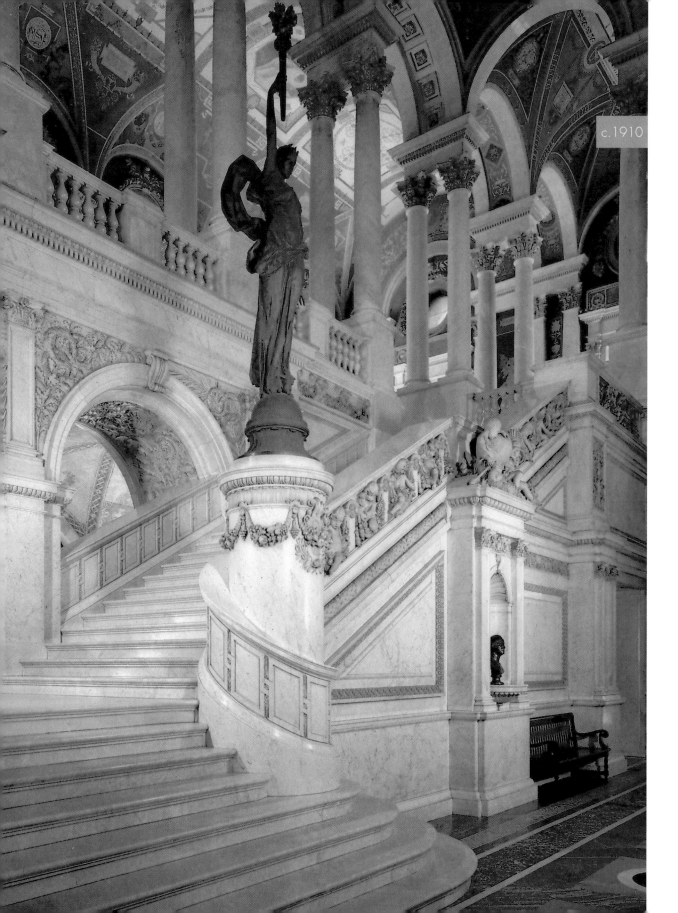

c.1910

GREAT HALL
Despite its grandeur, the ornamentation cost just $364,000

LEFT: The gem of the Jefferson Building of the Library of Congress—and arguably the whole of Washington—is its spectacular, richly decorated Great Hall. In spite of the outlandish decoration of the interior, the building was originally completed for $200,000 less than the original congressional authorization of $6,500,000. Of that, the costs of painting, sculpture, decoration, and three massive bronze doors was $364,000.

RIGHT: After eleven years of painstaking renovation of its curving marble staircases, bronze statuary, rich mosaics, and paintings and murals that would be the envy of ancient Egypt or Greece, the Jefferson Building was reopened to the public in 1997, the building's centennial year. It is as impressive today as it was when it was first built.

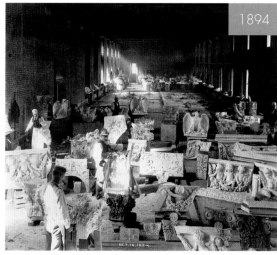

1894

BUILDING THE LIBRARY OF CONGRESS

Construction of the Library of Congress Building, as it was originally known, took eleven years. It was under the supervision of a unique father-and-son team. Brigadier General Thomas Lincoln Casey was chief of the U.S. Army Corps of Engineers and an obvious choice to oversee the building work. His twenty-five-year-old son Edward Pearce Casey was appointed artistic supervisor. It was General Casey's military efficiency in bringing the construction in under budget that allowed his son to extend the program of commissions for artistic enrichment of the interior. The expanse of sculpture, architecture, and painting, which was without equal in the nation, was designed to proclaim America's achievements in art, science, and literature to the world.

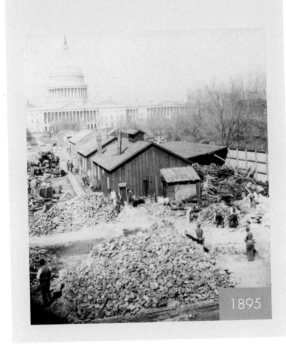

1895

LEFT: This 1894 photograph shows sculptors carving some of the cherubim friezes adorning the stairs of the Great Hall.

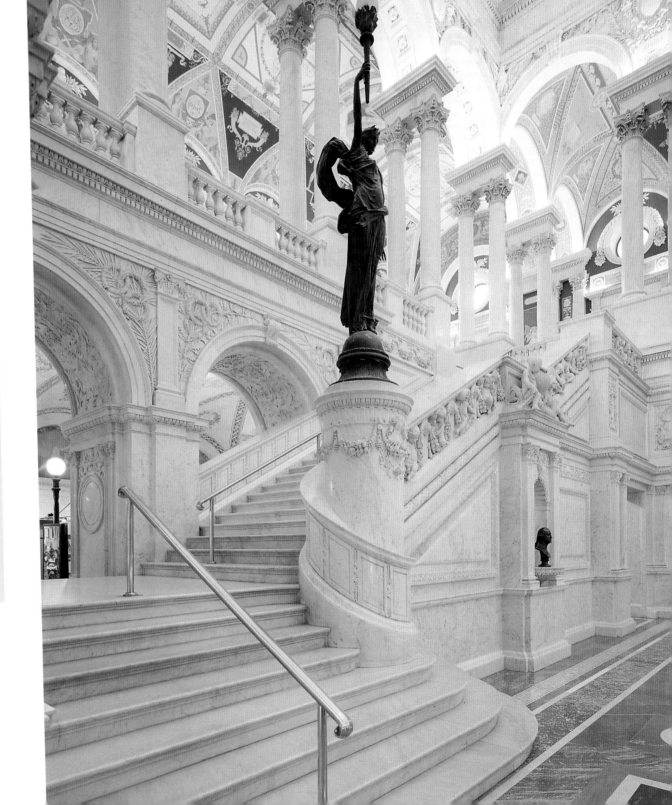

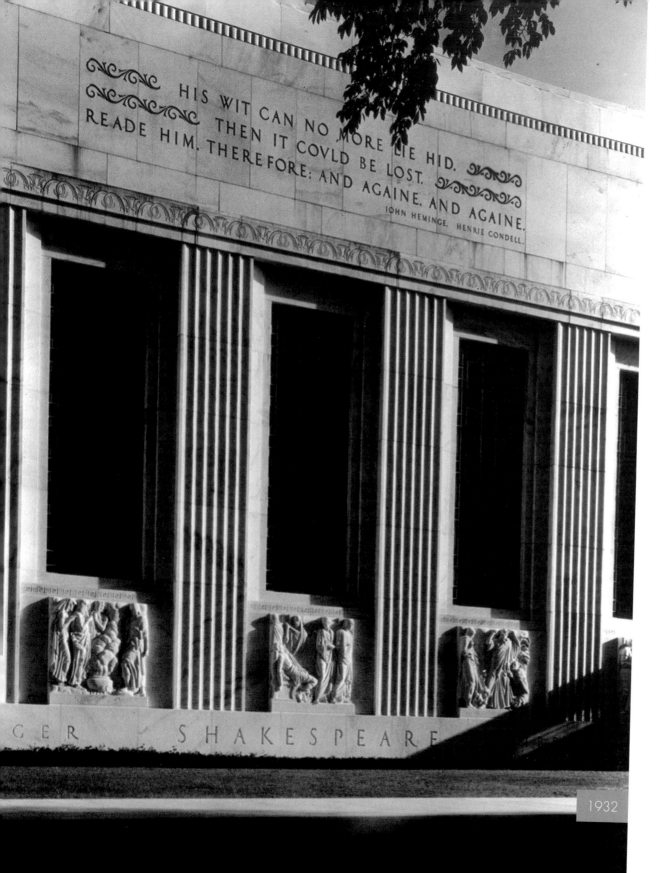

HIS WIT CAN NO MORE LIE HID.
THEN IT COVLD BE LOST.
READE HIM. THEREFORE: AND AGAINE. AND AGAINE.
IOHN HEMINGE. HENRIE CONDELL.

GER SHAKESPEARE

1932

SHAKESPEARE LIBRARY

Henry Clay Folger's tribute to the Bard and gift to the American people

LEFT: The Folger Shakespeare Library was a gift to the American people from Henry Clay Folger and his wife Emily Jordan Folger. Henry had made a fortune in petroleum as president of Standard Oil of New York, but his passion was Shakespeare; he was inspired as a college student by a lecture given in 1879 by the great American poet Ralph Waldo Emerson. Folger was determined to build a library for his collection next to the Library of Congress, and spent years acquiring the land on East Capitol Street SE, plot by plot. He lived to see the cornerstone laid there in 1930, but died later that year. His gift, designed by architect Paul Philippe Cret, opened two years later in 1932, on April 23—the reputed birthday of the English playwright.

RIGHT: The marble exterior is pure Art Deco, adorned with quotations chosen by Folger and panels depicting scenes from Shakespeare's plays. The interior is completely different, adopting a Tudor style of plaster ceilings and oak paneling. A major center for research, the Folger Library houses the world's largest collection of Shakespeare's printed works and other rare Renaissance books and manuscripts, in disciplines such as history, theology, politics, and the arts. It contains a total of more than 300,000 books and manuscripts; about as many other printed items such as playbills, photographs, and prints; and a further collection of paintings, sculptures, musical instruments, costumes, and films. In addition to reading rooms for researchers, it contains a reconstruction of an inn-yard theater, which is regularly used for theatrical and musical performances.

BELOW: Reference librarian Dr. Giles E. Dawson examines some of the Folger Shakespeare Library's 9,000 volumes of early modern English.

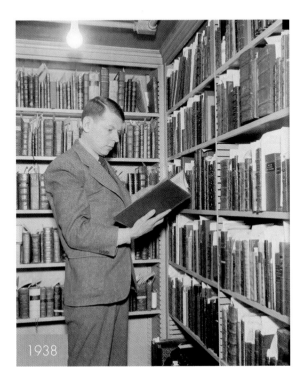

1938

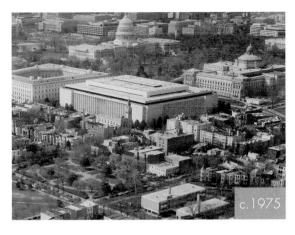

c.1975

ABOVE: An aerial photograph shows the proximity of Folger Park (bottom left, with an oval path) to the Capitol and Library of Congress Building (top right).

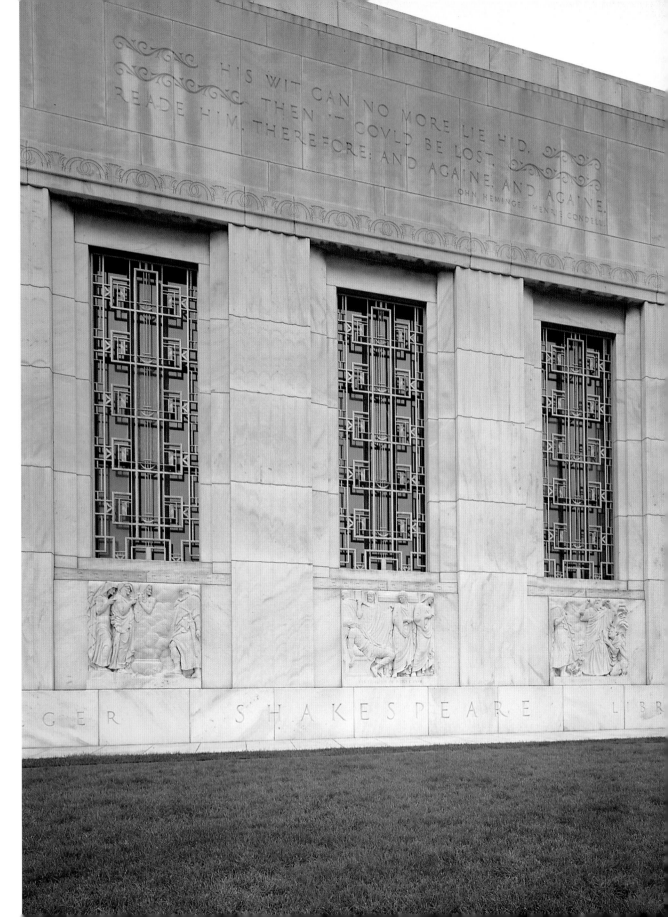

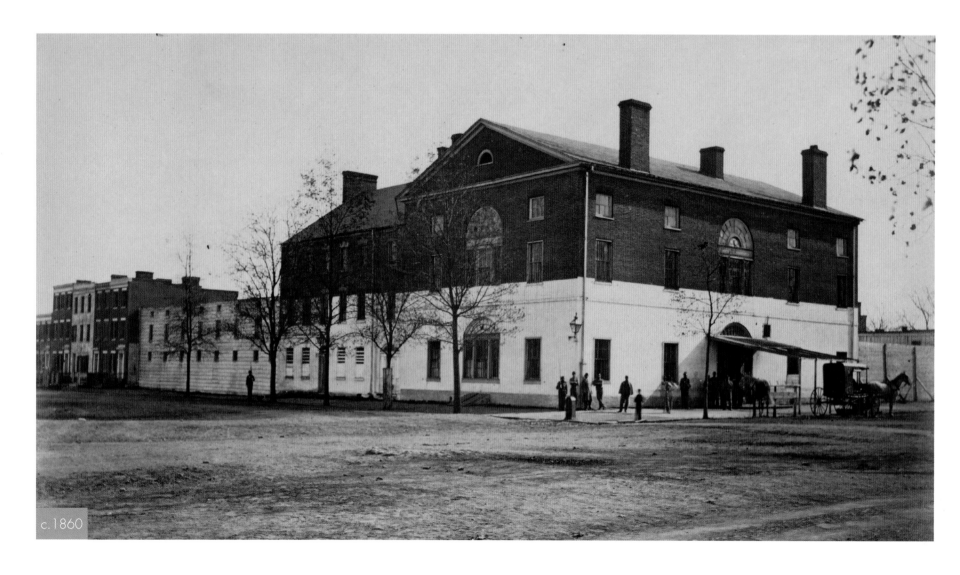

c.1860

OLD BRICK CAPITOL / SUPREME COURT

From the site of the Capitol, to a Civil War prison, to the Supreme Court Building

ABOVE: The site east of the Capitol between First and Second Street NE and East Capitol Street and Maryland Avenue NE has seen several uses over the centuries. After the British raids on Washington, a brick building was hastily erected at the location as a temporary replacement for the burned-out Capitol. It served in that capacity until 1819. Later, the "Old Brick Capitol" became a boardinghouse, a school, and finally a Civil War prison (as shown in this picture). It was demolished in 1867 and replaced by a row of brick houses,

which in their turn were demolished to make way for the Supreme Court Building. The U.S. Supreme Court had occupied chambers within the Capitol since 1810, but in 1928 Congress passed the Public Buildings Act, which provided among other things for the construction of a separate home for the Supreme Court—an important visible demonstration of the Supreme Court's independence from government. The cornerstone was laid in 1932, and construction was completed under budget just three years later.

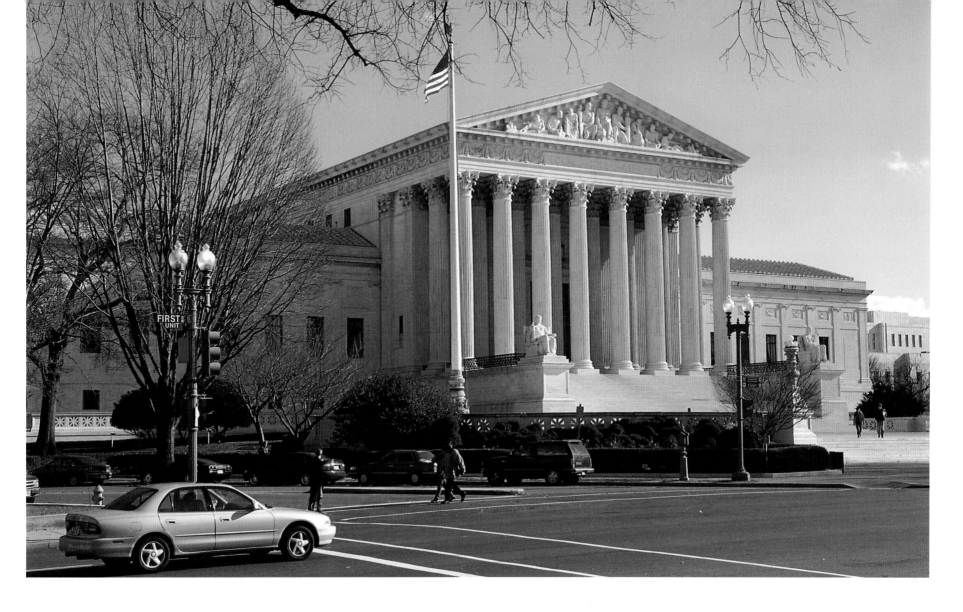

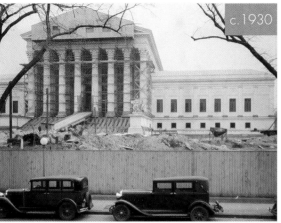

c.1930

ABOVE: The neoclassical building was designed by Cass Gilbert. Three sources of American marble were used for its walls: Vermont (for the outer facades), Georgia (for the courtyard within the complex), and Alabama (for the interiors). Gilbert insisted on Italian marble for the columns of the courtroom itself, and when the building opened for business, many judges felt that it had pretensions bordering on the pompous. But it was designed to be a temple to justice in the same way that its neighbor the Library of Congress was intended to declare America's worship of learning. Today it is the symbol of the federal government's judiciary branch, regularly featured in newscasts and photos, and frequently the scene of demonstrations for and against Supreme Court decisions. In 2010 security concerns resulted in the closure of the main entrance to the building, a decision seen by some as symbolically restrictive of access to justice. Instead, access is by a side door through a modern reinforced screening area of metal detectors and body scanners.

LEFT: This picture from around 1930 shows the Supreme Court Building nearing the end of its construction.

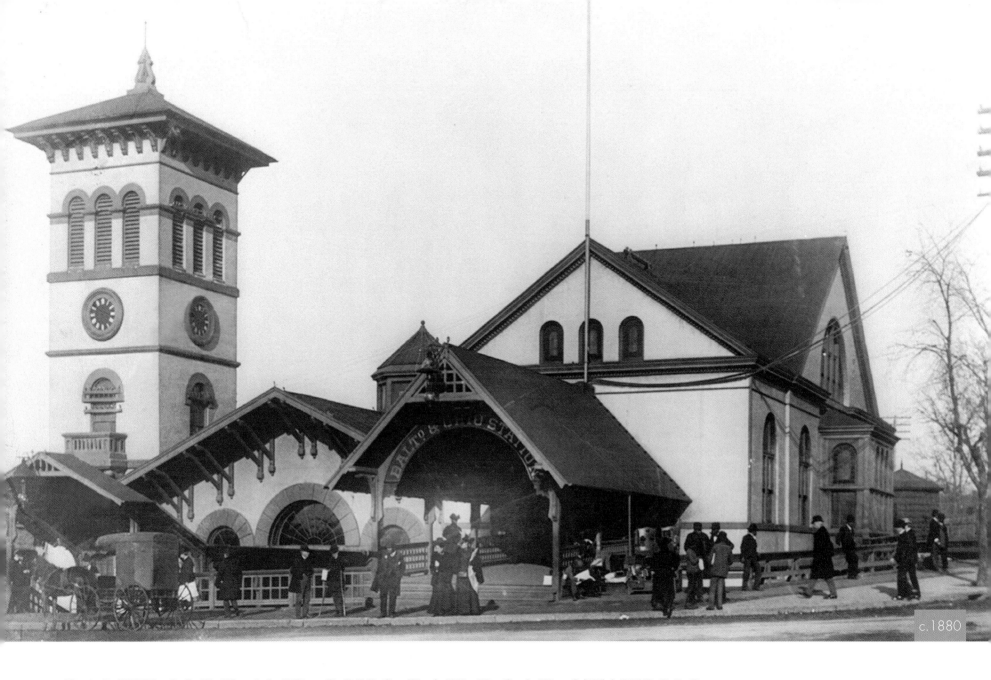

c.1880

BALTIMORE AND OHIO RAILROAD STATION

Home to the first chartered public railroad company in the United States

ABOVE: In 1827 the Baltimore and Ohio Railroad (B&O) became the first railroad company in the United States to be chartered for public use as a "common carrier." The Washington branch, from Relay, Maryland, into the heart of the city, was built in 1835, with its terminus at Second Street and Pennsylvania Avenue NW—now part of a park north of the Ulysses S. Grant Memorial. It was on telegraph wires strung along the B&O's Washington branch that the world's first Morse code message was sent, from the Supreme Court in the Capitol to Baltimore. President-elect James Polk arrived by train from Relay to that original Washington terminus for his inauguration in 1845, the first president to do so. In 1851, as traffic increased, this new terminal building was erected in an Italianate style at the corner of C Street and New Jersey Avenue NW, seen here around 1880.

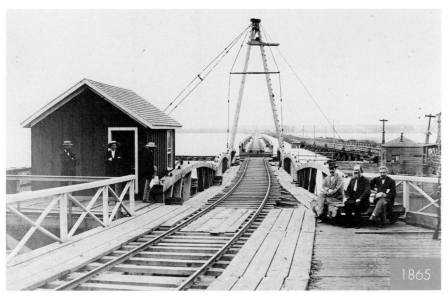

1865

ABOVE: Tracks heading south from the station were laid along Maryland Avenue SW to the north shore of the Potomac River in 1855, although there was no railroad crossing until the army built tracks alongside the Long Bridge during the Civil War. The B&O played a crucial role for the Union side throughout that conflict. The 1851 depot originally dealt with only three or four trains a day, but by the end of the century it could not cope with the demands of modern travelers and freight. It was demolished in 1907 when the newly built Union Station to the north was ready for operation. Under the Public Buildings Act of 1928, the area between Union Station and the Capitol (the former freight yards of the old station) became part of Union Station Plaza. The area is now a park and open space.

LEFT: The Long Bridge across the Potomac River, seen in 1865. Only months earlier, it had been under guard as a potential target for Confederate raiders.

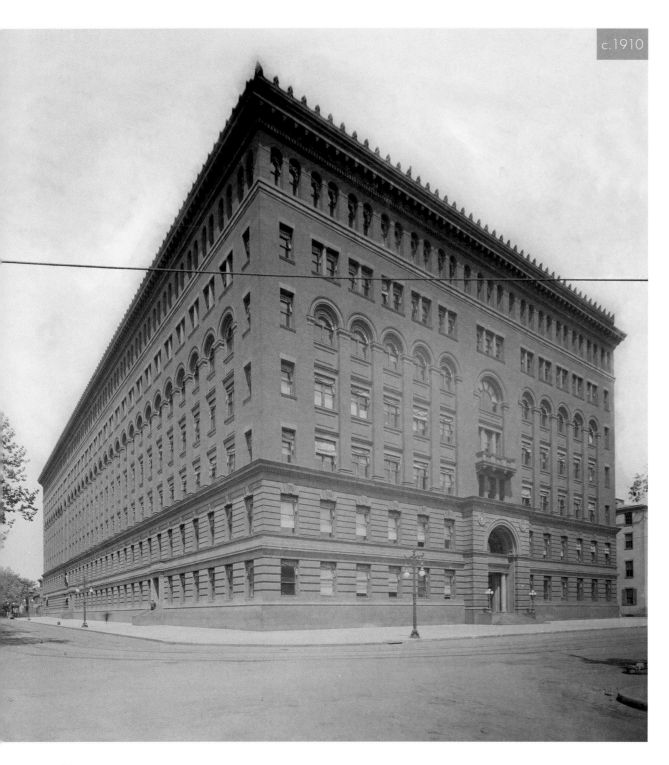

c.1910

GOVERNMENT PRINTING OFFICE

In a city built with marble and granite, a redbrick building stood out

LEFT: The Government Printing Office (GPO) was created in 1860 by a congressional act to satisfy the printing needs of the government. Since then it has always occupied the same site in Washington, on the southwest corner of North Capitol Street and H Street NW. The current monumental redbrick construction is the second structure built at that location for the GPO; it replaced the original premises in 1903. This view from around 1910 is from the vacant lot now occupied in part by the National Postal Museum. When it first opened in 1861, the GPO housed a staff of 350; government bureaucracy increased over the decades, and at its peak in 1972 the GPO had 8,500 employees.

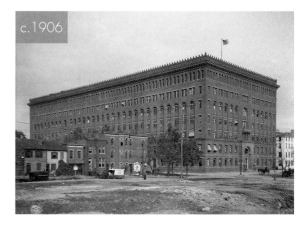

c.1906

ABOVE: This photo from around 1906 shows that the GPO had humble neighbors during its early years.

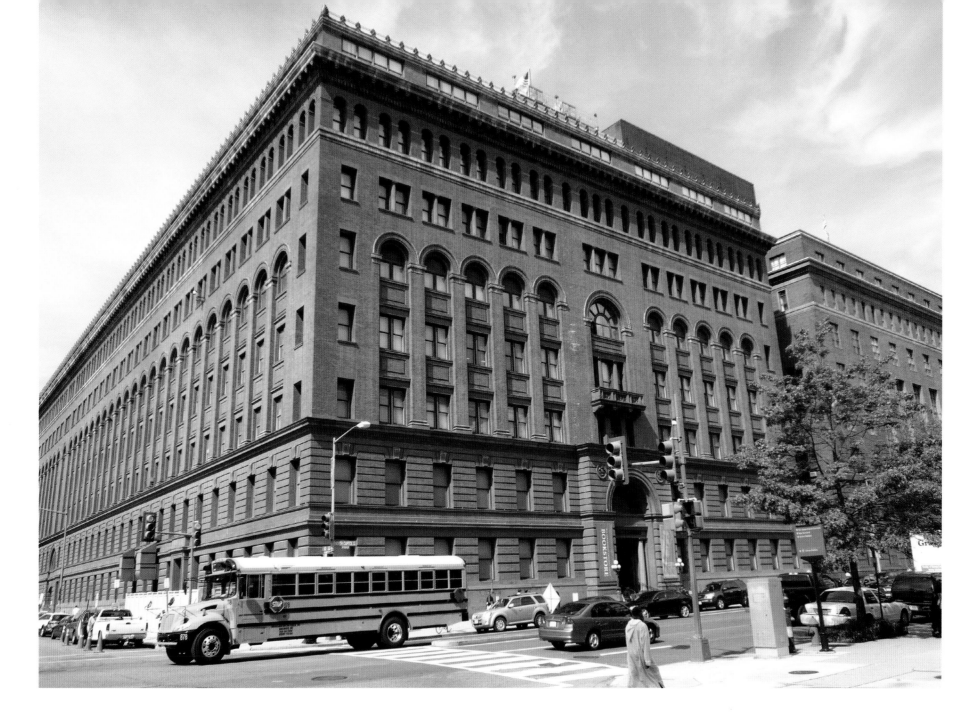

ABOVE: The GPO is a distinctive building in a city of marble and granite; it is one of only a few built of brick; the Pension Building (now the National Building Museum) is another example. It is still regarded as the largest printing plant in the world, performing nearly all the printing and binding requirements of the federal community. In addition to the official journals of the government, it produces documents such as passports and Trusted Traveler Program cards. Since the 1980s, it has gradually adopted modern technology. The trend toward electronic distribution and away from paper documentation has resulted in lower staffing levels, but no diminishment in the importance of the GPO's motto, "Keeping America Informed."

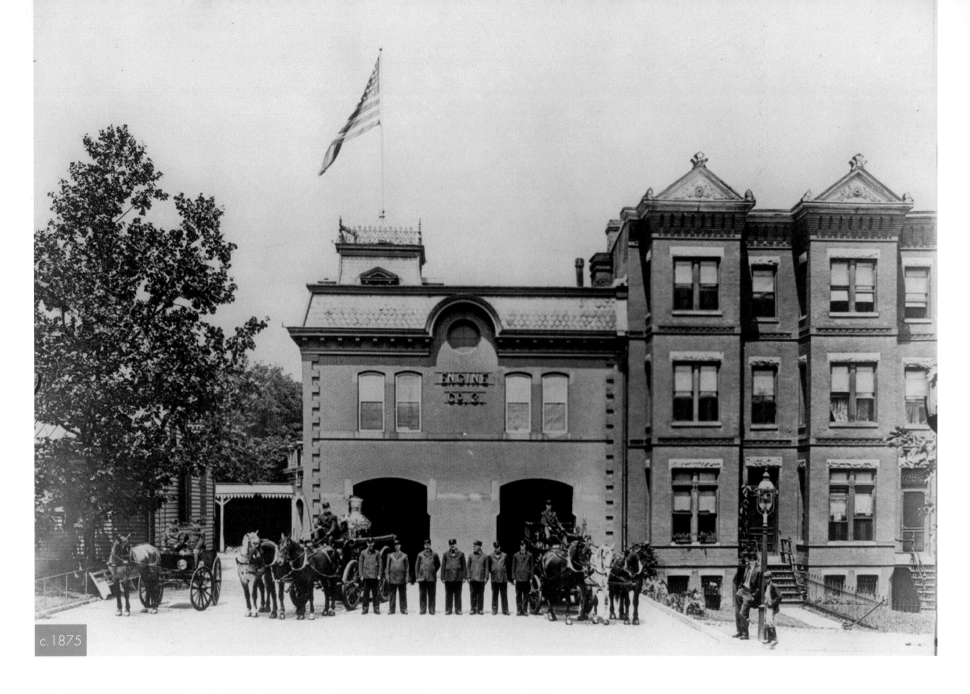

c.1875

C STREET AND DELAWARE AVENUE
Serving the District of Columbia until 1928

ABOVE: The District of Columbia Fire Department was proposed in 1864 as a consolidation of various volunteer fire companies such as the Vigilant Firehouse of Georgetown. The DCFD went into operation in 1871 with three engines, manned by a mixture of paid staff and volunteers. By the end of the century it had expanded along with the city, and ran fourteen engines; today the figure stands at thirty-three. Engine Company 3, pictured here in May 1875, occupied this firehouse at C Street and Delaware Avenue NE, between the Capitol and what later became Union Station. Their horse-drawn wagons were by no means unusual—the last horse-drawn apparatus in Washington was retired in 1925.

BELOW: Firemen and their engine outside the front elevation of the Vigilant Firehouse at 1066 Wisconsin Avenue NW.

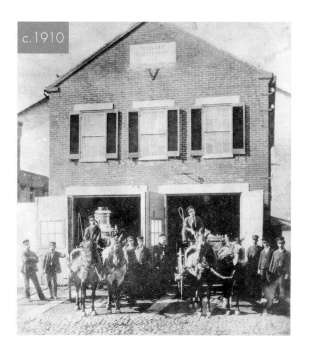

c.1910

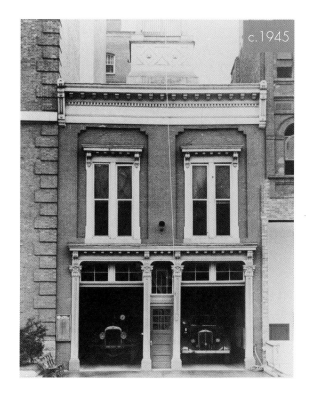

c.1945

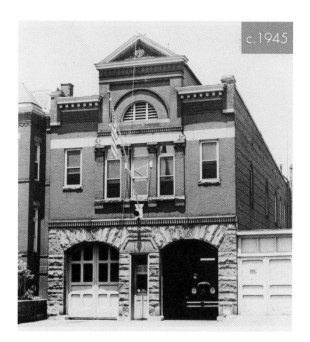

c.1945

ABOVE: The original firehouse of Engine Company 3 fell victim to the 1928 Public Buildings Act, which eliminated most structures between the Capitol and Union Station. No trace remains, and today the location is an entrance to the underground parking garage of the Russell Senate Office Building. In 1916 Company 3 had moved out of its old premises to 439 New Jersey Avenue NW, just around the corner. It closed as a firehouse in 1993 but still operates there as an ambulance station. The Vigilant team (top left) became Engine Company 5, and after several moves, Company 5 is now based on Dent Place NW. Its old home, the firehouse on Wisconsin Avenue NW, has become a restaurant.

FAR LEFT: The firehouse of Engine Company 1 at 1643 K Street NW.

LEFT: The firehouse of Engine Company 4 at 219 M Street NW.

33

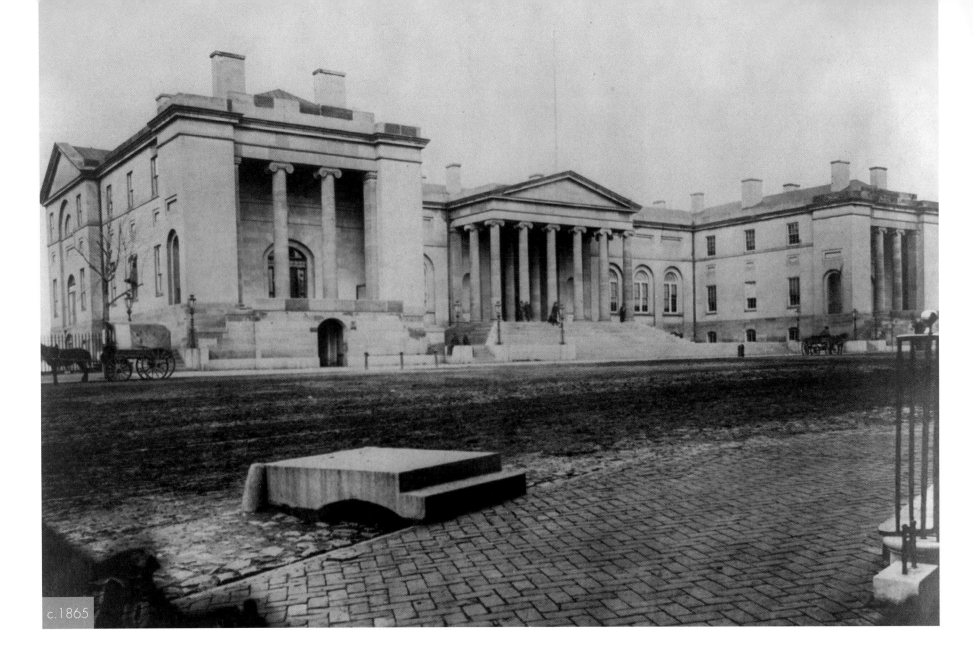

c.1865

OLD CITY HALL
The historic heart of the city

ABOVE: Few buildings in Washington have had such a variety of municipal and federal occupants in their lifetime as the Old City Hall at Fourth and D Streets NW. Even its construction was a complex, drawn-out affair. It was designed by British architect George Hadfield, who also worked on the North Wing of the Capitol. His proposal to include a dome similar to that of the Capitol in the plans for City Hall was rejected on grounds of cost. Work began in 1820 and the city administration moved into part of the building during 1822. However, the project was not completed until 1849, twenty-three years after Hadfield's death, due to funding problems. A lottery plan failed to raise enough capital to finish the structure, and the federal government allocated funds for its completion on condition that it be permitted to occupy one wing when it was finished; it used the wing for circuit and criminal courts. This photograph was taken before 1868, when the first memorial statue of Abraham Lincoln was erected as a focal point in front of the building.

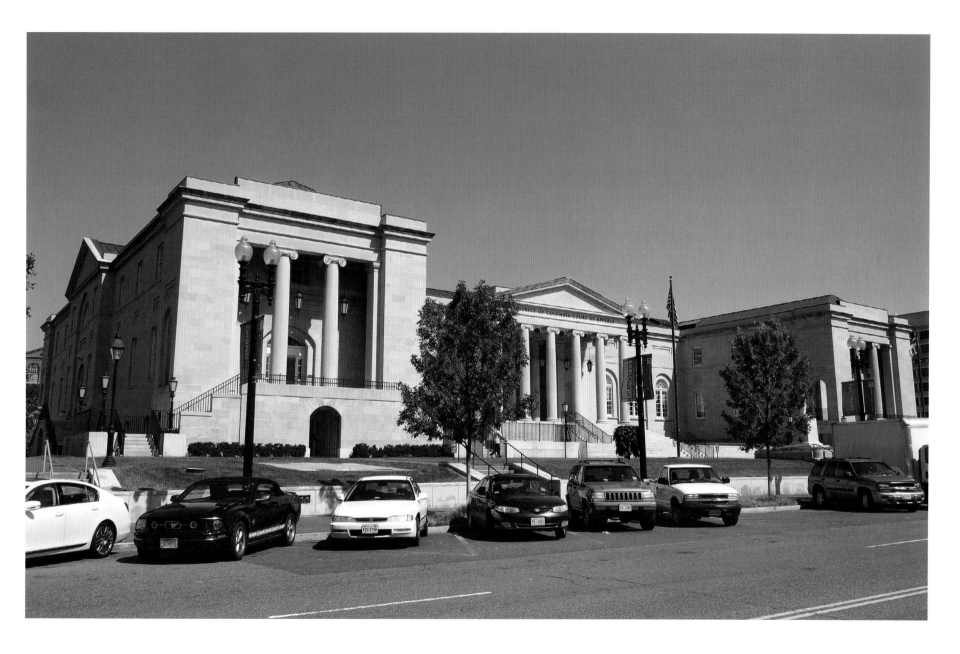

ABOVE: In the 1860s, the federal government purchased the entire building, which became the Supreme Court of the District of Columbia. In 1952, a year after the outbreak of the Korean War, it became the headquarters of the Selective Service Program, responsible for U.S. Army conscription. Ten years later it returned to use as a local courthouse, serving the city in that capacity for thirty-seven years. While its original outward appearance is preserved today,

Old City Hall has twice undergone substantial refurbishment. In 1916 the stucco brick walls were refaced in Indiana limestone, and in 1999 it was significantly renovated with the addition of a glass atrium to the north, a new and appropriately transparent main entrance for a building facing Judiciary Square. It reopened in 2009 with yet another change of use, becoming the District of Columbia Court of Appeals.

PENNSYLVANIA AVENUE

A long-established location for the grandest of ceremonial parades

BELOW: The avenue between the White House and the Capitol has hosted parades triumphant and somber over the years. The massive edifice in the center of both of these photographs is the Main Post Office, now the third-tallest structure in Washington (including the Washington Monument) at 315 feet. Rising to the right is the clock tower of the Southern Railway Building, which was completed in 1903 but destroyed by fire in 1916, four years after this photograph was taken.

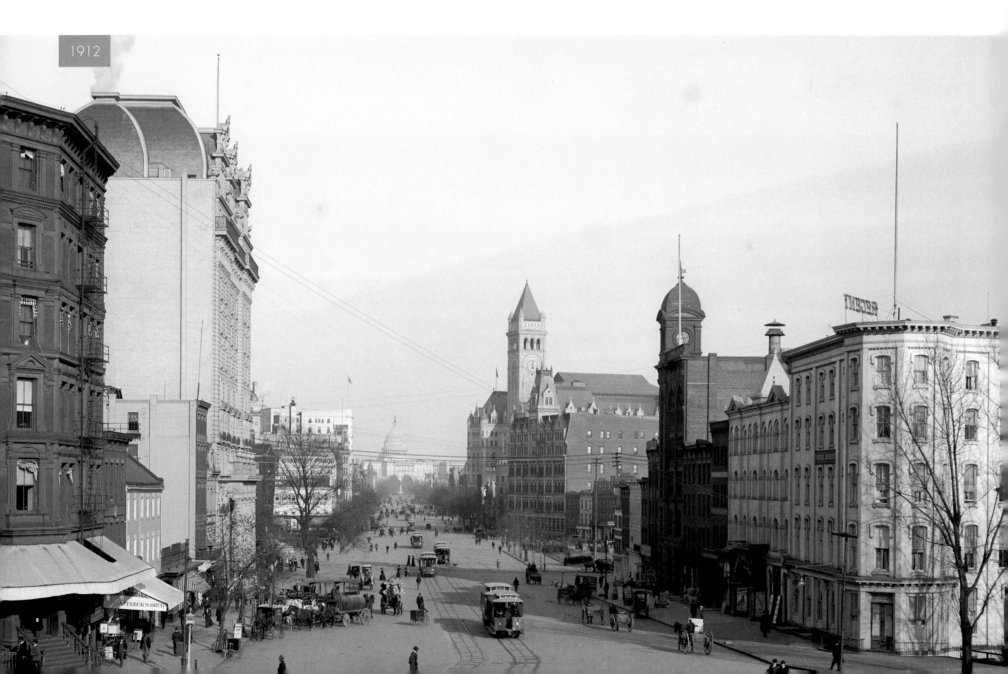

1912

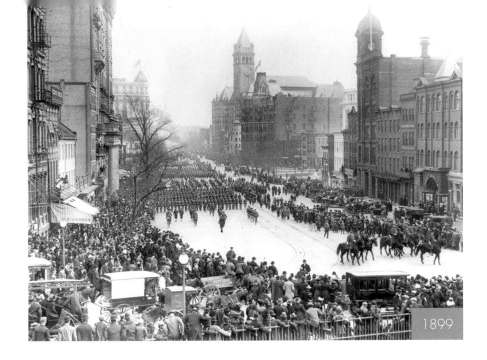

BELOW: Pennsylvania Avenue was one of the earliest elements of Pierre Charles L'Enfant's plan for Washington, symbolically linking and separating the Capitol and the White House. Pennsylvania Avenue was supposedly given its name to compensate the state when the nation's capital was moved from Philadelphia. The classic view of the ceremonial route can only be obtained from the steps of the Treasury Building at Fifteenth Street NW (under permit). The modern view shows the Willard Hotel on the left, in which Dr. Martin Luther King Jr. wrote his "I Have a Dream" speech in 1963; the former Western Plaza, renamed Freedom Plaza in 1988 in honor of Dr. King, is seen in the foreground underlining the grand perspective. The Federal Triangle borders almost the entire southern side of Pennsylvania Avenue on the right.

LEFT: This 1899 photo, taken from the Treasury Building, shows the memorial parade for the 163 victims of the 1898 USS *Maine* tragedy, in which the ship's magazine exploded in Havana Harbor.

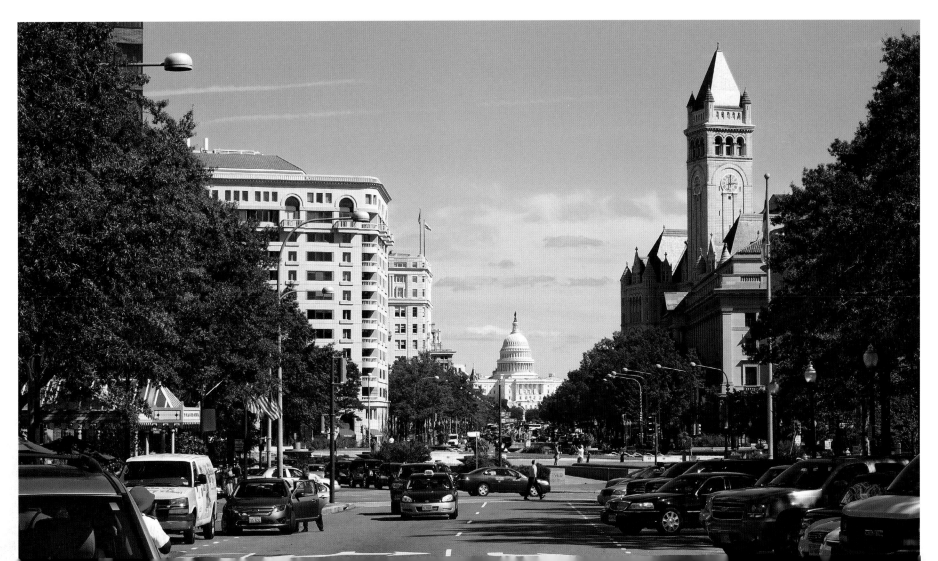

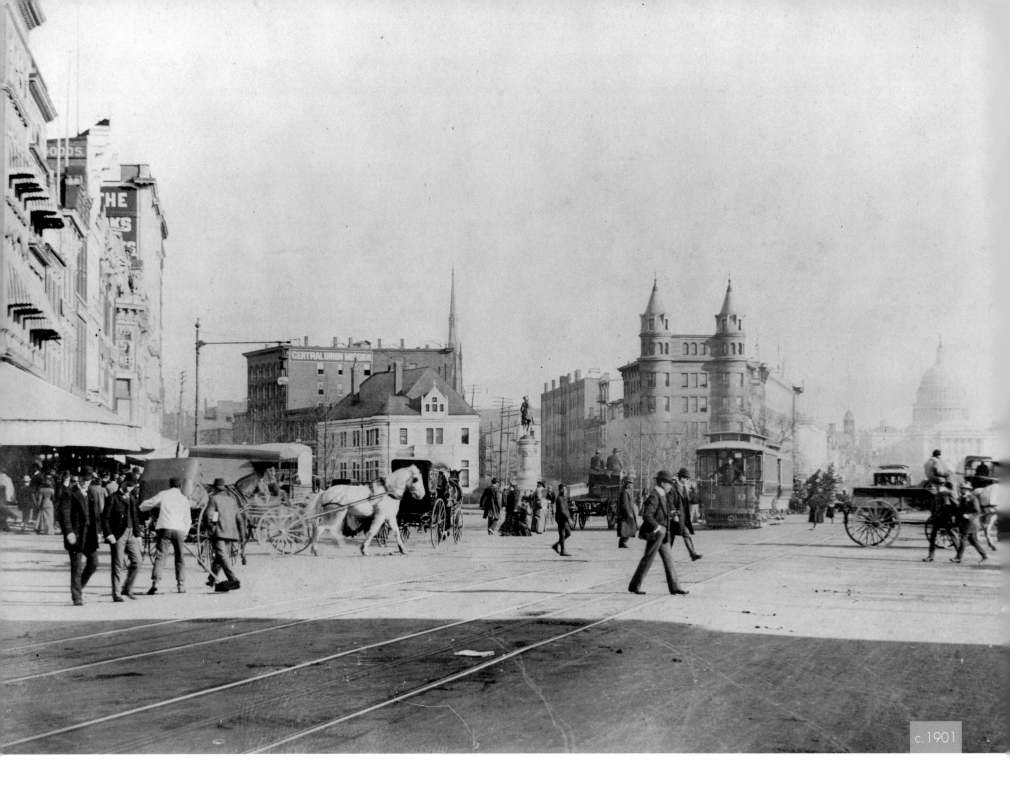

c.1901

PENNSYLVANIA AVENUE AND SEVENTH STREET

A busy crossroads dominated by the Central National Bank

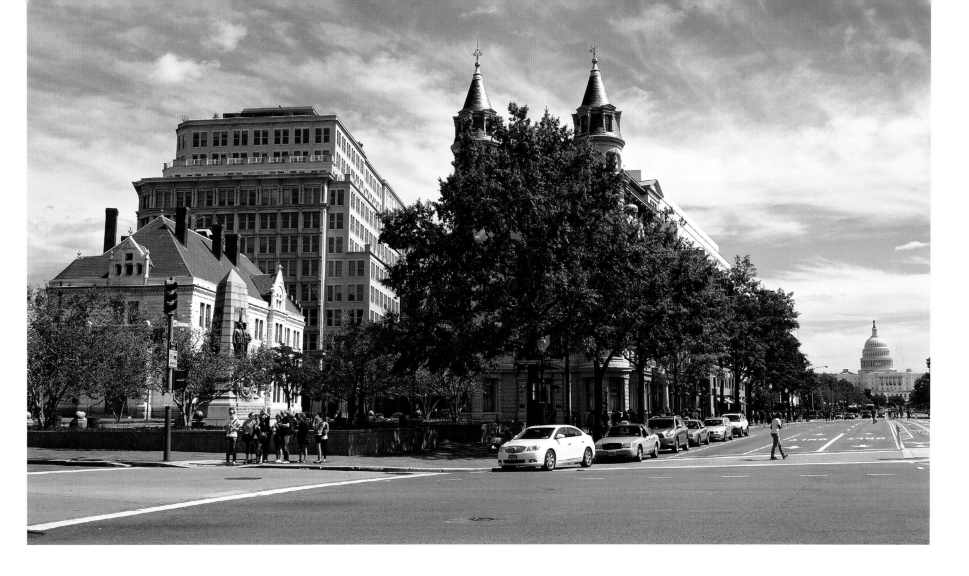

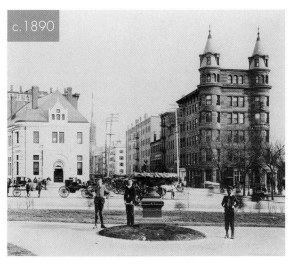

LEFT: This view of Pennsylvania Avenue shows pedestrian traffic that would be almost unthinkable today. Note the white-coated street-sweeper to the left. The twin-towered building to the right of center was built in 1860 as the St. Marc Hotel, but it was purchased by the Central National Bank in 1887 and refurbished according to plans by architect Alfred B. Mullett. Another bank was erected in the building to its left in 1889; just down Pennsylvania Avenue from this building was the studio of the revered Civil War photographer Mathew Brady.

LEFT: This view from 1890 shows the Central National Bank of Washington, located at 301 Seventh Street.

ABOVE: In the center of the modern photograph is the granite-and-bronze monument to Benjamin F. Stephenson, founder of the Grand Army of the Republic (GAR), an organization for veterans of the Civil War. The monument was erected in 1909 in what is now Indiana Plaza; the GAR, which Stephenson formed in 1866, was disbanded in 1956 when the last Civil War veteran died. The twin-towered building, renovated again in 1984, is now the headquarters of the National Council of Negro Women; it is formally known as the Dorothy I. Height Building after the former president of the organization, who died in 2010.

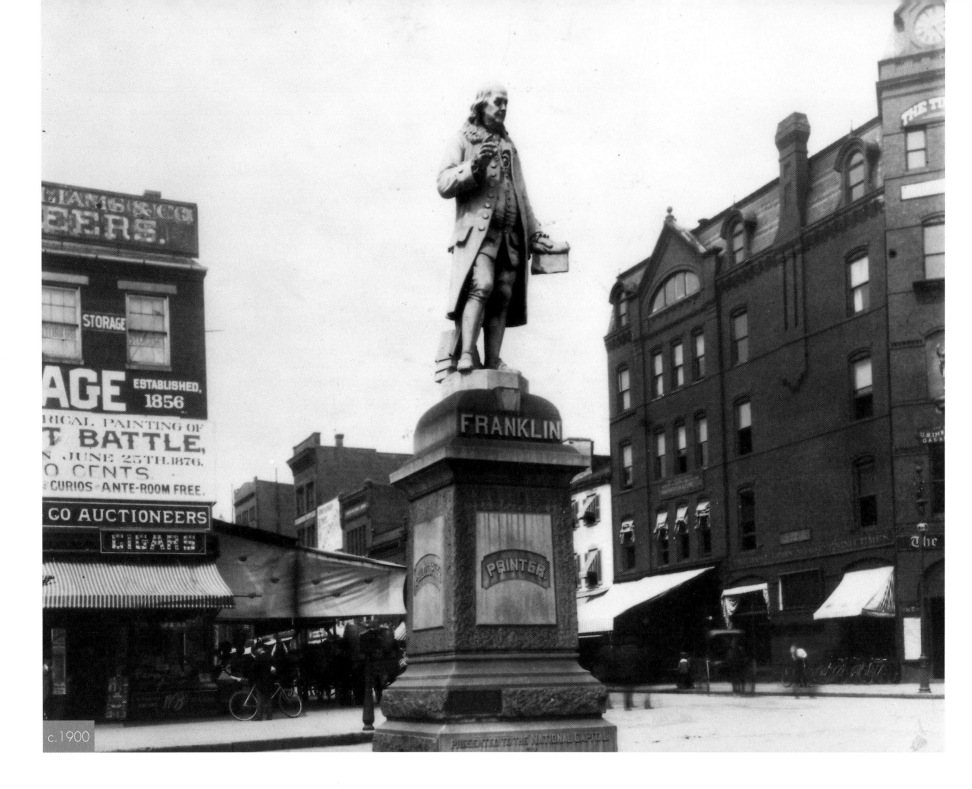

c.1900

BENJAMIN FRANKLIN STATUE
Stilson Hutchins's tribute to the great American printer, philanthropist, philosopher, and patriot

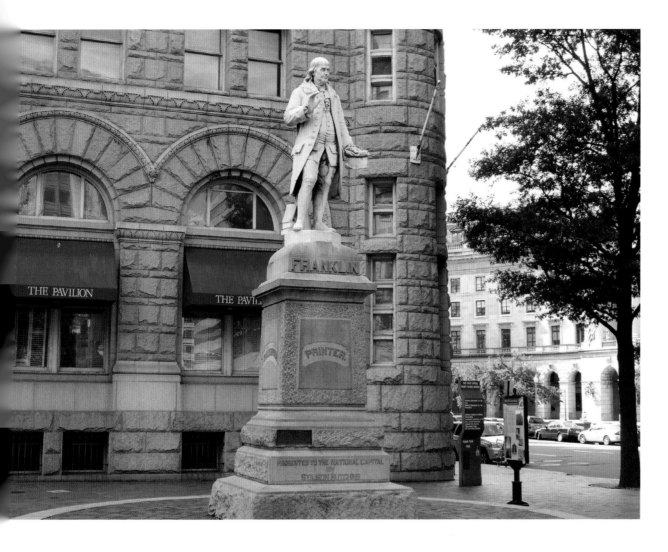

BENJAMIN FRANKLIN

Benjamin Franklin (1706–90) was one of the greatest minds of his age. He invented bifocals, the Franklin stove, and the lightning rod. He campaigned tirelessly to unify the colonies of the emerging nation. He was the first U.S. ambassador to France, where he did much to cement friendly relations between the two countries. His statue on Pennsylvania Avenue recalls his many connections with that state. It was through his newspapers the *Pennsylvania Gazette* and *Pennsylvania Chronicle* that he expressed revolutionary anti-British sentiment. And toward the end of his life he served a term as governor of Pennsylvania, during which he freed his slaves. In his thoughts, publications, and actions he proclaimed many of the ideals which today define the United States.

BELOW: Henry Smythe Jr. by the statue in 1937. Smythe wrote to the Secretary of the Treasury, urging that the head of Benjamin Franklin adorn the one-cent piece to be issued in 1938.

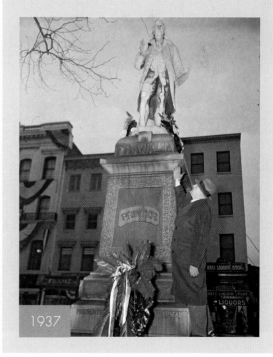

1937

LEFT: This eight-foot marble statue, portraying Founding Father Benjamin Franklin in the diplomatic dress of American minister to the French government, was donated in 1889 by Stilson Hutchins, the founder of the *Washington Post* and other American newspapers. By 1889 he had sold the *Post*, but he nonetheless donated the statue to honor one of America's first journalists and printers of note. To the right in the photo is an office of the *Post*, which had moved from its old home at Tenth and D Streets (now covered by the FBI Building).

ABOVE: The humble statue to Benjamin Franklin has seen nearly everything around it change. Behind the statue in the modern photo is a corner of the Old Post Office, and behind it to the right are buildings occupied by the Interstate Commerce Commission. Engraved on the four sides of the statue are the words "printer," "philanthropist," "philosopher," and "patriot."

c.1920

OLD POST OFFICE
From the home of the U.S. Post Office to a luxury hotel

LEFT: The building now known as the Old Post Office was completed in 1899 and served as both the main city post office (1898–1914, replaced by a new post office across the street from Union Station) and as the offices of the U.S. Post Office Department (1899–1934). Noted for its 315-foot clock tower and its elaborate Flag Day pageantry and displays, it was the first federal building along Pennsylvania Avenue between the White House and the Capitol, and the first in what would eventually become the Federal Triangle. This photo shows a Flag Day display circa 1920.

RIGHT: Designed by Willoughby J. Edbrooke, the rustic Richardsonian Romanesque style of the Old Post Office made it architecturally old-fashioned even before it opened. It closed as a D.C. mail depot after only fifteen years, and the U.S. postmaster general abandoned the building for new premises on the other side of Twelfth Street in 1934. It escaped threats of demolition throughout the twentieth century, and is the only building in the Federal Triangle to survive the wholesale rebuilding of federal institutions in the area in a unified neoclassical style. In 1983 the refurbished building was renamed the Nancy Hanks Center after the chairwoman of the National Endowment for the Arts (NEA) who had campaigned for its preservation. It became home to the NEA and several other cultural bodies, but in 2011 it was declared surplus property. It gained a new lease on life when plans were made to rebuild it as the Trump International Hotel.

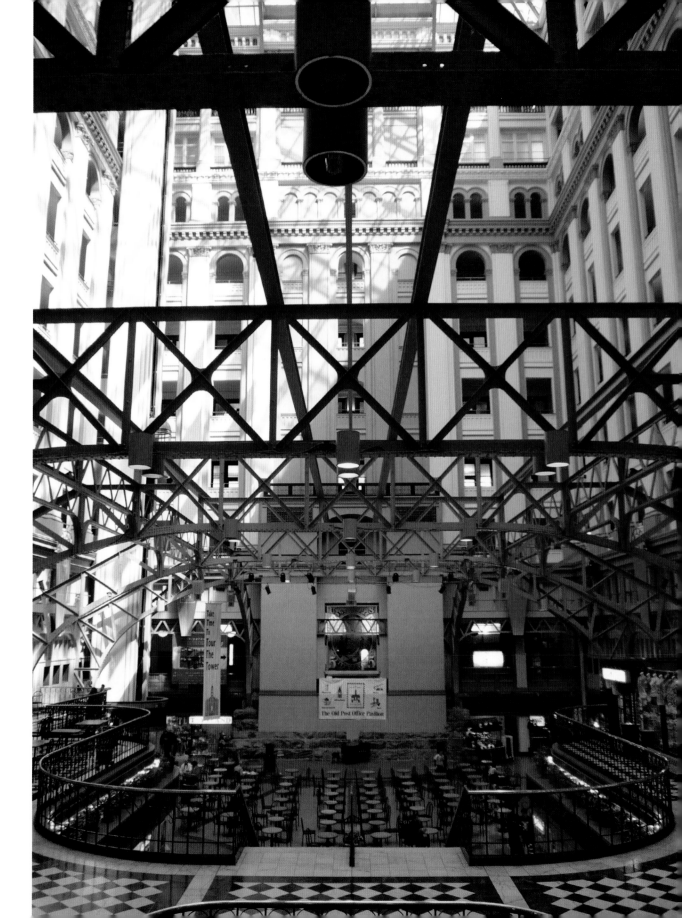

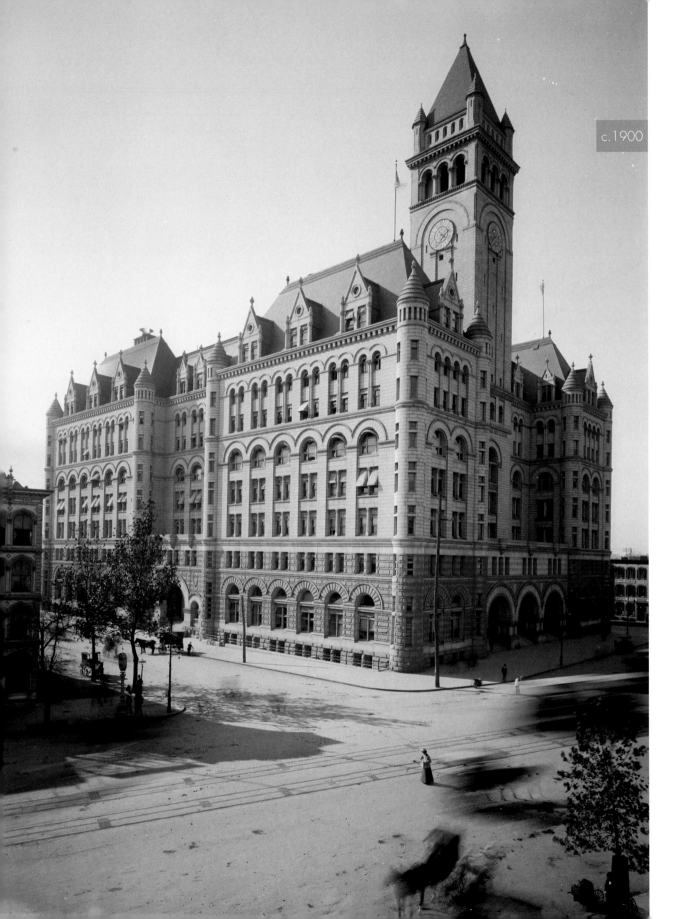

OLD POST OFFICE
Washington's first skyscraper

LEFT The site for the Old Post Office was selected in 1880 by Senator Leland Stanford of California to revitalize what was regarded as a shabby neighborhood between the Capitol Building and the White House. Upon its completion in 1899, the Old Post Office was the largest office building in Washington, and the first to incorporate a steel frame. It was also the first federal building on Pennsylvania Avenue and the first in the city to have its own power plant, which generated enough electricity to light 3,900 lightbulbs. Its large, glass-covered interior courtyard encompasses one of Washington's largest uninterrupted spaces. The Old Post Office's imposing 315-foot clock tower was second in height only to the Washington Monument, which gave the building the distinction of being Washington's first skyscraper. The exterior of the tower displayed a working clock on all four sides, a unique feature that added to the Post Office's importance. The seven-year construction project cost $3.5 million.

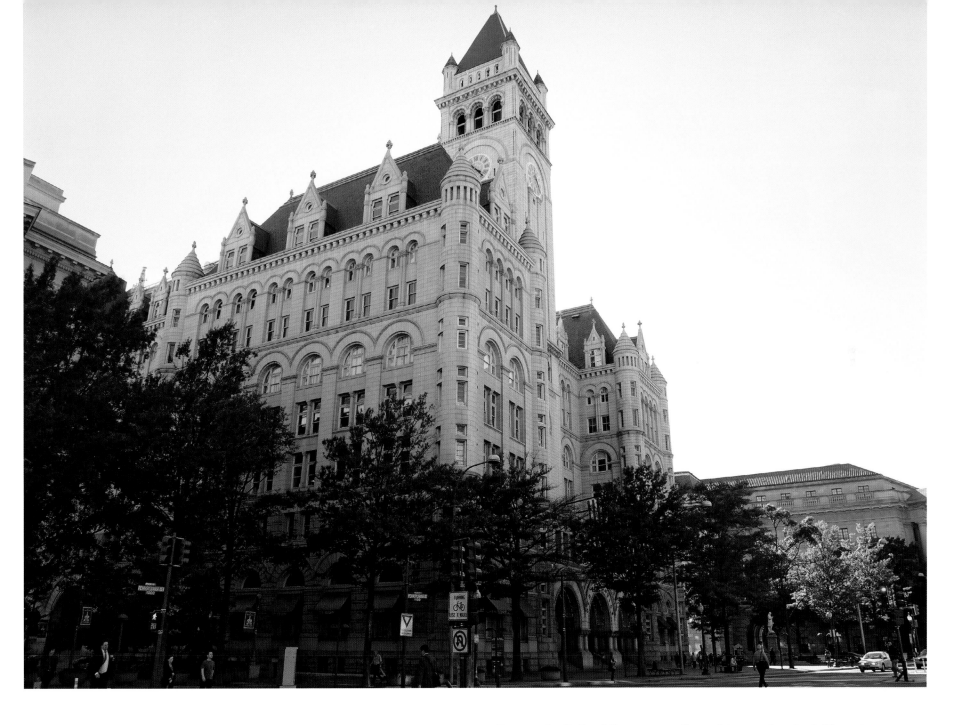

ABOVE: After World War II, the Old Post Office became home to numerous federal agencies such as the Department of Agriculture, the General Accounting Office, and the Federal Bureau of Investigation. Today, National Park Service rangers provide guided tours of the Old Post Office Tower. At the 270-foot level is an observation deck that provides visitors with a commanding view of Washington and the surrounding area. The tower also includes an exhibit room depicting the building's long struggle for survival. On the tenth floor are the Bells of Congress, replicas of those at London's Westminster Abbey and a gift from the Ditchley Foundation to the United States in 1983 to celebrate the bicentennial of the end of the Revolutionary War. The Washington Ringing Society sounds the Bells of Congress every Thursday evening and on special occasions. The building is managed by the General Services Administration and costs $6.5 million per year to operate. It is slated to become a Trump International hotel.

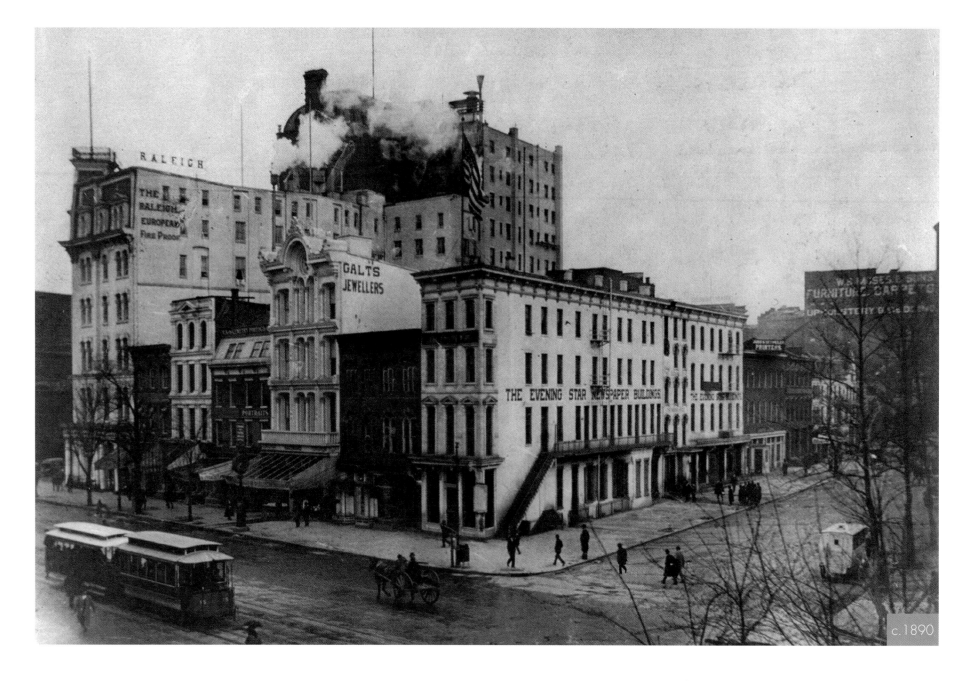

c.1890

PENNSYLVANIA AT ELEVENTH AND TWELFTH STREETS

Home to the *Evening Star* newspaper until 1981

ABOVE: This view from about 1890 shows the haphazard architecture typical of Pennsylvania Avenue after the Civil War on a section that housed a great many newspaper offices. Prominent on the near corner are the offices of the *Washington Evening Star*, which was founded in 1852 and occupied a building on the southwest corner of this intersection from 1854 to 1881. The *Evening Star* then moved around this side of Pennsylvania Avenue in various buildings until 1898, when it constructed the building that now stands on this corner.

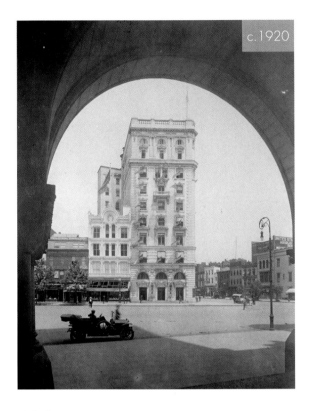

c.1920

ABOVE: By 1920 the new *Evening Star Building* was in place, towering over other buildings in the area.

BELOW: A view from the other side of the building shows its neighbor, the Old Post Office, across the street.

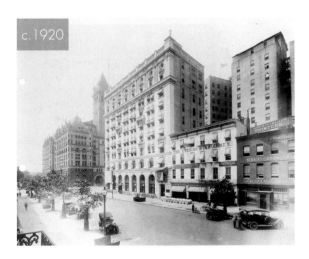

c.1920

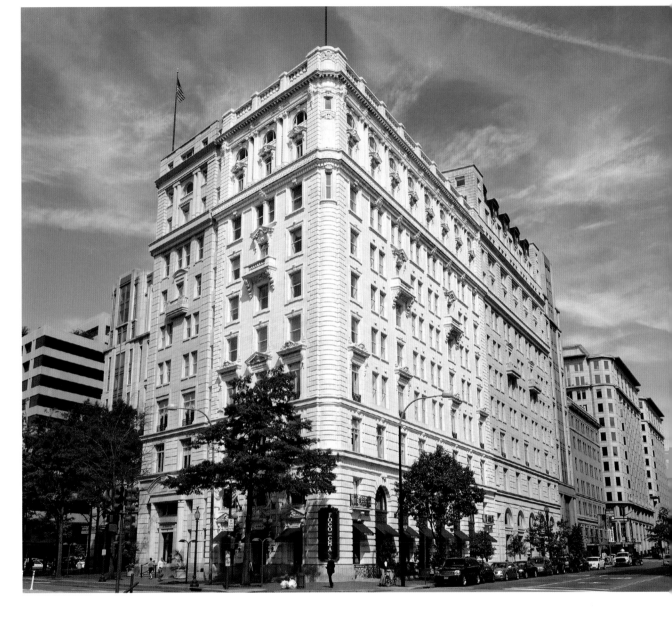

ABOVE: The Beaux-Arts replacement to the original Evening Star Building is now the oldest building on Pennsylvania Avenue after the White House. It still commands uninterrupted views of the Capitol and the Treasury Building. The *Evening Star* was a victim of declining evening newspaper circulation in the 1970s and filed for bankruptcy in 1981. The building continues to be known as the Evening Star Building, even though it now houses offices and has expanded into the building next door, which hosts the upscale Brazilian steakhouse Fogo de Chao.

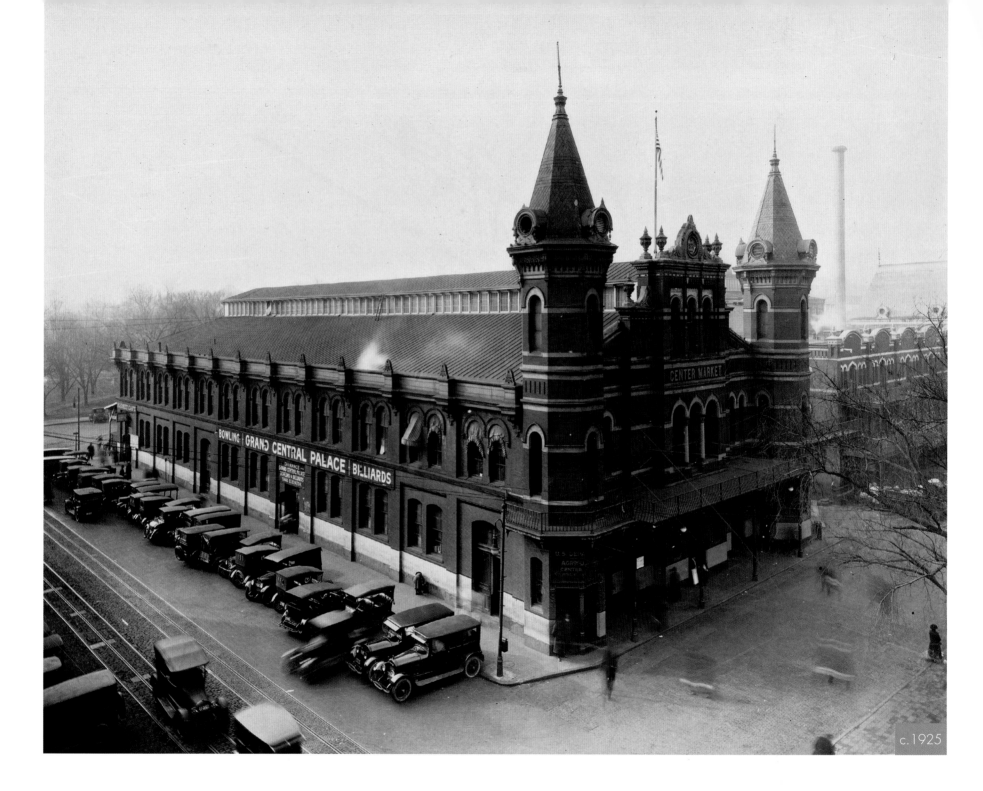

c.1925

SEVENTH AND B STREETS
The former site of Central Market, Washington's largest market

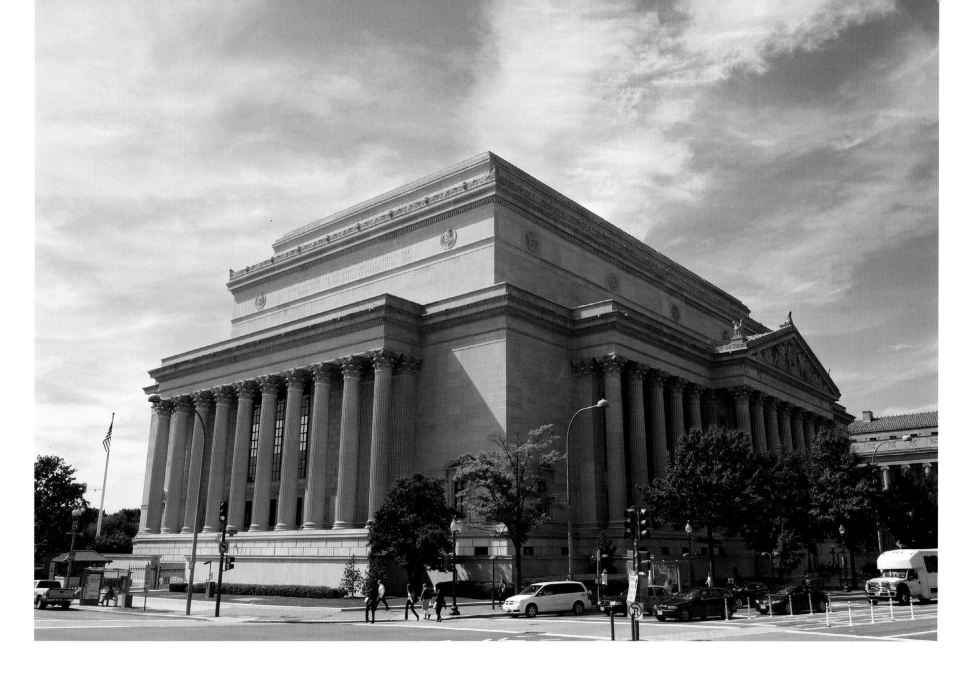

LEFT: The Central Market was the largest of five major markets in the city (of which only Eastern Market, at Seventh Street and South Carolina Avenue SE, survives today) and among the largest market houses in the nation. It offered space for up to 300 vendors and their wagons. Designed by Adolph Cluss and built in 1871–73 on the location of the city's primary market site since its beginnings, it was conveniently located on the Washington Canal (now Constitution Avenue), which allowed for daily delivery of fresh produce.

ABOVE: The Central Market had lost much of its business to corner shops and supermarkets when it was demolished in 1931 as part of the Federal Triangle redevelopment. The National Archives Building was built on the site between 1931 and 1935. It was designed by the determinedly neoclassical architect John Russell Pope, who was also responsible for the Jefferson Memorial and the National Gallery of Art. All three buildings boast serried ranks of columns—the National Archives Building alone is surrounded by seventy-two of them. Its centerpiece is the Rotunda of Charters of Freedom, whose display includes the founding documents of the United States—the Declaration of Independence, the Constitution, and the Bill of Rights.

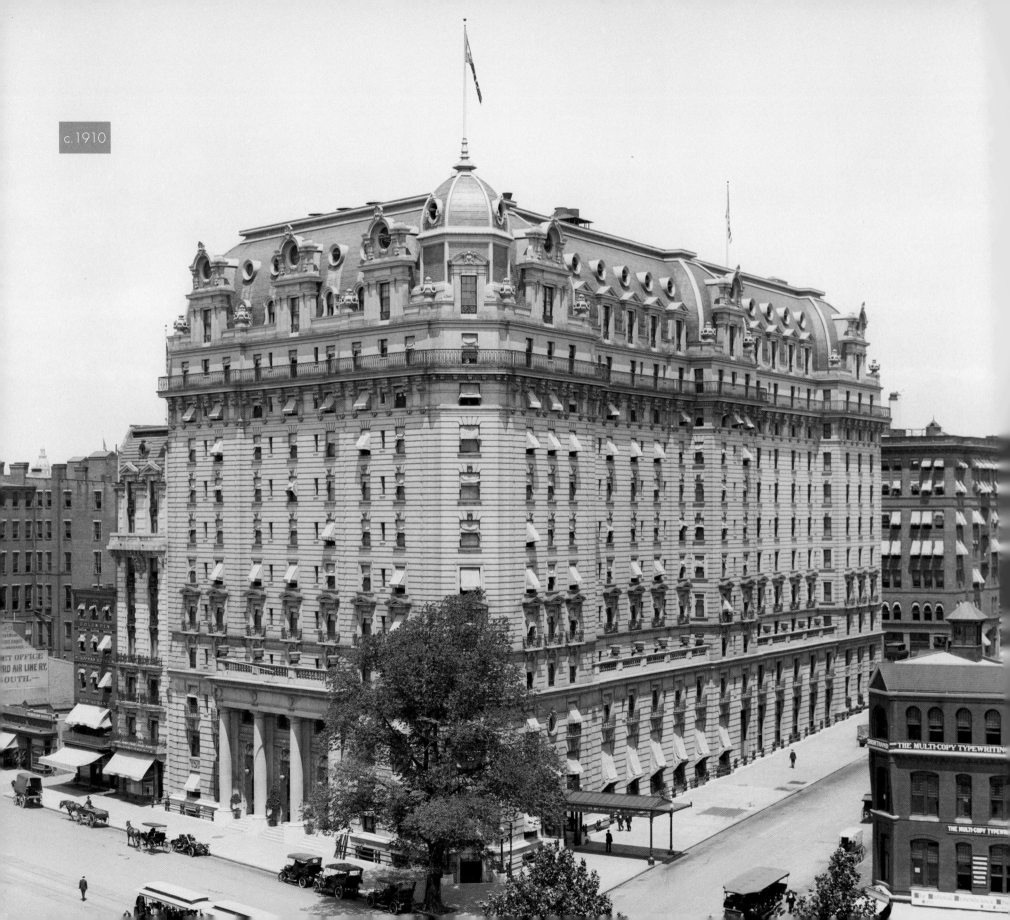

c.1910

WILLARD HOTEL

Prestigious hotel and center of political, artistic, and social activities

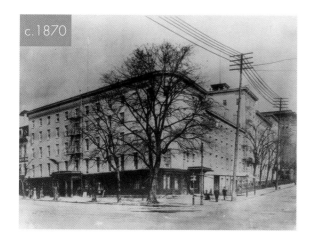

c.1870

ABOVE: The original Willard Hotel may have been just five stories tall, but the business conducted in its lobby had a large impact on Washington.

LEFT: Originally founded as the City Hotel at Fourteenth Street and Pennsylvania Avenue NW in 1816 by Benjamin Ogle Tayloe, the Willard would be named after Henry Willard, who took over the hotel in the 1850s. Due to its central location and proximity to the White House, it became a center of political and social activity for decades. Among the famous guests were Charles Dickens (in 1842) and Presidents Taylor, Fillmore, Buchanan, and Lincoln. In 1861 Julia Ward Howe wrote "The Battle Hymn of the Republic" while staying at the hotel. The term "lobbyists" was supposedly coined by President Ulysses S. Grant to refer to power brokers who continually courted him in the Willard's lobby. Henry Willard's original group of buildings was replaced in 1901 by the grand Beaux-Arts edifice that stands today.

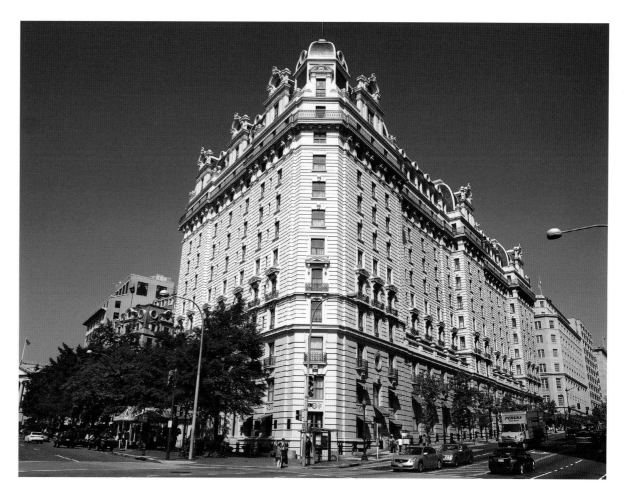

ABOVE: The 1901 Willard Hotel was designed by Henry Hardenbergh, who had made his name with many great New York buildings, including the Dakota Apartments and the Plaza and Waldorf-Astoria Hotels. The Willard continued to be the residence of choice of the rich and famous, from the Duke of Windsor to Gloria Swanson. But after the Willard family sold it in 1946, its fortunes declined until it was closed in 1968. It lay empty for many years, but in 1986 it was redeveloped, with the addition of an architecturally sympathetic new office block (seen to the left of the hotel in the modern photograph). The Willard Hotel continues to attract celebrities from the arts and politics: Steven Spielberg filmed scenes for *Minority Report* here in 2001, and in 2012 Australian foreign minister Kevin Rudd made an unexpected resignation speech at the hotel.

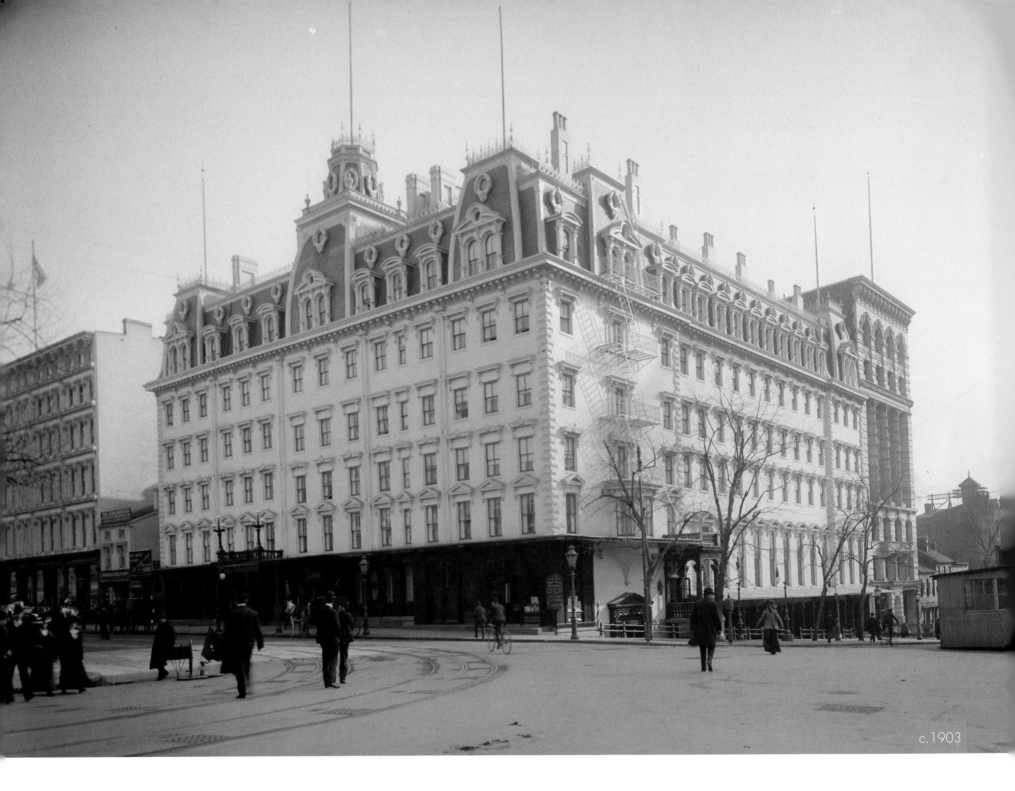

c.1903

FOURTEENTH AND F STREETS
Site of the Ebbitt House Hotel and the subsequent Grand Hyatt Hotel

52

LEFT: The site on the corner of Fourteenth and F Streets SE was originally occupied by private houses. They included 1336–38 F Street, home of Aaron Burr, Thomas Jefferson's vice president, who killed Alexander Hamilton in a duel in 1804. By 1856 several houses had been combined as a boardinghouse called the Frenchman's Hotel, one of many in the area, which William E. Ebbitt bought and renamed the Ebbitt House. Eight years later it was sold to Caleb C. Willard, one of the brothers who owned the nearby Willard Hotel. Willard extensively refurbished the building in 1872, adding an elaborate mansard roof that incorporated rooms within it. In 1895 he extended the roof further upward to include accommodations for staff in the attic—the circular windows seen in this view. The Ebbitt House Hotel was very popular with the armed forces thanks to Willard's policy of extending credit to them between paydays. As a result, the hotel was given the unofficial title of "Army and Navy Headquarters" for many years.

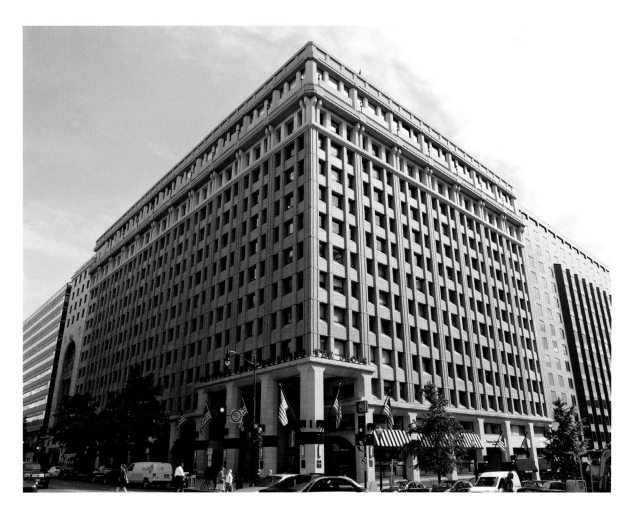

1880

ABOVE: The Ebbitt House Hotel (right) at 1344 F Street, pictured in 1880.

ABOVE: In the twentieth century the Ebbitt House Hotel struggled to keep up with the competition offered by rivals such as the Raleigh, the Mayflower, and the Willard Hotel. It was demolished in 1925. The following year, the National Press Building rose up in its place. It was a new home for the highly influential National Press Club, a social and professional association for American journalists founded in 1908. The building was substantially reconstructed in 1982 with a new facade and the inclusion of a shopping mall; the club still thrives there, occupying the top floor. World leaders continue to visit and address the members; dignitaries such as Franklin D. Roosevelt, Nelson Mandela, and the Dalai Lama have appeared at the club's weekly luncheons over the years. Meanwhile, the New Ebbitt Hotel was built at Tenth and H Streets NW. It never enjoyed its earlier success, and was finally pulled down in 1986; the Grand Hyatt Hotel now occupies the site. One little piece of the original Ebbitt House survives: its beautiful mahogany-paneled bar was saved during the demolition and installed in a barroom on Fifteenth Street NW now called the Old Ebbitt Grill.

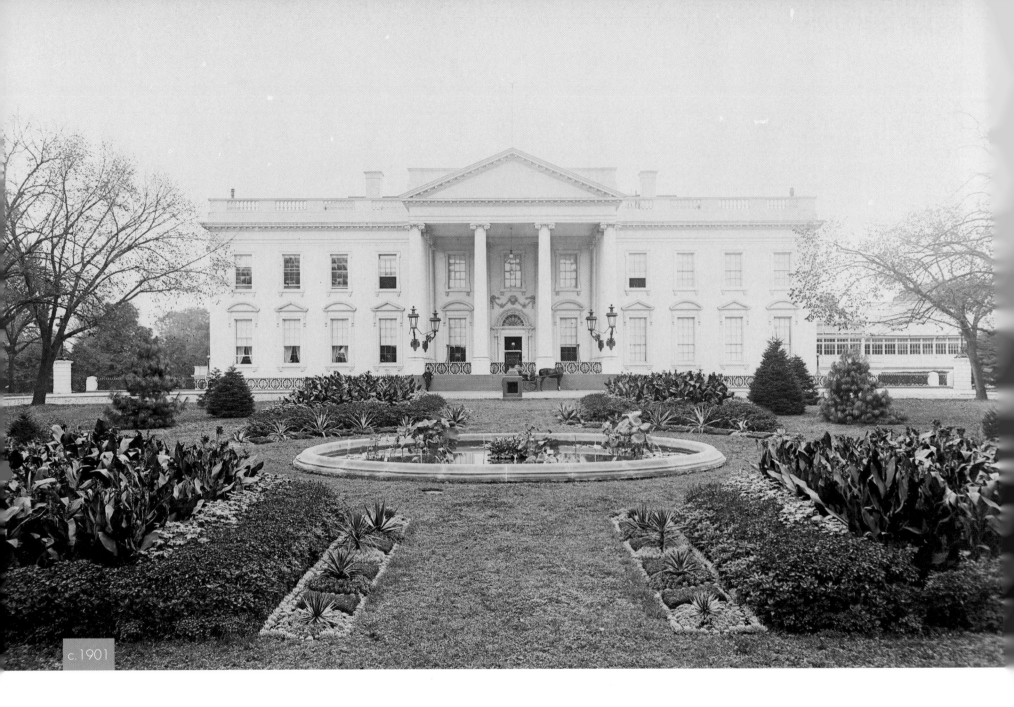

c.1901

THE WHITE HOUSE

The oldest public building in Washington, designed to emulate a British country estate

ABOVE: Located at the most famous address in the nation, 1600 Pennsylvania Avenue, the oldest public building in Washington at first looks little changed from its original design by James Hoban, based on country estate houses in Britain and Ireland. However, many changes have been made to what was

officially called the Executive Mansion for its first century. Construction began in 1793, and it was complete enough for John Adams to move in at the end of his term in 1800. It was rebuilt under Hoban's supervision between 1815 and 1817 after its torching by the British in 1814.

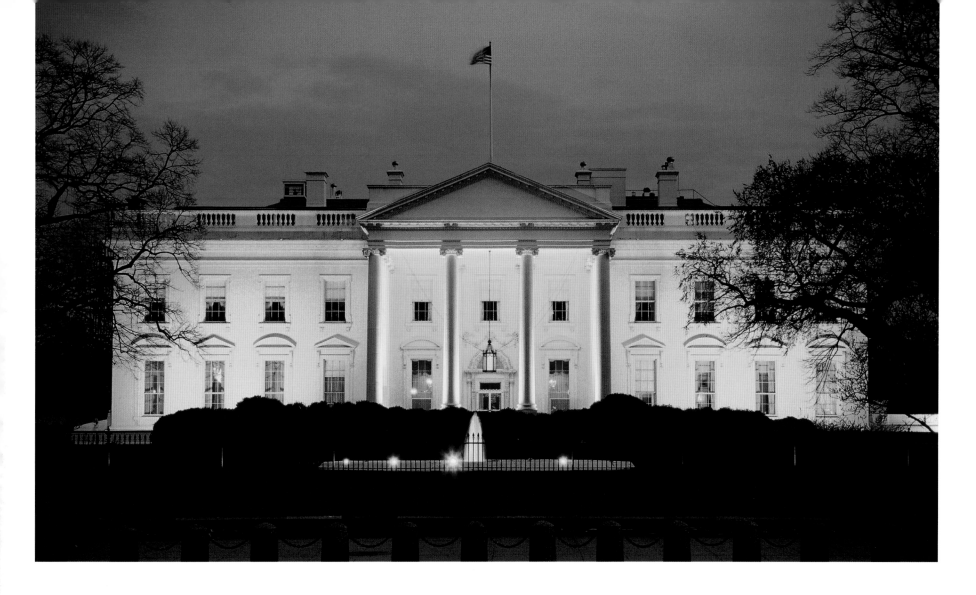

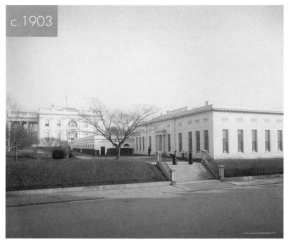

c.1903

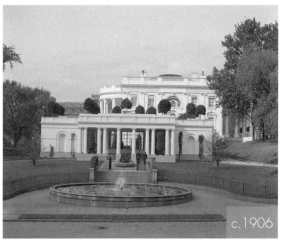

c.1906

ABOVE: Over the years, successive occupants of the White House have made additions and refurnishings as progress allowed, including gas lighting (seen in the old view of the north portico), central heating, plumbing, and electricity. President Theodore Roosevelt officially changed the name of the residence to the White House in 1901 and undertook a major reconstruction of the interior in 1902. Also changed frequently was the landscaping surrounding the building.

LEFT: The West Wing of the White House (left) and the East Entrance (right).

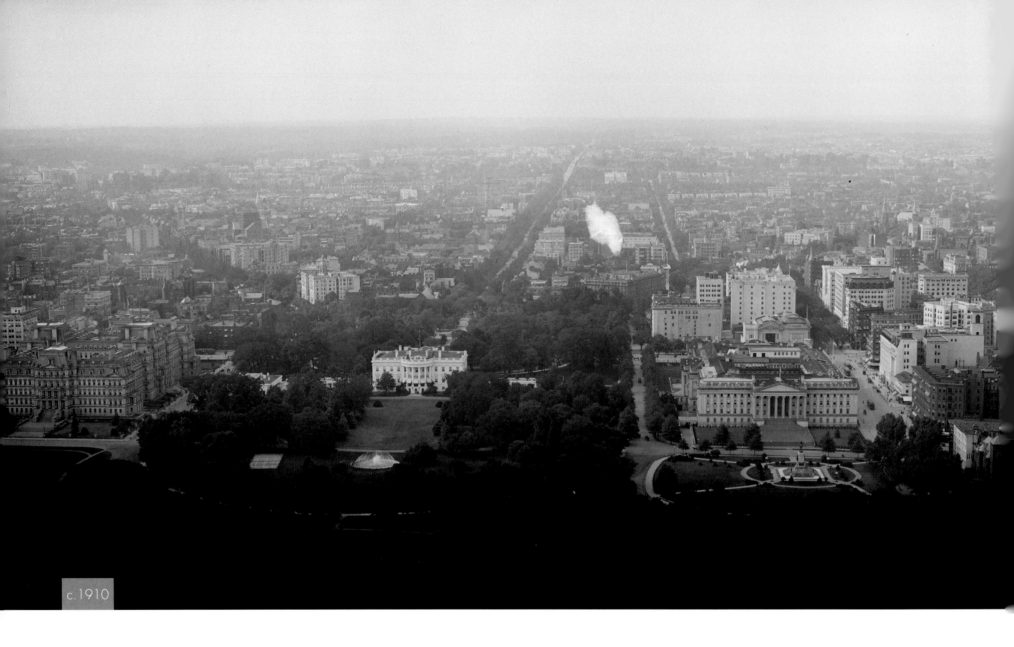

c.1910

THE WHITE HOUSE
Long-standing symbol of the executive branch of the United States government

ABOVE: The South Lawn of the White House was open to the public until World War II. It has been landscaped over the centuries to give it a gentler downward slope; the scheme of formal terraces stepping down to the Potomac River, originally proposed by Pierre Charles L'Enfant in 1793, was never implemented. Originally a natural meadow leading to the marshy banks of the river, the lawn was temporarily returned to pastoral use during World War I when a flock of sheep was permitted to graze there. The propaganda value of such a rural scene was a bonus; the sheep also supplied wool during the wartime shortage, and kept the grass trimmed when gardeners joined the army. Just before the war, in 1913, the Rose Garden was laid out immediately in front of the house (to the left of the portico). Fifty years later, it would be balanced by the Jacqueline Kennedy Garden to the right.

56

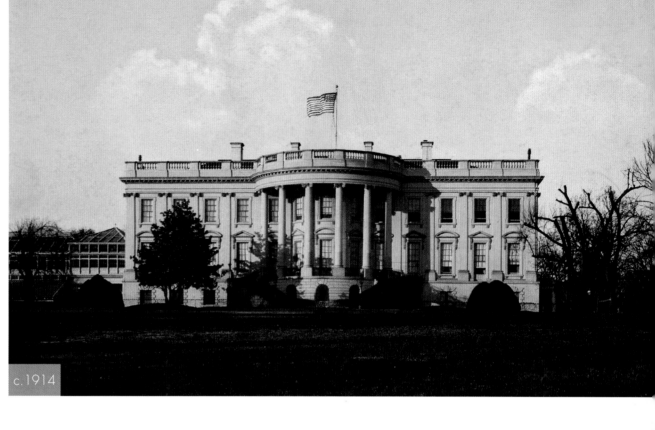

c.1914

RIGHT: The White House enters its third century as the symbol of the executive branch of the U.S. government. The trees that frame the modern view of the South Lawn also mask the West Wing (on the left, begun by President Theodore Roosevelt in 1901 to house the presidential staff) and the East Wing (built by President Franklin D. Roosevelt in 1942 to conceal a secret underground operations bunker). Major changes to the White House itself were undertaken in 1927 when a third floor of residential accommodations was added, mostly hidden behind the rooftop railings. In 1948, during President Harry S. Truman's administration, the fabric of the building was found to have deteriorated severely; Truman moved across the street to the Blair House while a complete interior reconstruction was undertaken, with steel and concrete replacing wood and masonry. The second-floor balcony visible within the south portico was also added at that time. Each new first family makes its mark on its new home, but internal changes are now regulated by the Committee for the Preservation of the White House.

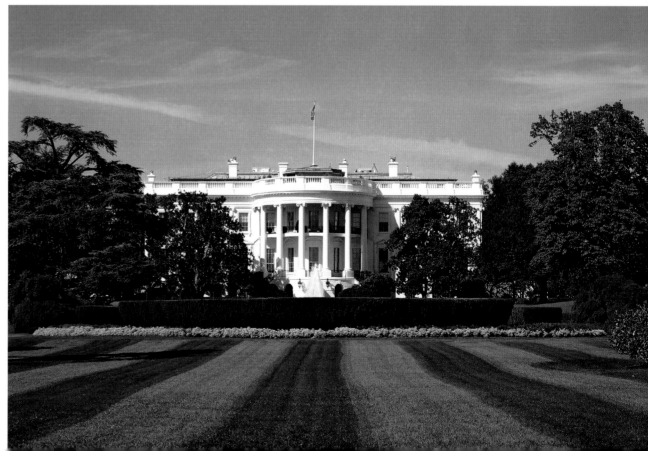

DOLLEY MADISON HOUSE

Former home of President James Madison, it now houses the American Institute of Architects

BELOW: The Octagon House, also known as the Dolley Madison House, was designed by William Thornton and built by John Tayloe III in 1799 for the princely sum of $26,000—twice the estimates. The house, at 1741 New York Avenue NW, became the temporary residence of James and Dolley Madison after the burning of the White House in August 1814. The Treaty of Ghent, which ended the war with Britain and formed the basis of British-American relations for the next 180 years, was signed in the main parlor room above the entrance on February 17, 1815.

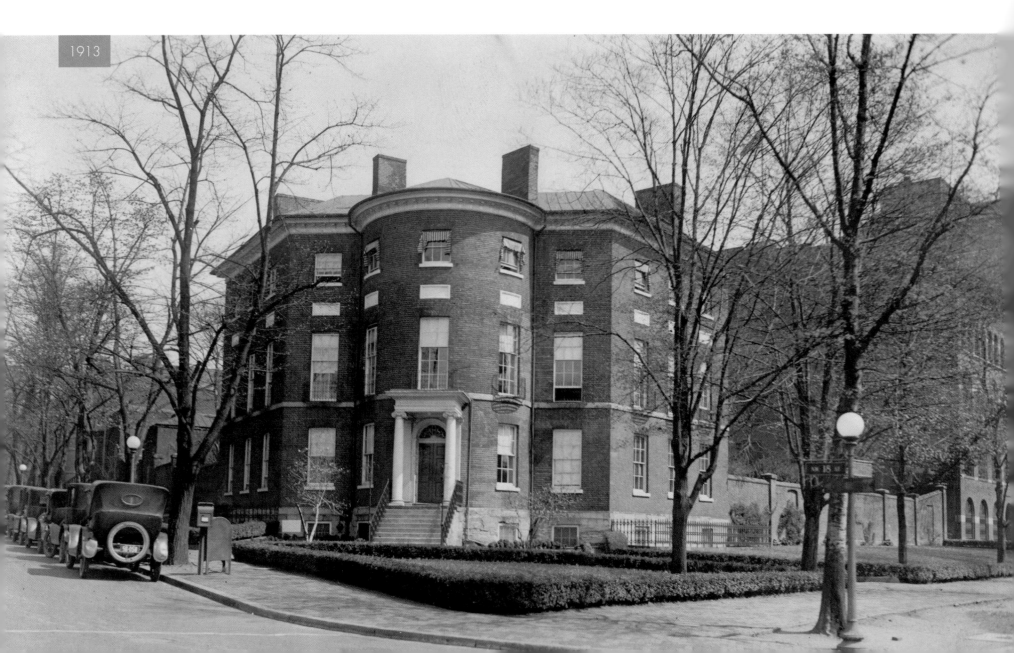

1913

1920

MOST HAUNTED

The Octagon House is said to be the most haunted house in the District of Columbia. The apparitions include two of John Tayloe's daughters, who both fell to their death down the central spiral staircase of the house in the early nineteenth century. The spirit of a British soldier of 1812 has been seen, and the screams of the slave girl whom he threw downstairs that year are sometimes heard. The ghosts of Tayloe's slaves, who are known to have lived in the back of the house, were heard to ring servants' bells in the 1870s. The smell of lilacs, Dolley Madison's favorite flower, are said to accompany the vision of her passing through a locked door into the garden. More otherworldly incidents include the mysterious opening of doors and switching of lights, ghostly footmen welcoming guests at the front door, and sightings of a gambler murdered in his bed in the late nineteenth century.

BELOW: The Octagon House became the headquarters of the American Institute of Architects (AIA) in 1899. The AIA was founded in 1857 (nearly sixty years after the Octagon House was built) to promote the image and professional practice of its members. The institute's nonprofit arm, the American Architectural Foundation, now operates a museum in the building. It was extensively restored in 1996, and only the rooftop balustrade distinguishes its present appearance from that of 1913. The modern building towering behind the Octagon House was completed in 1973. The original plans, by the architectural firm Mitchell/Giurgola, was rejected by the U.S. Commission of Fine Arts. That may have been a source of embarrassment for the architects' customers—it was built to house the new offices of the AIA.

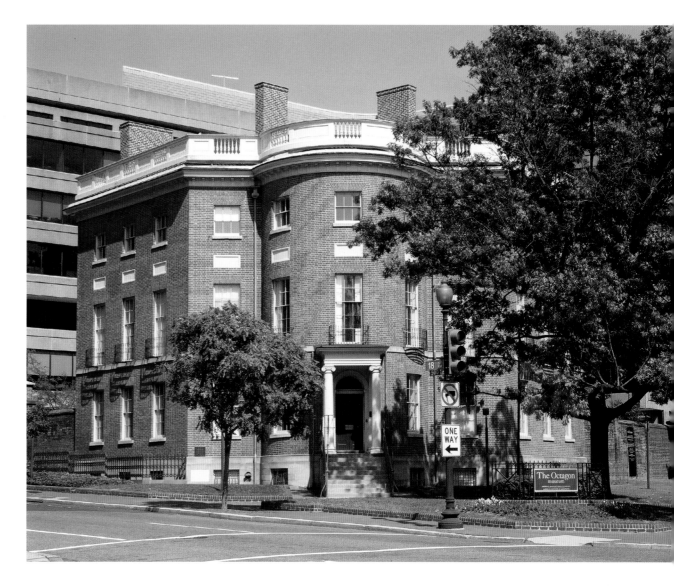

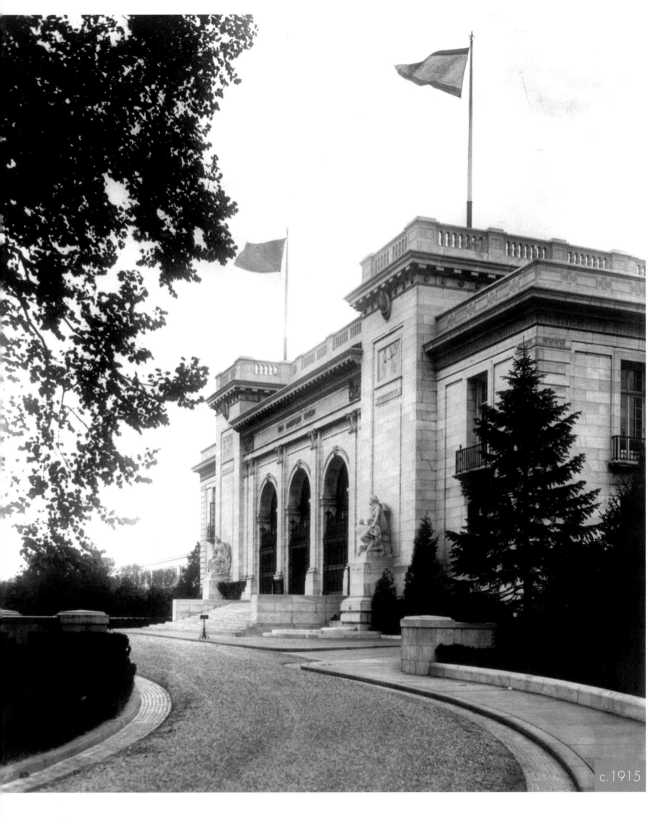

c.1915

PAN-AMERICAN BUILDING

Designed by the architect of the Folger Shakespeare Library

LEFT: One of the earliest houses in the future District of Columbia was the Burnes House, on the site of the present Organization of American States at Seventeenth Street and Constitution Avenue NW. Located at the southwestern corner of the present-day South Lawn of the White House, at the geographical heart of the district, the Burnes House was built around 1750 by David Burnes, who marketed many parcels of land in the vicinity. An attempt to preserve the old building was made by his only daughter and her husband, who had built the adjacent Van Ness Mansion in 1816. But the Burnes House was demolished in 1894, and the property found a variety of uses over the next few years—as a beer garden, an athletic club, and finally a street-cleaning company's base. In 1907 it was sold to the government; the headquarters of the Pan-American Union was dedicated there in 1910.

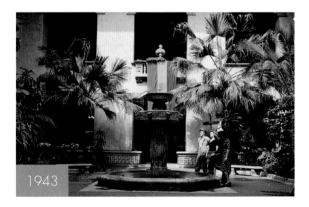

1943

ABOVE: An inner courtyard of the Pan-American Building showing Spanish influences. In 1969 it was added to the National Register of Historic Places.

RIGHT: Another wartime image, this time showing the formal garden to the rear of the Pan-American Building.

RIGHT: The cornerstone was laid in 1908 by President Theodore Roosevelt, future Nobel Peace Prize winner Elihu Root, and philanthropist Andrew Carnegie. Carnegie donated $900,000 of the $1.1 million cost of the new building, which was designed by Paul Phillipe Cret. This was the first of the French-American architect's many contributions to the Washington landscape, which include the Folger Shakespeare Library and the Eccles Building. The Pan-American Union, an organization of the nations of the Americas, was dedicated to fostering democracy and peace in the region. It became the Organization of American States in 1948. Now well into its second century, it remains a powerful force for Pan-American stability. Cret's building reflects that stability with its strong vertical and horizontal lines. The only visible change in a hundred years is the height of the trees and the lettering above the gated arches.

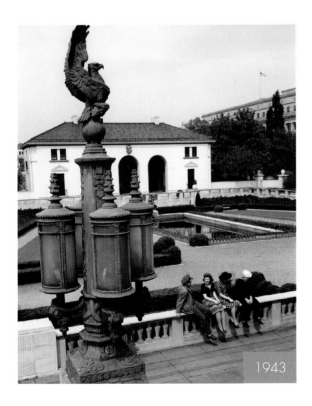

1943

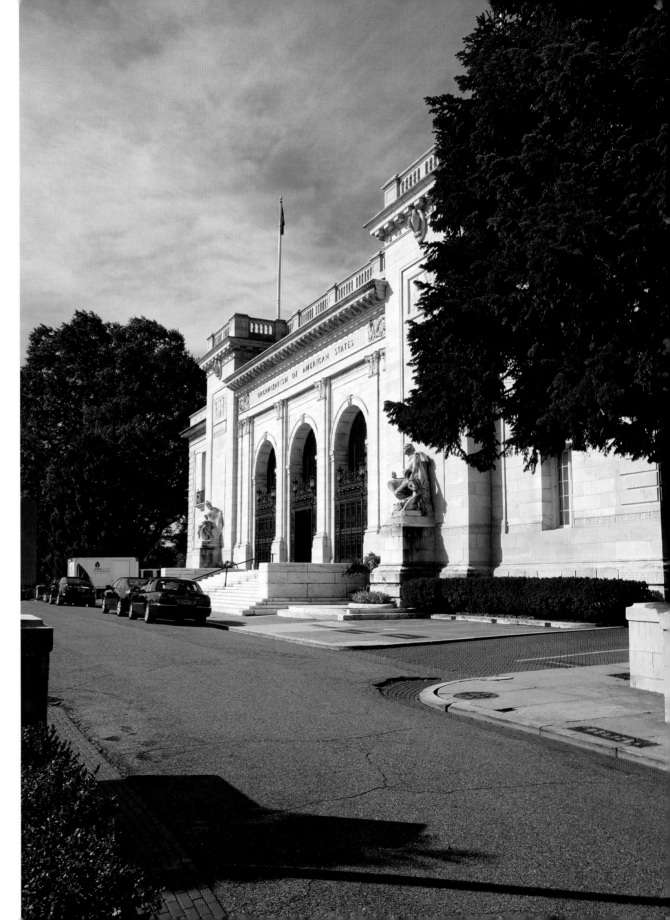

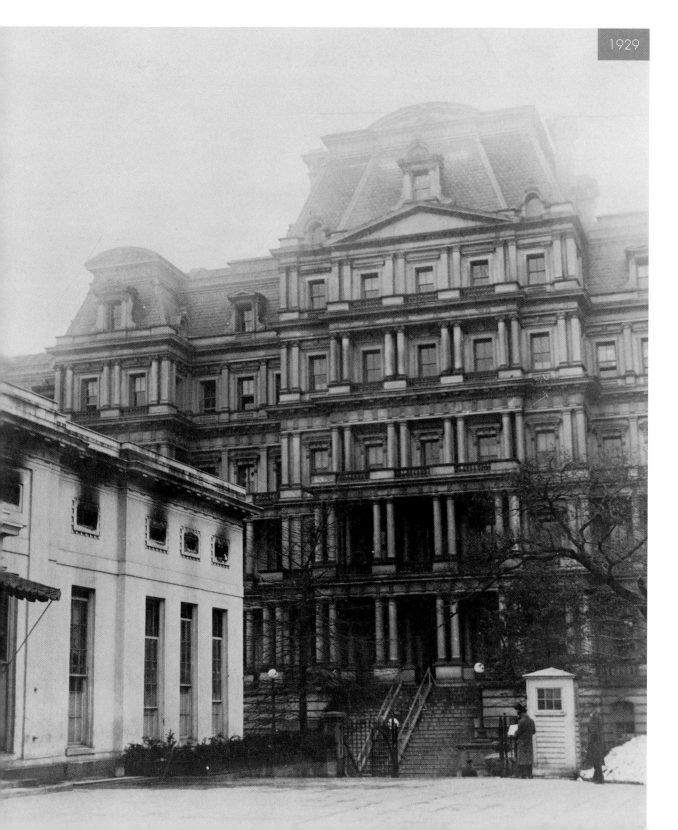

1929

OLD EXECUTIVE OFFICE

Mark Twain called it "the ugliest building in America"

LEFT: The old Department of State, War, and Navy Building, pictured here in 1929, sits to the immediate west of the White House. It was commissioned by Ulysses S. Grant and built between 1871 and 1888 on the site of the original 1800 State, War, and Navy Building and the stables of the White House. Arguably the most grandiose and ostentatious block in Washington, this massive structure was for years the world's largest office building, with 566 rooms and about ten acres of floor space. Its architect, Alfred B. Mullett, had a reputation for hotheadedness and arrogance; he was not paid by the government for many commissions, and financial problems drove him to take his own life in 1890. Patterned after French Second Empire architecture that clashed sharply with the neoclassical style of other federal buildings in the city, it was generally regarded with scorn and disdain—Mark Twain described it as the ugliest building in America.

BELOW: A view of the Old Executive Office Building with a line of people stretching around Pennsylvania Avenue waiting to enter the White House for the New Year's reception in 1922.

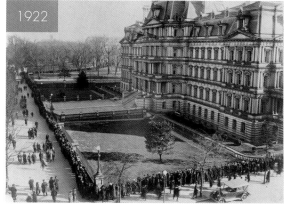

1922

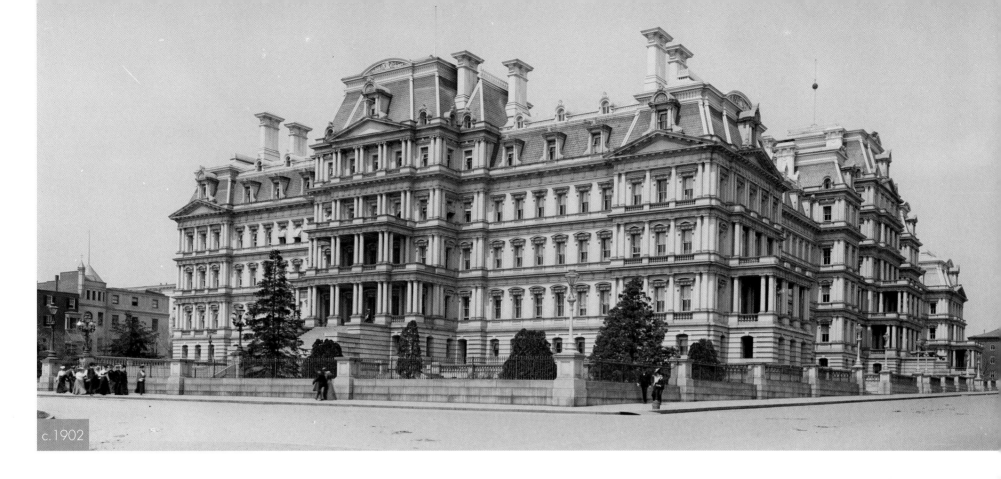

c.1902

ABOVE: Mullett was inspired by the restoration of the Louvre in Paris, and certainly the Old Executive Office (as the building was later known) would be more at home in the French capital than the American one. It was as ornate inside as out, and the doorknobs were decorated with patterns that indicated which department lay behind them. Truman regarded it as America's greatest monstrosity. During its construction, Mullett was accused of corrupt links to a ring of granite suppliers, and to this day it remains the largest granite structure of any kind in the world. But fashions change and the building is now admired for its scale and sheer difference from other federal buildings.

RIGHT: The State, Navy, and War Departments moved out in the 1930s, and the building now houses various executive branches of the government, most notably the ceremonial office of the vice president.

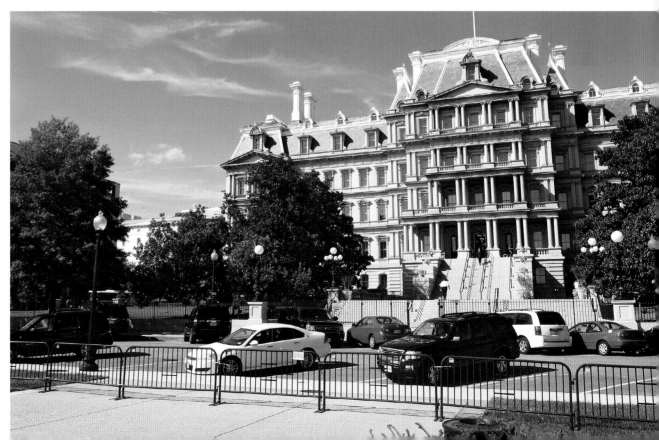

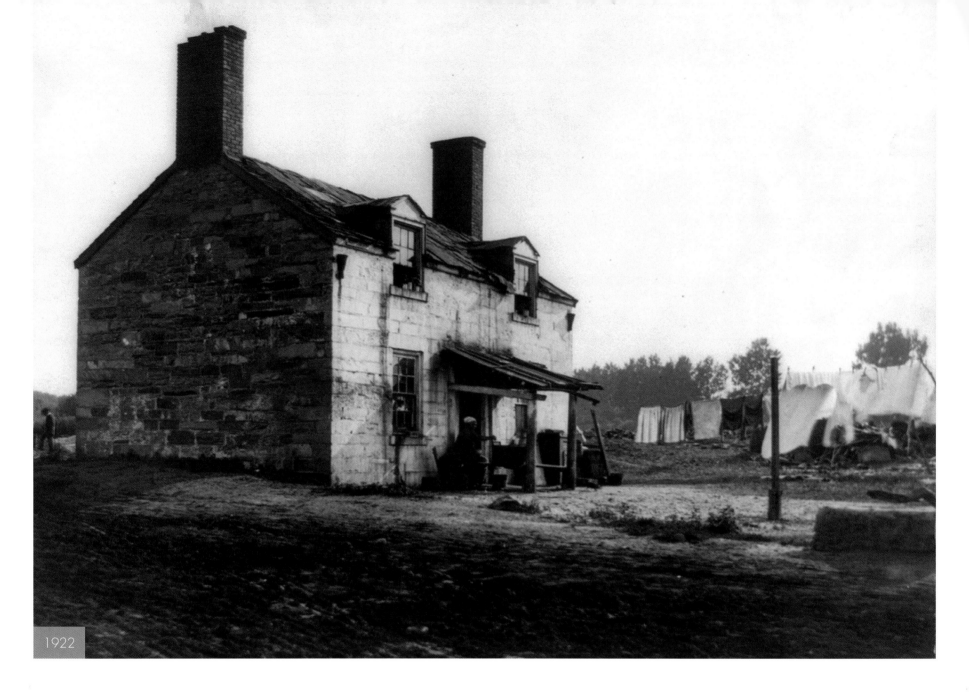

1922

LOCKKEEPER'S HOUSE

This modest house is one of the oldest surviving buildings in the city

ABOVE: Unbelievably, this homely little house that sits at Constitution Avenue and Seventeenth Street near the White House, looking for all the world like a grandiose public toilet, is one of the oldest surviving houses within Washington. Even more incredible, it once guarded the junction of what were at the time major national transportation arteries—the Potomac River and the Washington branch of the Chesapeake and Ohio (C&O) Canal. Erected around 1835, it housed the keeper of the canal lock between the Washington Canal and the C&O branch, and sat on a narrow spit of land between the canal and the river. Later landfill would place this structure blocks from the tidal basin and nearly a half-mile from the Potomac proper.

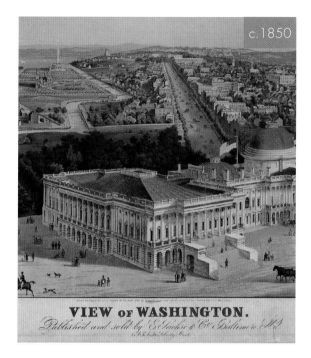

VIEW of WASHINGTON.
Published and sold by E. Sachse & Co. Baltimore & N.Y.

ABOVE: An illustration of Washington from 1850 emphasizes the importance of the canal, and what is now Constitution Avenue, which would form one side of the Federal Triangle. The lock and lockkeeper's cottage were omitted from the illustration. The land beyond the Washington Monument would be reclaimed over the next seventy years.

BELOW: The Lockkeeper's House around 1935.

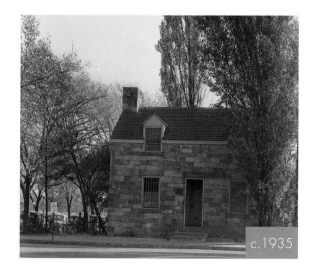

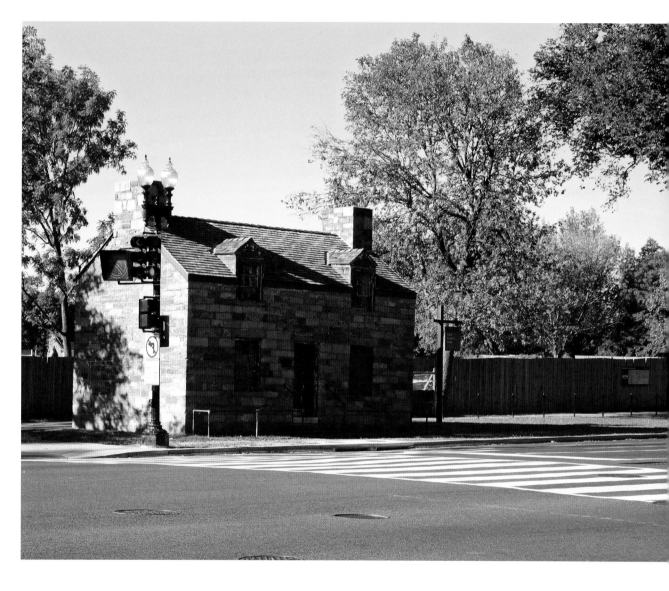

ABOVE: By the 1850s both the Washington Canal and the Washington branch of the Chesapeake and Ohio Canal had fallen into disuse, their function overtaken by the expanding railroad network. Beginning in the 1870s, the waterway's route through the city was filled in. The stretch leading to the Lockkeeper's Cottage, originally known as Tiber Creek, became B Street NW, which is now Constitution Avenue. Farther east, Canal Street SE is evidence of the canal's former path, which continued under present-day Washington Avenue. By the time of the earlier photograph, the abandoned building was occupied by squatters. Today it sits empty, but is preserved by the National Park Service, occupying a corner opposite one of Charles Bullfinch's guardhouses for the White House.

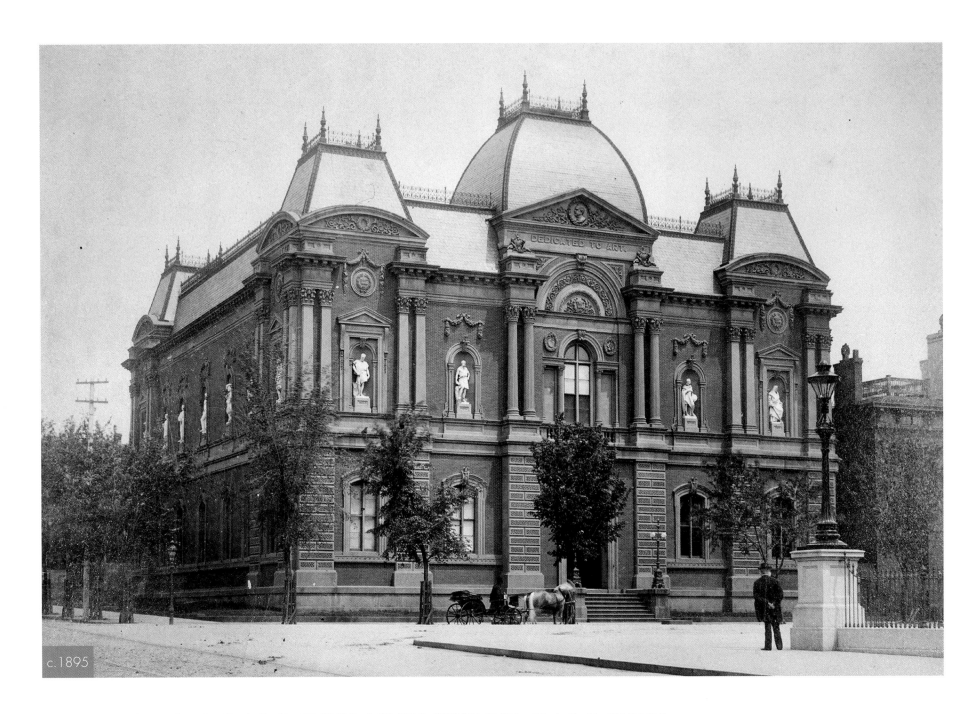

c.1895

CORCORAN GALLERY / RENWICK GALLERY
Washington's first art museum, which opened in 1874

LEFT: This ornate building at Seventeenth Street and Pennsylvania Avenue NW was given to the city by philanthropist William Wilson Corcoran to house his art collection. He was a partner in the firm of Corcoran and Riggs, which eventually grew into the local banking chain Riggs National, now PNC Bank. Corcoran was a benefactor of many universities, and also bought and donated land to be used as Washington D.C.'s Oak Hill Cemetery. When it opened as the Corcoran Gallery of Art in 1874, this building was Washington's first art museum, but that was not its first use as a building. Construction began in 1859, five years after Corcoran's retirement, and during the Civil War the unfinished building was seized by the U.S. government and pressed into service as a military warehouse. Corcoran's board of trustees later sued for back rent and eventually collected $125,000.

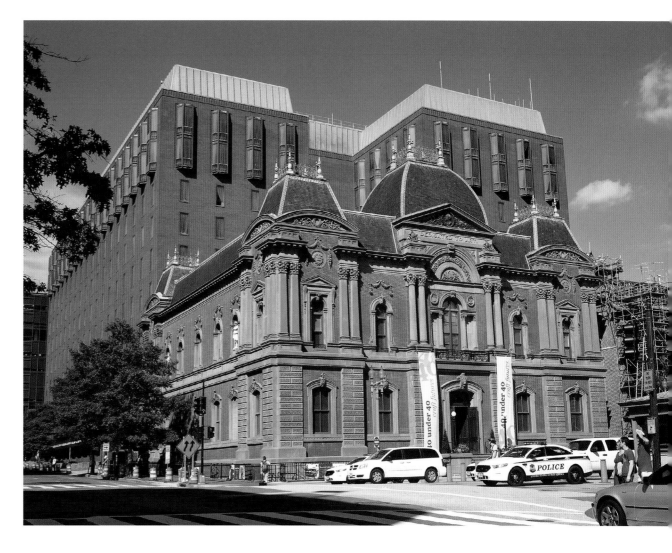

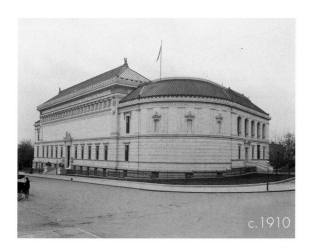

c.1910

ABOVE: The new home of the Corcoran Gallery, built in 1897 on Seventeenth Street.

ABOVE: The building, in the French Second Empire style, was designed by architect James Renwick Jr., whom Corcoran also employed for the chapel at Oak Hill Cemetery. Corcoran's collection soon outgrew the gallery and moved to a new home nearby at Seventeenth Street and New York Avenue NW. The building was occupied throughout the first half of the twentieth century by the Federal Court of Claims. In 1965 it became part of the Smithsonian Institution's portfolio of galleries. The renamed Renwick Gallery is now used to display exhibitions of American craft art. The grand salon inside has been restored in the style of the late nineteenth century, and many of the gallery's original external statue niches have been opened up as windows. Although now dwarfed by the modern U.S. General Services Administration block behind it, the Renwick Gallery's fine decoration ensures that it is not overshadowed.

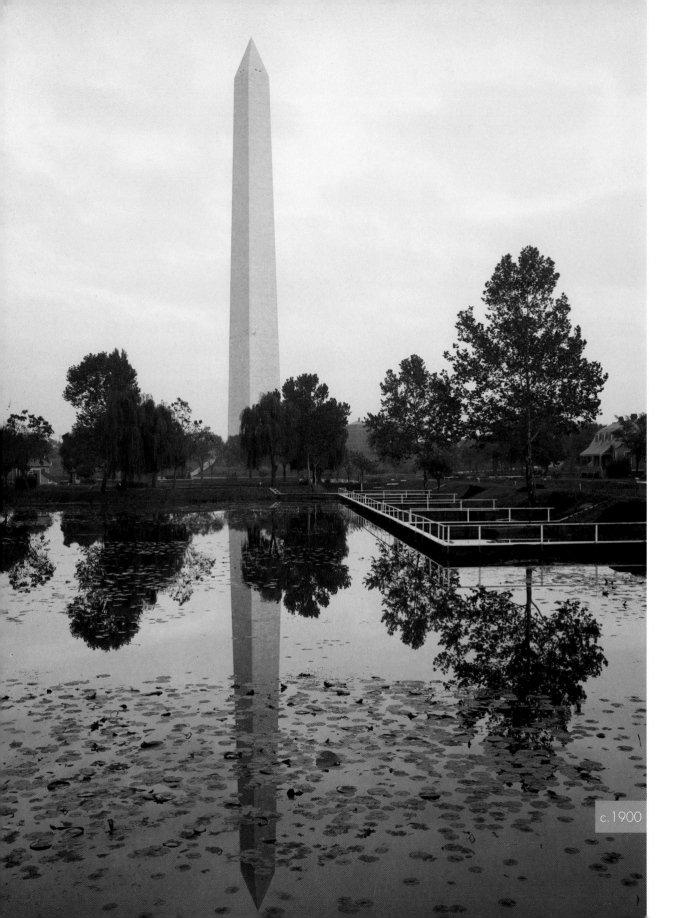

c.1900

WASHINGTON MONUMENT
America's emblematic memorial to its first president

LEFT: Construction on the memorial to the nation's first president was begun in 1848, but funding by public contributions ran out in 1853, and it stood uncompleted at 152 feet for nearly twenty-five years. The federal government later approved funds to complete the structure, and it was finished in December 1884, using a design radically simplified from Robert Mills's original colonnaded temple. Close examination will reveal a slight change in stone color at the 152-foot level, where Massachusetts marble was substituted for the earlier Maryland marble.

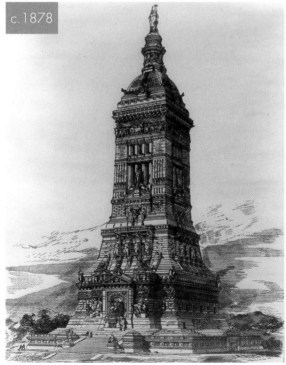

c.1878

RIGHT: The monument is still the world's tallest stone structure and the world's tallest true obelisk. When it was opened on October 9, 1888, it trumped Cologne Cathedral as the world's tallest structure. It held the title for only one year, losing out to the Eiffel Tower in 1889. Repair and maintenance of the monument have always been difficult due to problems with erecting scaffolding. It closed as a result of damage sustained during the Virginia earthquake of August 2011 as well as Hurricane Irene that same year. The National Park Service, which administers the site, plans to reopen the monument by 2014.

BELOW LEFT: When construction of the monument stalled, architects proposed new designs that incorporated the costly stump already built. This treatment, published in the 1870s, has been attributed to H. R. Searle.

BELOW: The initial plan for the Washington Monument, published by Benjamin Smith in an 1852 lithograph.

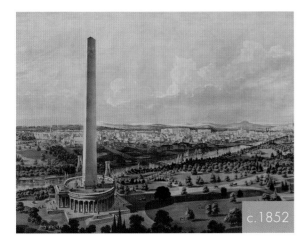

c.1852

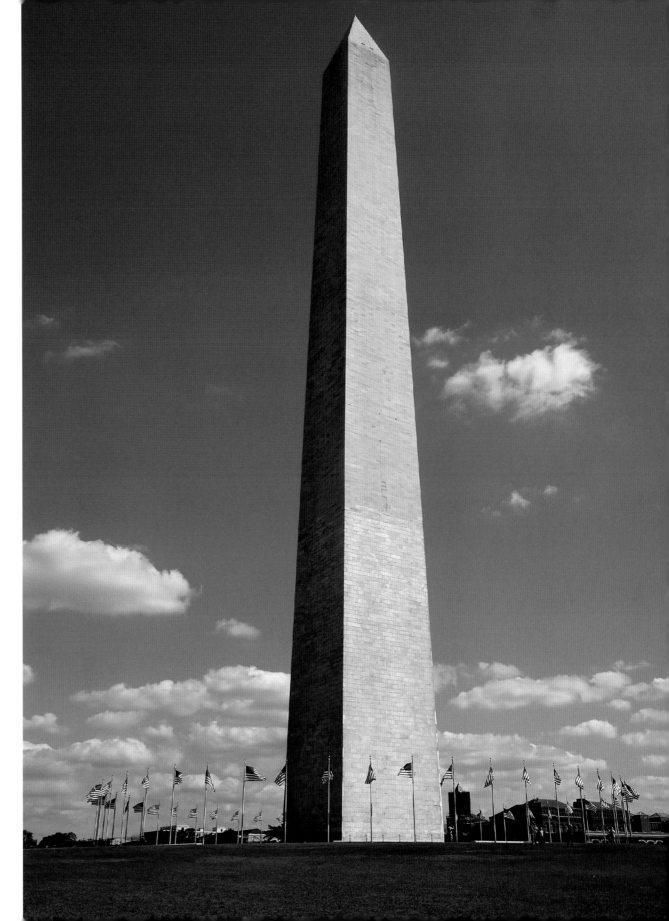

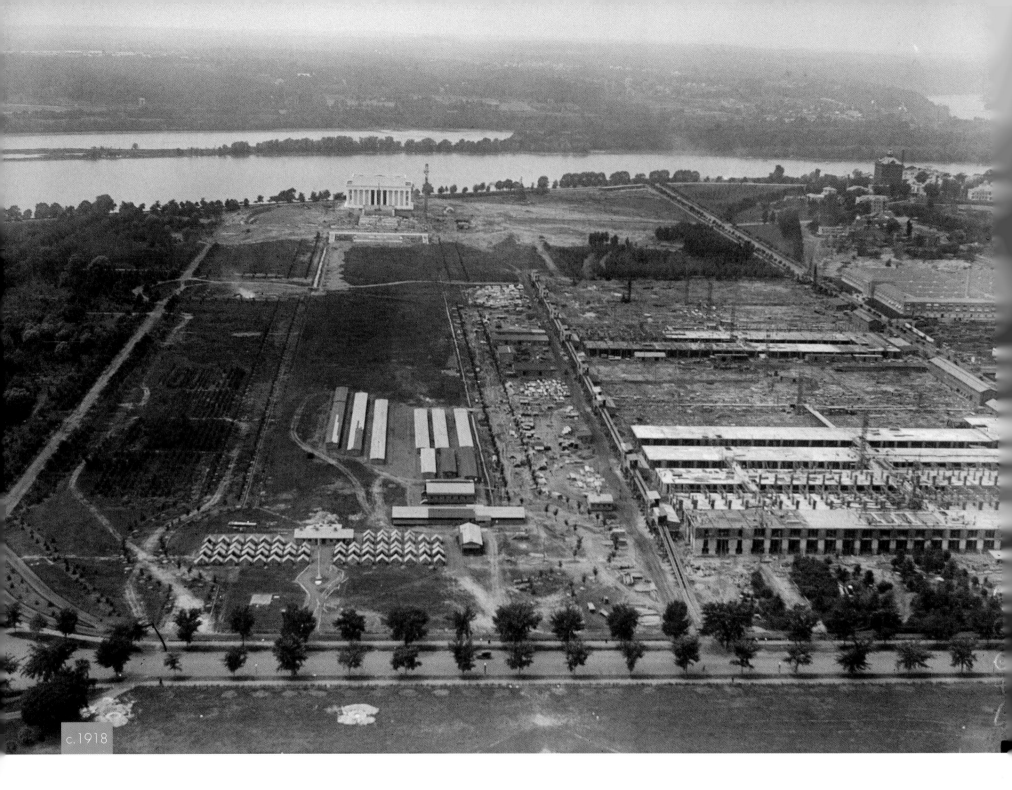

c.1918

LINCOLN MEMORIAL REFLECTING POOL

A stretch of water bookended by great memorials

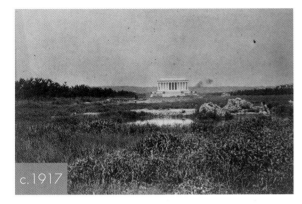

c.1917

ABOVE: This photo clearly shows the marshy nature of the ground between the Lincoln Memorial and the Washington Monument.

BELOW: The same stretch viewed from the top of the Washington Monument, with the World War II Memorial installed next to Seventeenth Street SW.

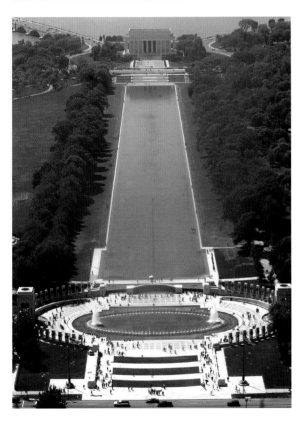

FAR LEFT: Having been used as a military camp during World War I, the marshy ground between the Lincoln Memorial and the Washington Monument was extensively excavated by the U.S. Army Corps of Engineers between 1922 and 1923 to create the Reflecting Pool. The ground between the Lincoln Memorial and the Capitol Building was notoriously difficult to build on, so a reflecting pool seemed the perfect use. Henry Bacon's design was often used as an impromptu skating rink in winter; at a depth varying between twelve and thirty inches, there was little danger of serious injury if the ice proved too thin.

ABOVE: The National World War II Memorial is dedicated to the sixteen million Americans who served in the armed forces during World War II, the more than 400,000 who died, and the millions who contributed to the war effort. Located on the axis of the National Mall, it lies between the Washington Monument and the Lincoln Memorial. It was dedicated by President George W. Bush on May 29, 2004. Friedrich St. Florian's design won the competition set in motion by President Bill Clinton and administered by the American Battle Monuments Commission. Senator Bob Dole, twice a recipient of the Bronze Star, and Frederick W. Smith, a former Marine officer and the CEO of FedEx Corporation, helped raise $197 million for the project.

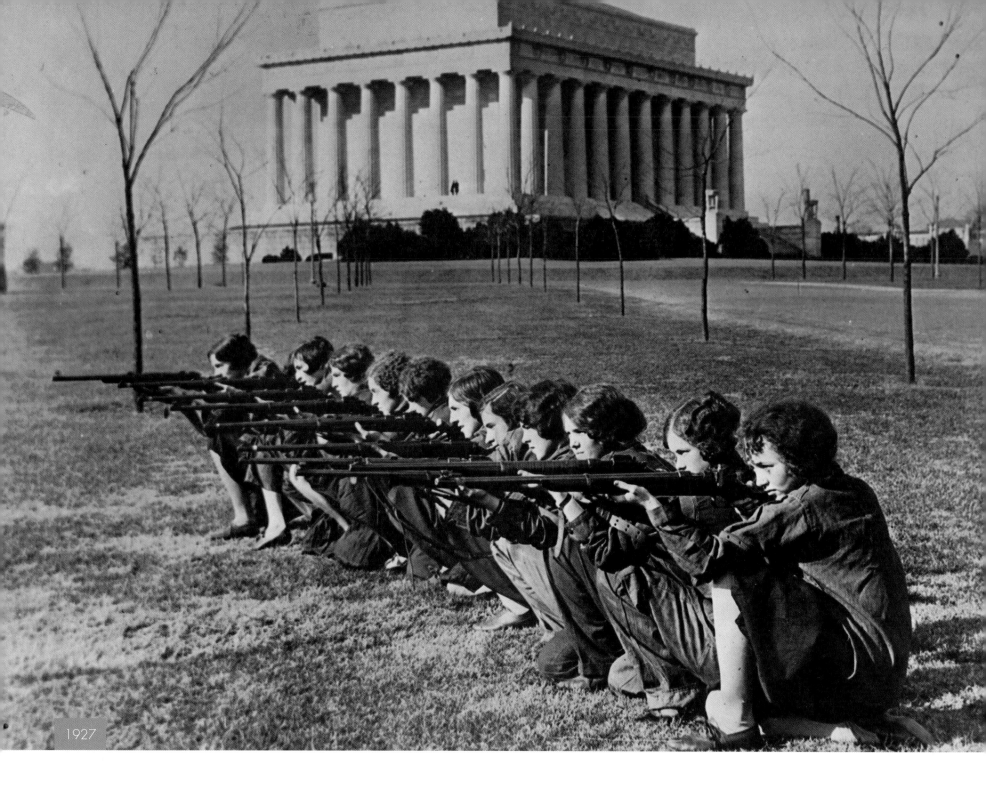

1927

MEMORIAL PARKS

The site of memorials to many conflicts, including the Korean and Vietnam Wars and World War II

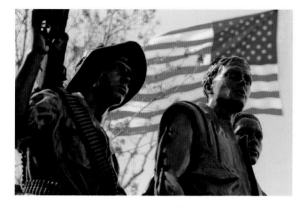

LEFT: The year is 1927 and the Girls' Rifle Association of George Washington University poses before the Lincoln Memorial on the grass of what will become Constitution Gardens, off Daniel French Drive. Much of the land, which had been reclaimed from the Potomac River at the beginning of the twentieth century, was taken over by the navy during World War I. They built eighteen long and tightly packed rows of "temporary" offices on the location (see page 70), which stretched along Constitution Avenue from Seventeenth to Twenty-first Street just out of shot to the right of this photograph. They were still in use over fifty years later when President Richard Nixon, who had served in Washington during his time as a naval officer, got the offices demolished in 1971.

ABOVE: In place of the naval complex a park was laid out on the site, and Constitution Gardens was opened in 1976 as part of the bicentennial celebrations. In 1982 a new monument was dedicated within it to the American men and women who had fought in Vietnam. Known officially as the Vietnam Veterans Memorial and unofficially as "VVM" or simply "the Wall," it was designed by Maya Ying Lin, who submitted her winning entry to a national competition in 1981. The monument consists of three elements: the wall with the inscribed names of casualties from the theaters of Vietnam, Laos, and Cambodia; a statue of three servicemen (above left); and a flagpole. By 2012 there were 58,282 names on the wall, and names continue to be added to the wall of servicemen who have died as a result of injuries sustained during the war.

BELOW: This picture shows the Vietnam Veterans Memorial, inscribed with the names of those who died as a result of the Vietnam War.

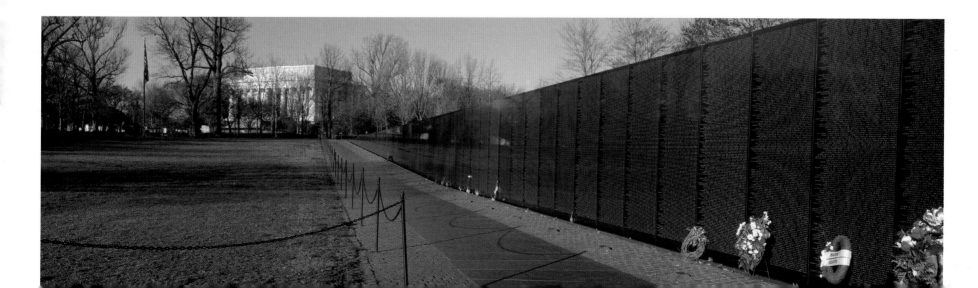

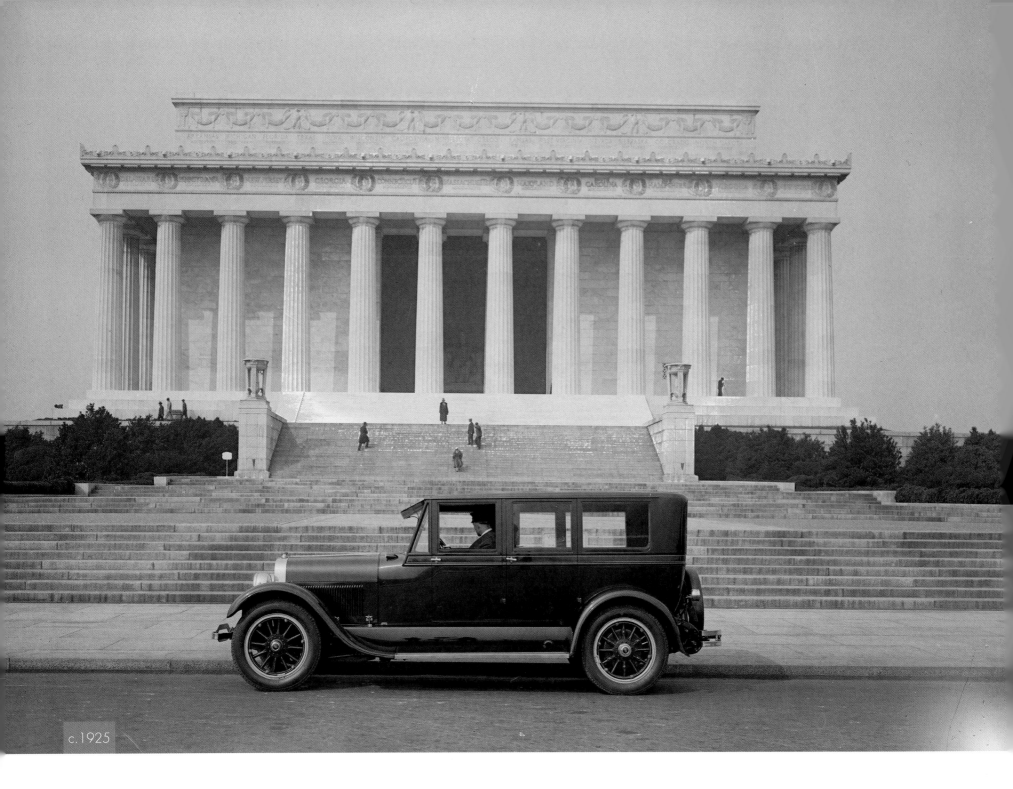

c.1925

LINCOLN MEMORIAL

The structure was so large that Daniel Chester French's statue of Lincoln had to be scaled up in size to match it

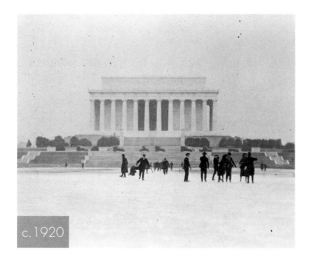

c.1920

ABOVE: The Reflecting Pool was a popular place for ice-skaters, and in snowy weather it was not uncommon to see children sledding down the steps of the Lincoln Memorial.

LEFT: Plans for a memorial to Abraham Lincoln had been discussed since his assassination in 1865. The Lincoln Memorial was finally constructed between 1914 and 1921 on land reclaimed from the Potomac River earlier that century. It was modeled on classical Greek temples by Henry Bacon and dedicated in 1922; Bacon added the Reflecting Pool in front of it over the following years. Frequent icy winters made the Reflecting Pool a popular place for ice-skating. The memorial is fringed with thirty-six Doric columns representing the thirty-six states of the union at the time of Lincoln's death, and their names are inscribed on the frieze above. It houses the famous seated statue of Lincoln designed by sculptor Daniel Chester French; at nineteen feet in height, it is nearly twice as large as originally planned so as not to be dwarfed by the sixty-foot chamber in which it rests.

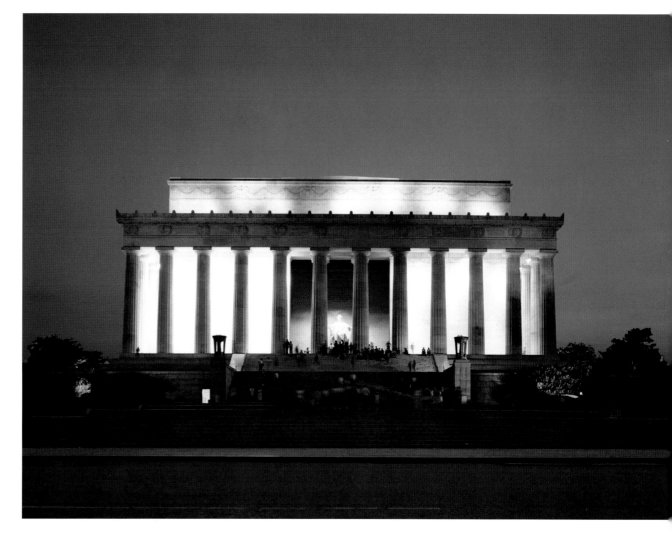

ABOVE: The Reflecting Pool, which is over 2,000 feet long, underwent major refurbishment in 2012 with new side paths, a relined pool, and improved circulation of the water to avoid stagnation. The monument itself remains largely unchanged since its construction, apart from the addition of an elevator in the 1970s to improve access for wheelchairs. The chambers on either side of the statue are inscribed with Lincoln's Gettysburg Address and his second inaugural address. Over the decades it has become a focus for civil-rights campaigners, most notably as the place where Martin Luther King delivered his famous "I Have a Dream" speech; an inscription on the steps marks the actual spot. Royal Cortissoz, the art critic of the *New York Herald Tribune*, composed the emotive legend above Lincoln's head: "In this temple, as in the hearts of the people for whom he saved the Union, the memory of Abraham Lincoln is enshrined forever."

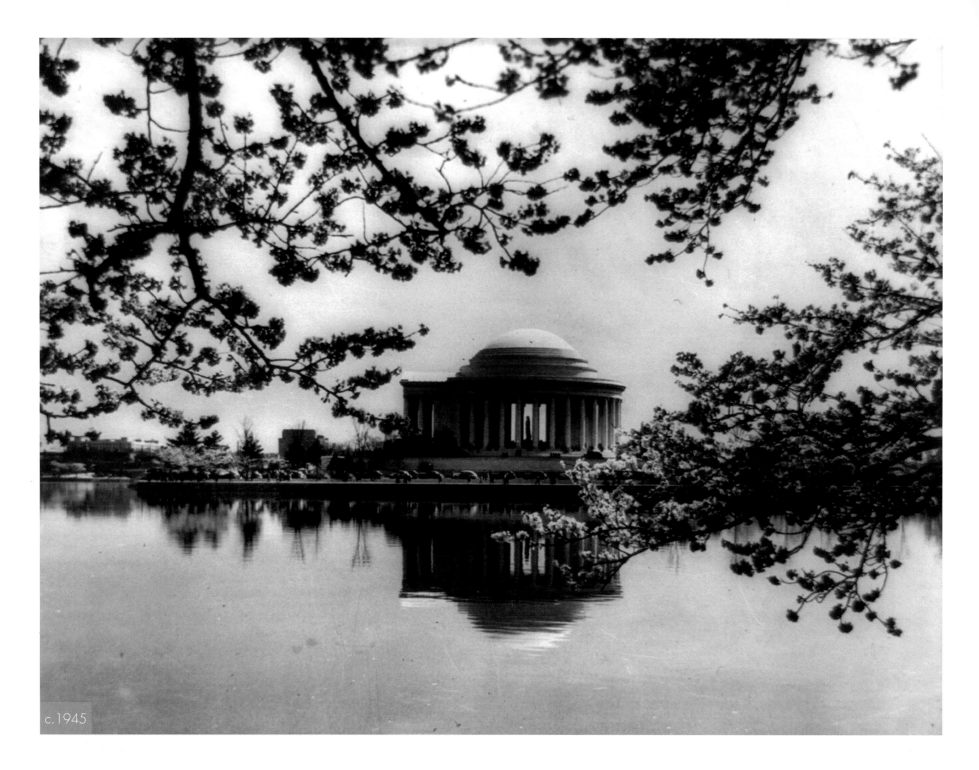

c.1945

JEFFERSON MEMORIAL
Surrounded by cherry trees, which were a gift from the city of Tokyo

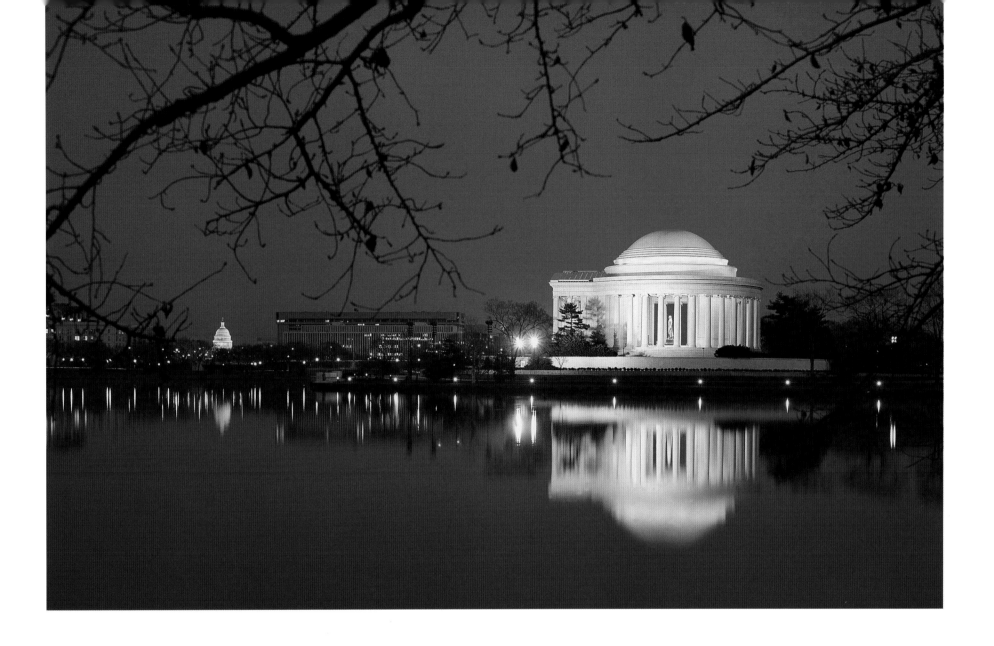

LEFT: The Jefferson Memorial was John Russell Pope's second design for a presidential memorial on the tidal basin—Congress approved his first, for Theodore Roosevelt in 1925, but never funded it. The memorial to Thomas Jefferson was authorized by Congress in 1935, erected between 1938 and 1942, and dedicated in 1943. The white marble structure features a nineteen-foot-high bronze statue of the third president, sculpted by Washington native Rudulph Evans, surrounded by twenty-six columns. Pope himself died in 1937 before construction began; he missed most of the criticism of his design, as its neoclassical approach—hitherto the defining style of most of federal Washington—was no longer fashionable.

ABOVE: The tidal basin, on whose shore the memorial sits, was created in 1882 to trap overflow water from the Potomac River and drain it into the Washington Channel to prevent the buildup of sediment there. It is ringed with cherry trees given by the city of Tokyo to the city of Washington in 1912. Subsequent further plantings have celebrated this gift, and in 1935 the first annual National Cherry Blossom Festival was held. The present basin was redesigned and engineered in 1949. Due to wartime shortages, Rudulph Evans's statue of Jefferson was originally of plaster—it was not until the late 1940s that the solid bronze version was finally installed. At night the floodlit white marble of the memorial still houses a thoughtful Jefferson looking across the water to the White House.

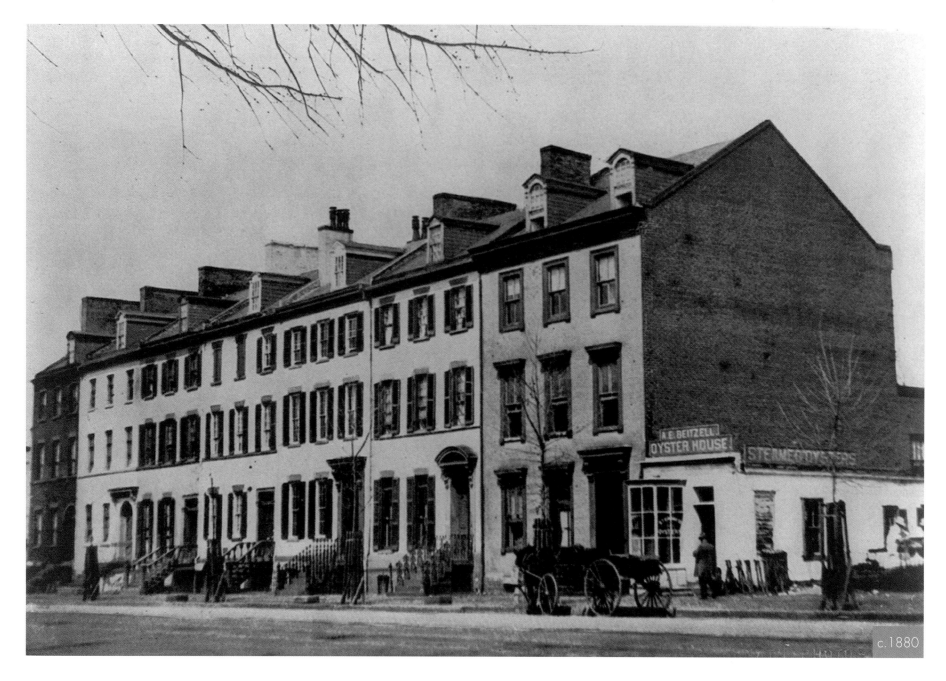

c.1880

PENNSYLVANIA AVENUE NW
Temporary offices of the U.S. Department of State

ABOVE AND BELOW RIGHT: Occupying the north side of the 2000 block of Pennsylvania Avenue NW, the "Six Buildings" (which were actually seven) were built around 1800 by Isaac Polock, an early investor in the city and a man recognized as Washington's first Jewish resident. Polock was the grandson of a founder of the Newport, Rhode Island, synagogue who moved from Savannah, Georgia, in 1795. The Six Buildings initially housed the U.S. Department of State and the Secretary of the Navy before being used for a variety of purposes. At one time they were the residences of James Madison and Sam Houston.

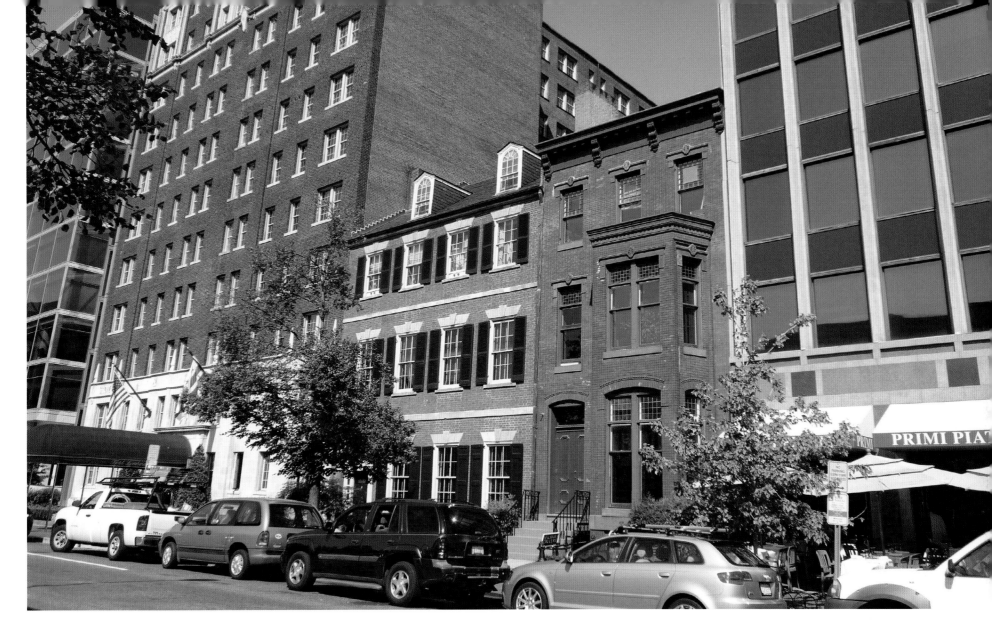

c.1880

ABOVE: The row was all but demolished in the 1930s, leaving only number 2017 as a consolidation of two of the original houses. The older building to the right of the extant house is home to the Arts Club of Washington, and to the other side is the Lombardi Hotel. Pepperdine University occupies the site at the right-hand end of the row, which originally stretched from 2007 to 2017 Pennsylvania Avenue NW.

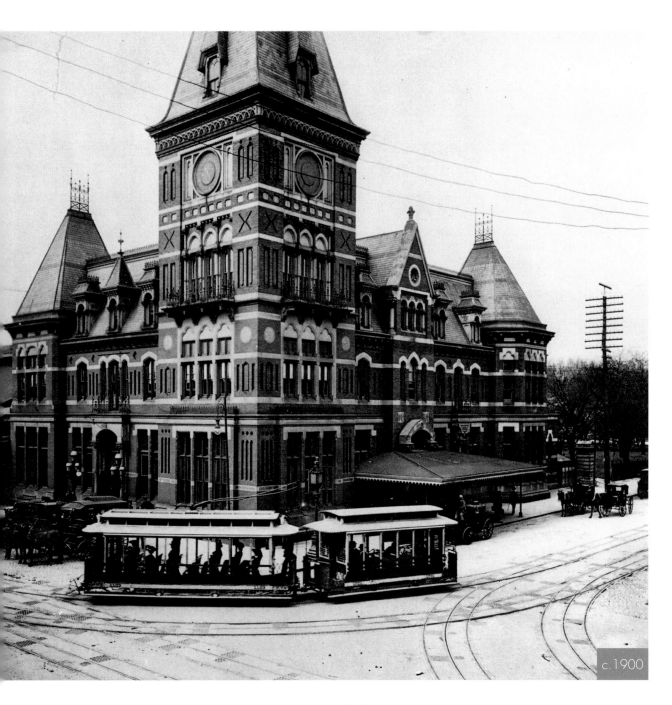

c.1900

SIXTH AND B STREETS

From railroad station to the National Gallery of Art

LEFT AND BELOW RIGHT: These photos show what was once the transportation hub of Washington, the Baltimore and Potomac Railroad Station at Sixth and B Streets (now Constitution Avenue). Built in 1873 as the Washington terminal for what would become part of the Pennsylvania Railroad's vast network, its departure tracks stretched south across the Mall parallel to Sixth Street. The station received its place in the history books on July 2, 1881, when President James Garfield was shot in a waiting room by Charles Guiteau, a disgruntled and deranged lawyer who had come to Washington seeking a job appointment. Garfield died two months later.

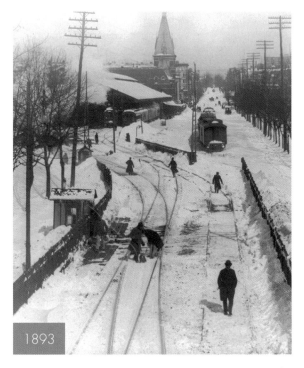

1893

RIGHT: Track workers clear the line to the train shed of the Baltimore and Potomac Railroad Station after the blizzard of 1893. Today the same view would be from the Smithsonian Air and Space Museum.

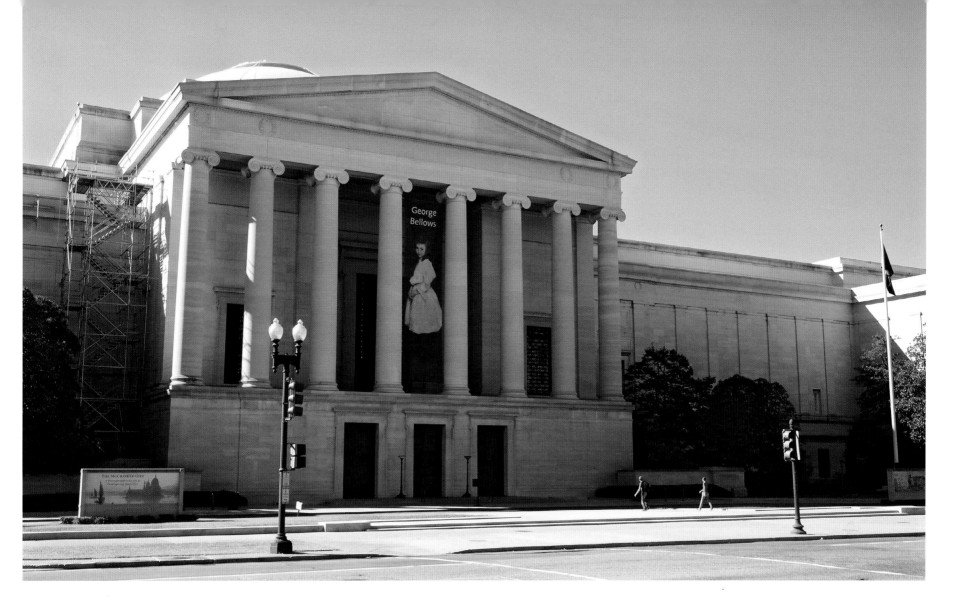

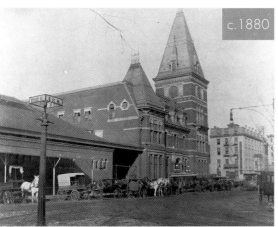

ABOVE: In 1902, through mergers, the Baltimore and Potomac Railroad became the Philadelphia, Baltimore, and Washington Railroad. The PB&W joined forces with the Baltimore and Ohio Railroad, the B&P's chief competitor in Washington, to build a new shared transportation hub, Union Station. It opened in 1907 and rendered the original terminals of both companies surplus to requirements. By 1908 both had been demolished. On the B&P site now stands the West Building of the National Gallery of Art, a branch of the Smithsonian Institution. If the dome and portico of the present building bring the Jefferson Memorial to mind, it is because they were both designed by John Russell Pope. The building was the gift of banker Andrew W. Mellon, who, like Pope, died before its completion, having donated his personal collection of paintings and sculptures to be the foundation of the new national collection.

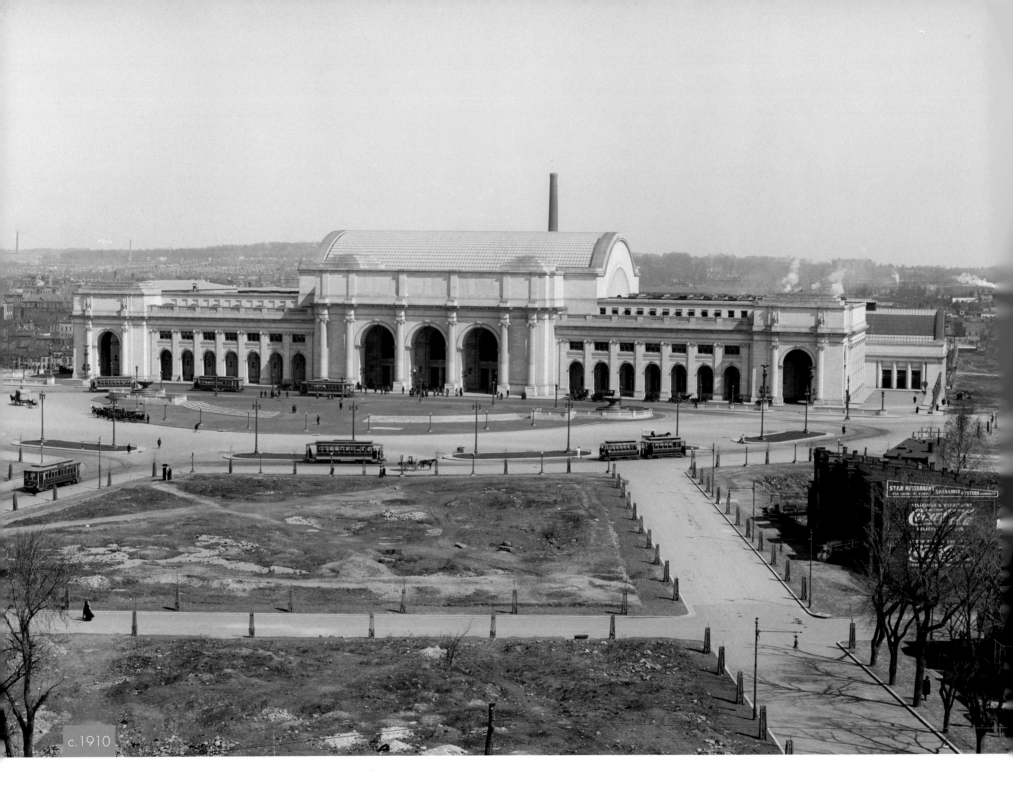

c.1910

UNION STATION
Daniel Burnham's grand cathedral to rail transportation

LEFT AND RIGHT: Construction of Washington's Union Station began in 1903; it received its first train on October 27, 1907, and was completed the following year. It was the product of cooperation between two rival railroad companies, the Baltimore and Ohio, and the Baltimore and Potomac (by then owned by the Pennsylvania Railroad Company). The new shared terminus, at the junction of Massachusetts and Delaware Avenues, was the result of the expansion of railroad traffic to and from the city. The B&O and B&P stations were simply too small, and the tracks leading to them from the south were preventing the development of the Mall. With a concourse measuring 760 feet by 130 feet (said to be the largest room of any kind in the world when it was built), Union Station is slightly larger than the nearby Capitol Building. It was the first large-scale structure to be built of granite from Bethel, Vermont, because the previous owner of the quarry there had reserved all the stone from it for tombstones—his son had died in a railroad crossing accident.

RIGHT: Architect Daniel H. Burnham based his design on the grand classical entrances of European terminals such as London's Euston Station. Burnham's firm also oversaw the construction of the globe-topped Columbus Fountain in front of Union Station, designed by sculptor Lorado Taft in 1912. Lorado was a cousin of President William Taft, who in 1909 was the first to use the station's palatial Presidential Suite. The sheer scale of the building was justified by the human traffic passing through it—40,000 a day by 1937, and up to 200,000 a day during World War II. But the decline in rail travel after the war saw the building fall into disuse. Although it was designated a potential fallout shelter in 1961, a 1977 survey found it to be in imminent danger of collapse. In the 1980s, the building was turned over to the Federal Department of Transportation and dramatically redeveloped into a combined passenger terminal and commercial retail center, with enormous success.

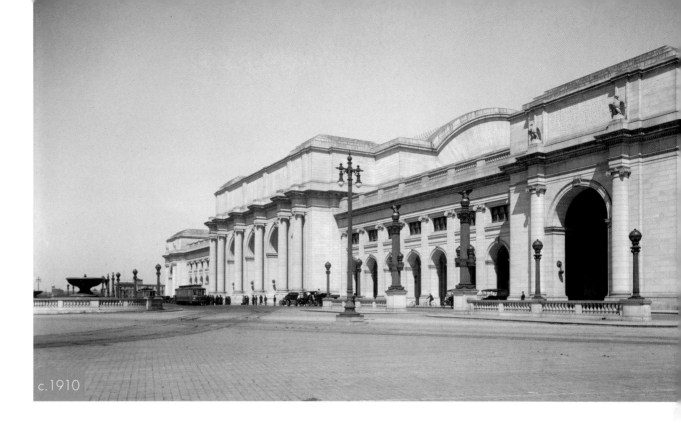

c.1910

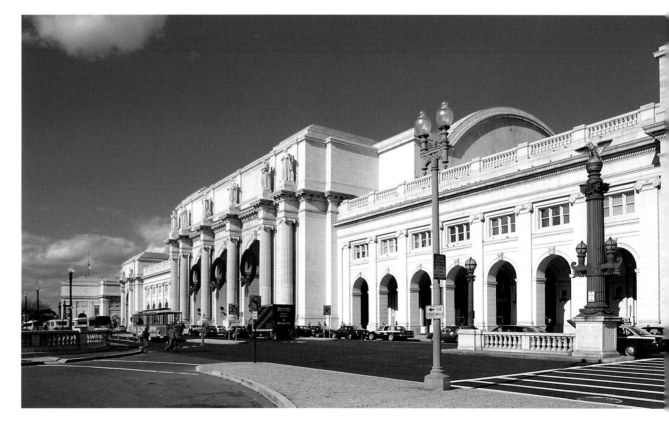

c.1880

SMITHSONIAN BUILDING

A gift from the illegitimate son of the Duke of Northumberland

LEFT: The Smithsonian Institution, formally established in 1846, was founded in 1835 with a bequest of $550,000 from English scientist James Smithson to the United States "for the increase and diffusion of knowledge." Smithson was an amateur chemist and an illegitimate son of the Duke of Northumberland, who died in 1829 unmarried and without heirs. Despite his generous gift, Smithson never visited the United States, but his remains were brought to Washington in 1905 when he was ceremoniously entombed in the very building that his legacy had erected. The Smithsonian Institution, or "the Castle" as it is informally known, sits prominently forward of its neighbors in the Mall, forcing Jefferson Drive to curve around it. It was designed by James Renwick Jr., who also designed New York's St. Patrick's Cathedral. A rare example of neo-Gothic red sandstone in a city of neoclassical white marble and granite, it was completed in 1855. Little had changed between 1880 and the photo taken below around 1900.

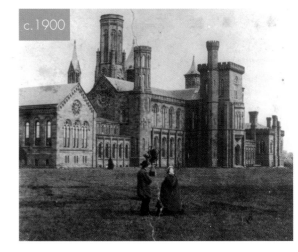

c.1900

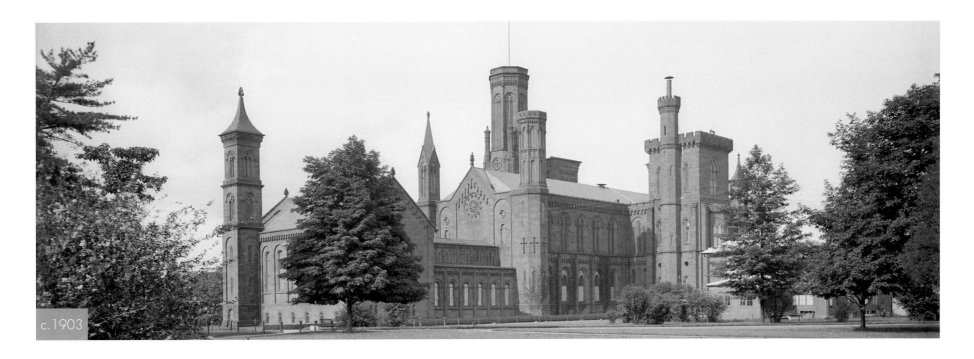

c.1903

ABOVE: Four of the Castle's towers contain usable space, while five smaller towers are primarily decorative.

RIGHT: It was assumed from the beginning that the Smithsonian Institution would expand. Renwick deliberately chose an asymmetric medieval style so that any additional wings built onto it would not spoil its appearance. Today the Smithsonian Institution has evolved to become the world's largest museum complex, housed in twenty locations ranging from the original building to the National Zoological Park. All but three of them are in Washington, and eleven of them, including the Castle, are to be found on the Mall. The newest is the National Museum of African American History and Culture. The oldest, the Castle itself, was never extended, although additional floors were discreetly added to the east and west wings in the 1880s. It is now home to the Smithsonian Visitor Center and all the institution's administrative offices. James Smithson's tomb sits in a crypt inside the northern entrance.

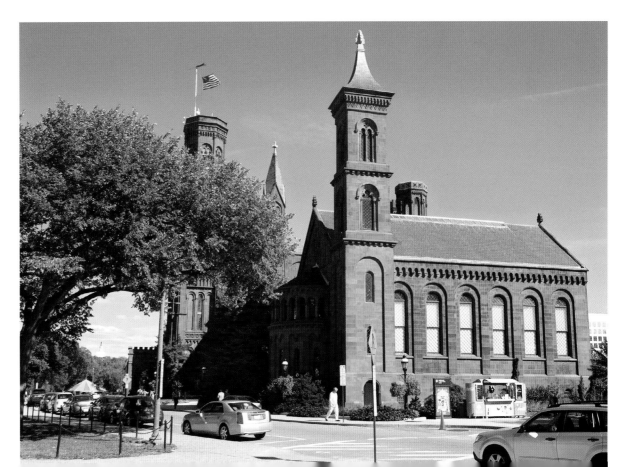

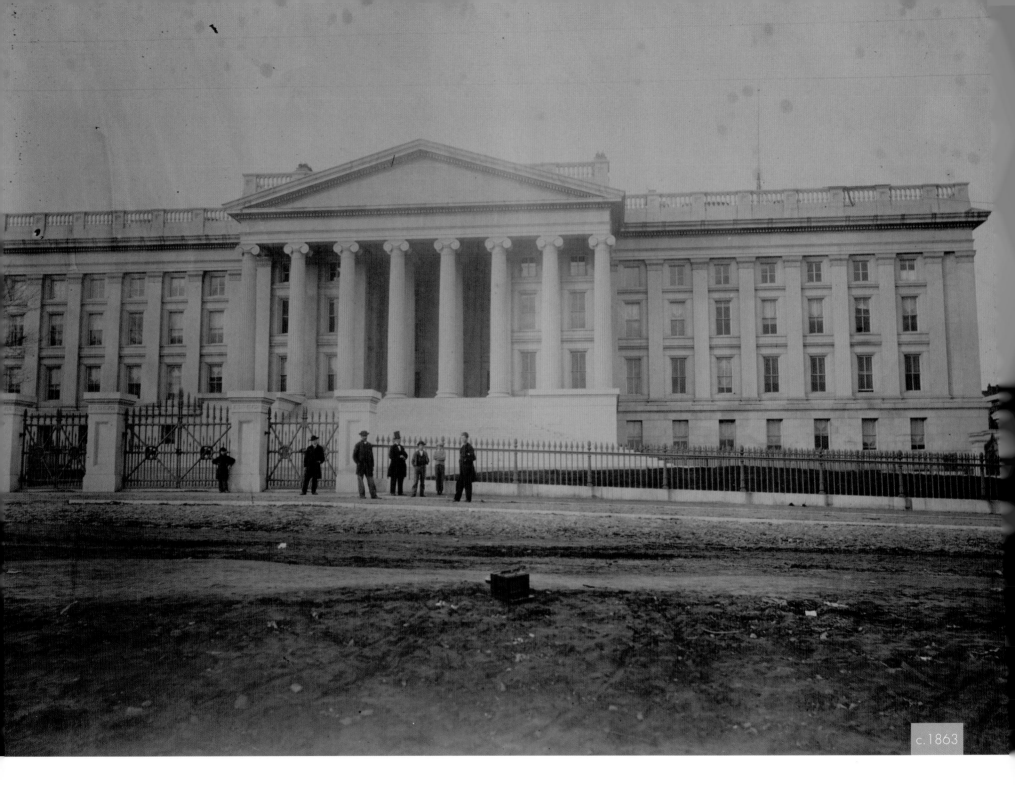

c.1863

U.S. TREASURY BUILDING
The offices of the Secretary of the Treasury since 1836

LEFT: Three Washington buildings—the General Post Office, the U.S. Patent Office, and the U.S. Treasury—were all principally designed by Robert Mills. Mills was appointed as the federal architect of public buildings by President Andrew Jackson in 1836, and construction of the Treasury Building began the same year, on a site personally selected by Jackson. It was the first radical departure from Pierre Charles L'Enfant's original plan for the city. Appropriately positioned alongside the White House and with an uninterrupted view of the Capitol down the length of Pennsylvania Avenue, the Treasury Building keeps one eye on the government and another on the president. Mills had made his reputation as a pioneer of the design of fireproof buildings, an obvious advantage for federal institutions that housed vital paper records.

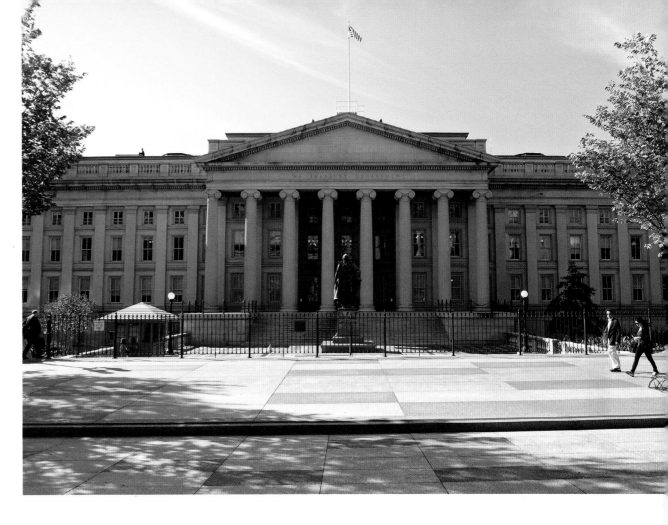

BELOW: This 1860 photograph shows the Treasury Building still under construction. The oxen are being used to pull carts laden with stone.

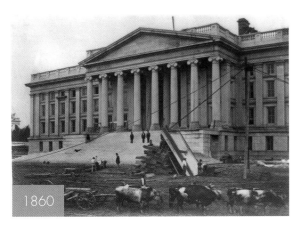

1860

BELOW: A cable car of the Washington Traction Co. passes the Treasury Building. The company took over from the Rock Creek Railway and the Washington and Georgetown Railroad.

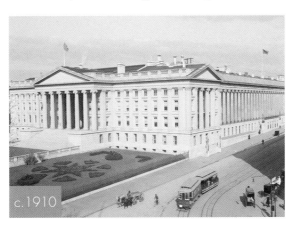

c.1910

ABOVE: The building still fulfills its original function today, and is pictured on the back of every $10 bill. It originally had a T-shaped plan, the long eastern side with a central wing. The southern wing, the one seen in both photographs, was the next to be completed; other wings were added in stages until the present building enclosing two internal courtyards was completed in 1869. Robert Mills's designs were put to the test in 1922 when the blowtorch of a worker repairing the building's roof started a serious conflagration. Happily for Mills and the country, none of the nation's currency or valuable blueprints stored in the vaults was damaged. The statue of Alexander Hamilton, the first Secretary of the Treasury, was erected in 1923, the work of James Earle Fraser, best known for his sculpture *The End of the Trail*, which depicts an exhausted Native American and his horse.

c.1935

NATIONAL ARCHIVES
Safeguard of the federal government's historical records and official documents

ABOVE: Almost at the eastern point of the Federal Triangle, between Pennsylvania and Constitution Avenues NW, sits the building housing the National Archives, the historical records and documents of the federal government. It was authorized by Congress in 1926 to solve a long-standing problem—vital government papers were being lost or misfiled because of the often chaotic, haphazard storage of records going back in some cases to the founding of the country 150 years earlier. The National Archives Building would bring all records under one roof and one administration. Originally intended as a rather dull, boxlike structure situated on Pennsylvania between Ninth and Tenth Streets, its design and status were dramatically elevated in the plans of architect John Russell Pope, who also relocated it to its present location, the site of the city's dilapidated Central Market. Instead of a box, Pope delivered a building worthy of housing the nation's history.

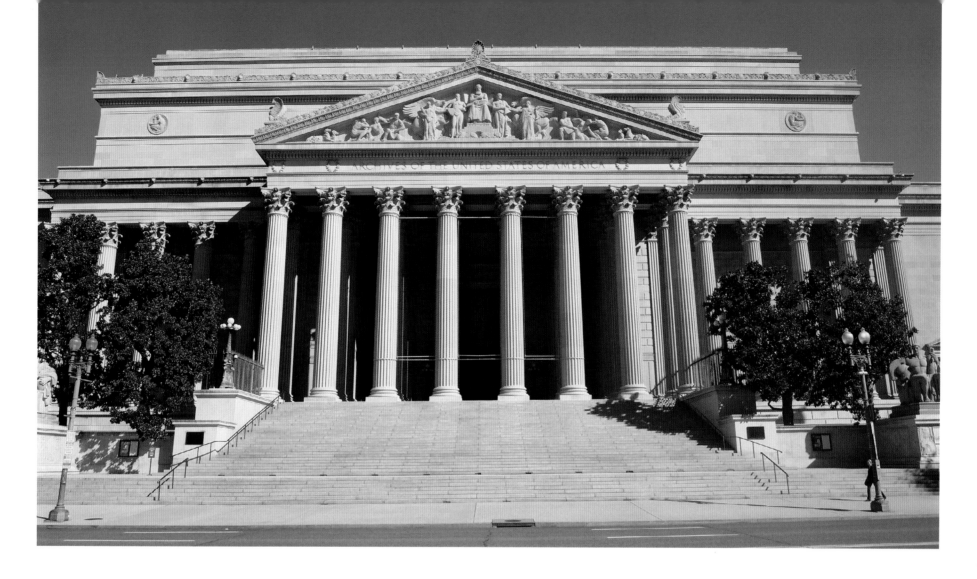

ABOVE: Construction began in 1931. The site sits above an underground stream, and almost 9,000 pilings were driven into the soft ground to help support the load of 400,000 square feet of paperwork that the building was intended to accommodate. As if that wasn't heavy enough, the vast bronze doors of the Constitution Avenue entrance are the largest in the world, each one thirty-eight feet high, ten feet wide, and six and a half tons in weight. Pope's plan included an internal courtyard, but the volume of the nation's archive was significantly underestimated; no sooner had the building been completed in 1935 than the courtyard was filled in, doubling the National Archives' capacity. By the late 1960s it was full again, and the administration had to rent warehouse space until 1993, when a second National Archives Building was completed in Maryland.

RIGHT: The National Archives viewed from across the street at the ice-skating rink of the National Gallery of Art's Sculpture Garden.

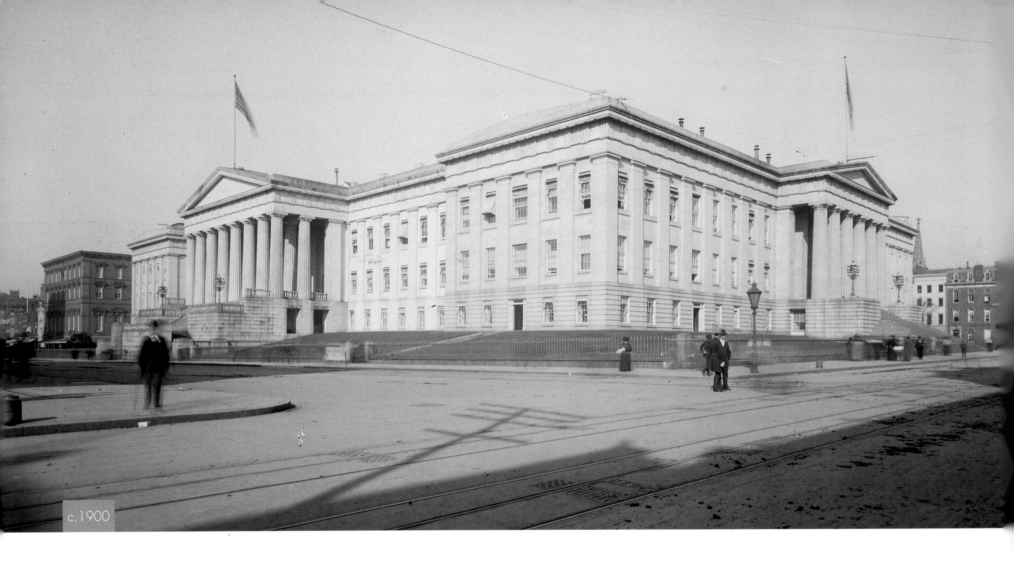

c.1900

U.S. PATENT OFFICE

A calamitous fire forced the Patent Office out of Blodget's Hotel

ABOVE AND RIGHT: In 1836 the U.S. Patent Office, then housed in Blodget's Hotel on Eighth and E Streets NW, suffered a disastrous fire in which thousands of patent records and models (the legal deposits that acted as proof of invention) were lost. A new storage facility was immediately commissioned from architect Robert Mills, an expert in fireproof buildings who began work on the U.S. Treasury Building that same year. Construction was beset with delays, many caused by questions about Mills's competence. He was forced to make unnecessary changes to his plans, and finally resigned in 1851. His fiercest critic, Thomas U. Walter, was then appointed in his place. Walter made additional changes to Mills's specifications. Progress was further held up by the Civil War, when the building was used as a military hospital; poet Walt Whitman served there, reading to injured men. Mills died in 1855, twelve years before the building's completion in 1867. He might have drawn some comfort from the fact that the damage caused by another major fire in 1877 was largely due to Walter's amendments, rather than to Mills's original fireproof designs.

c.1910

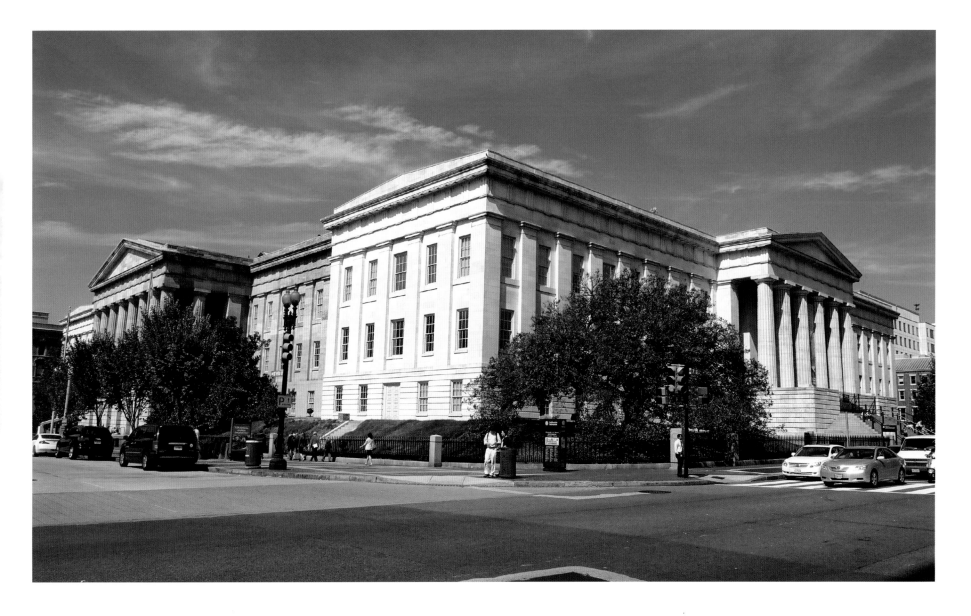

ABOVE: The U.S. Patent Office outgrew its Washington premises and relocated to Virginia in 1932; its old home was occupied until 1952 by the Civil Service Commission. During that time, as the modern photograph shows, the widening of F Street NW forced the removal of the grand staircase leading to the southern portico. Worse was threatened: in 1953 the site was slated for clearance to make way for a parking lot. But the building was spared primarily through the efforts of David Finley, the chairman of the Fine Arts Commission—an important victory for the emerging historic preservation movement. President Dwight D. Eisenhower transferred the building to the Smithsonian Institution, and in 1968 it reopened not as one museum but two— the National Museum of American Art (now the Smithsonian American Art Museum) and the National Portrait Gallery. Not visible in this photograph is the large internal courtyard; it was given a dramatic curved glass canopy by the London architectural firm Foster and Partners as part of a program of restoration and refurbishment in the first decade of the twenty-first century.

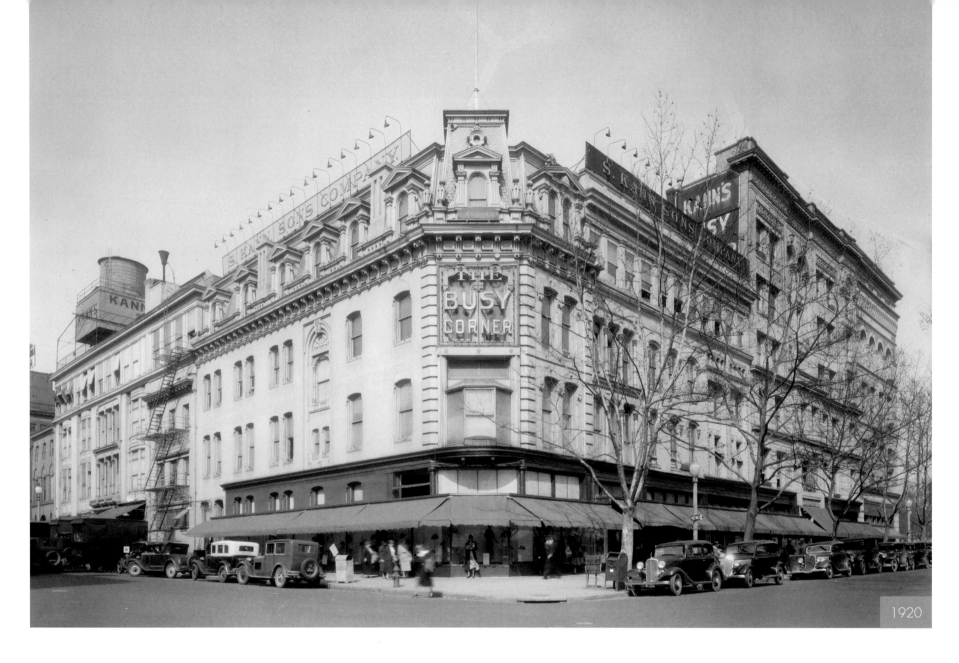

1920

KANN'S DEPARTMENT STORE / U.S. NAVY MEMORIAL

"Busy Corner" wasn't so busy after 1979

ABOVE: Kann's, seen here in the 1920s at the self-declared "busy" northeast corner of Eighth Street and Pennsylvania Avenue NW, was a Washington institution. The three Kann brothers from Baltimore, who bought out Dorsey Carter's clothing store on the site in 1890, built their success on two innovative principles: "the customer is always right" and "satisfaction guaranteed or your money back." They sold goods at fixed prices (with no haggling), and sometimes priced items in fractions of a cent to demonstrate their value. Kann's expanded into neighboring premises, including the store on the corner of Seventh Street and Pennsylvania Avenue, which had been the former Boston Dry Goods store, later the first home of Washington's Woodward and Lothrop chain, and finally the emporium of their friendly rival Andrew Saks (whose son founded Saks Fifth Avenue). Kann's purchased the Saks corner in 1932, giving it control of the whole southern half of the block.

ABOVE: Like many downtown institutions, Kann's declined after World War II. In 1959, in an ugly attempt to modernize, Kann's unified its eclectic facade by covering it in aluminum sheeting. The modern minimalist look dated quickly, and in 1971 the Kann family sold out. The business lasted only another four years under the new owners. After years of political debate about whether to demolish or preserve the old buildings contained within the tin box, a mysterious fire broke out in 1979, damaging the buildings beyond repair. Demolition swiftly followed. Today, not only Kann's but its stretch of Eighth Street is gone, replaced by Market Square (the East Market Square block sits over the site of Kann's). The square is home to the U.S. Navy Memorial, which was dedicated in 1987. It includes a granite map of the oceans and Stanley Bleifeld's bronze sculpture *The Lone Sailor.*

LEFT: A photo from April 1979 shows that there was little to be salvaged from the extensive fire on the Kann's site.

NINTH AND F STREETS

Featuring one of the few Richardsonian Romanesque buildings in Washington, D.C.

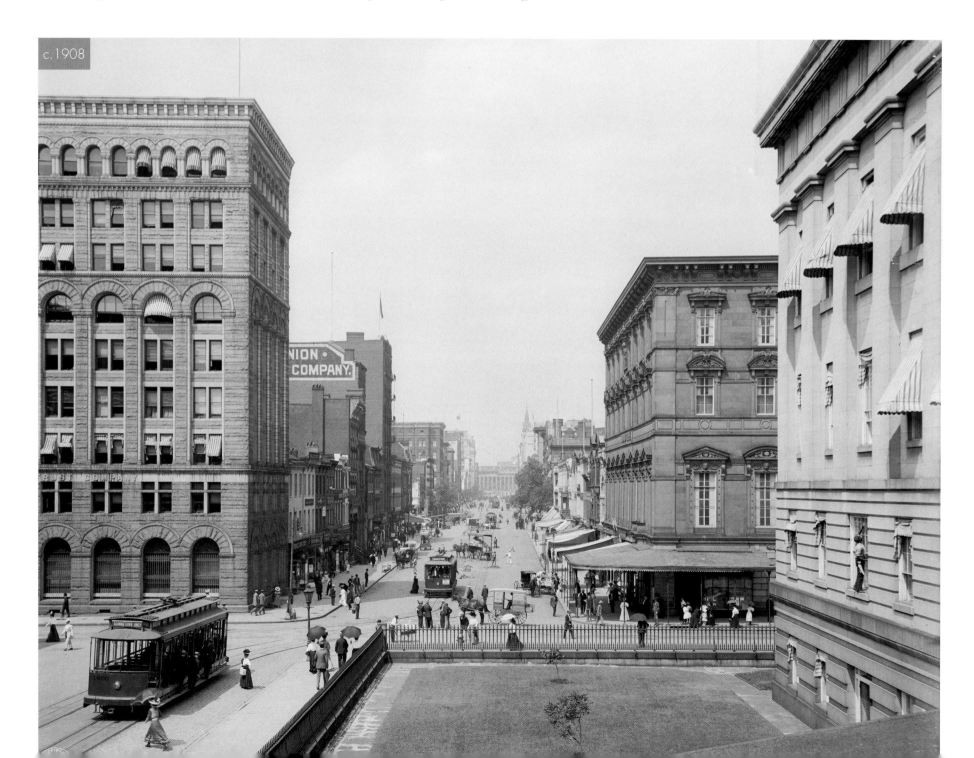

c.1908

c.1885

ABOVE: The same view taken from the Patent Office in 1885 with the Masonic Temple already in place, but with the Oppenheimer Sewing Machine Company across the street.

BELOW: In 1927 the WL&T was sympathetically extended through the purchase of neighboring lots, preserving James Hill's design over ten arches along F Street instead of the original four. It is now a hotel. The gable-end sign of the NUIC was still visible at the start of the twenty-first century, but is now obscured by modern development on the adjacent plot. Some of the older, lower buildings on the block still survive, however. The Masons moved to a new temple in 1908, and their original building was put to a variety of uses that remodeled the ornate interior beyond recognition. In the 1970s and 1980s, it lay empty and under threat of demolition before it was saved and restored to its former glory in the 1990s. It is now part of the Gallup organization's headquarters. The Treasury Building can be glimpsed at the far end of F Street in both views.

LEFT: This view, looking west from the steps of the U.S. Patent Office around 1909, shows a rapidly developing commercial district downtown. Before the demolition of the Patent Office steps, traffic had to veer southward around the railings of the building's forecourt. To the left are the rounded Richardsonian Romanesque arches of James G. Hill's Washington Loan and Trust (WL&T) Company Building, constructed in 1891. Hill was also the architect of the nearby Government Printing Office. Behind the WL&T (later part of Riggs National Bank) is the recently built National Union Insurance Company (NUIC) Building, with its sign at the top plainly visible. To the right at 901 F Street is the Masonic Temple, built between 1868 and 1870 by the architectural partnership of German exiles Adolf Cluss and Joseph Wildrich von Kammerhüeber. The temple had shops on the ground floor and meeting rooms above, including a great hall that regularly hosted 1,000 people for balls and banquets.

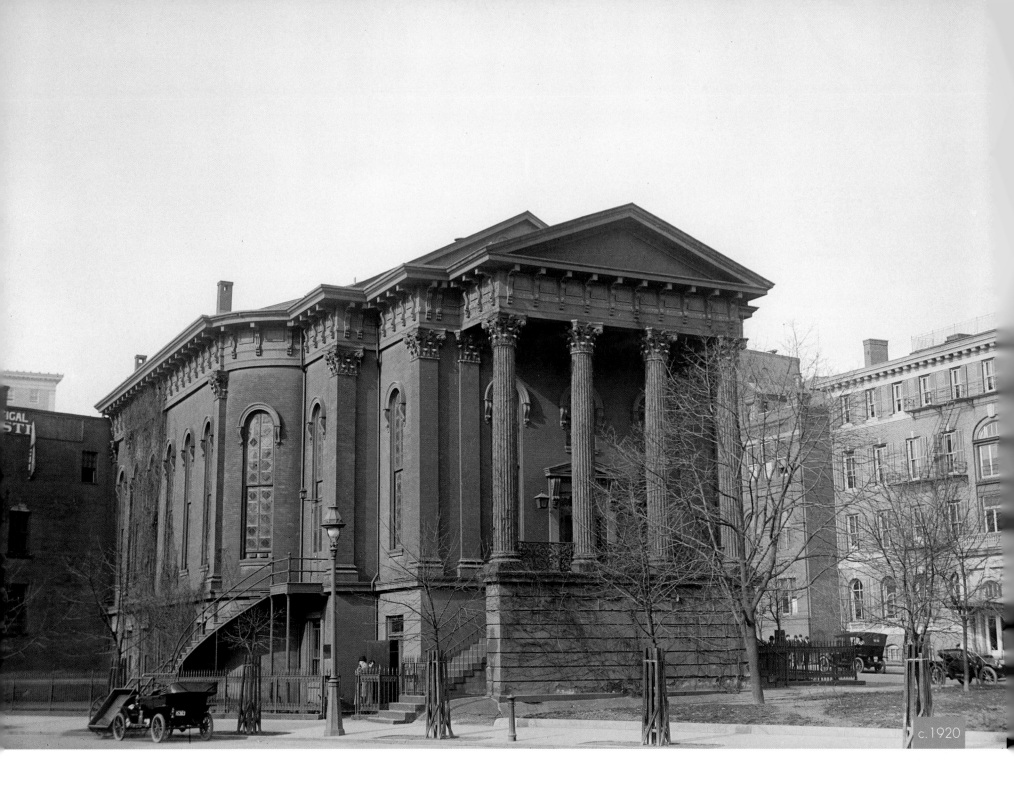

c.1920

NEW YORK AVENUE PRESBYTERIAN CHURCH
President Lincoln sought the advice of the church's chaplain, Phineas Gurley

LEFT: The church building seen here in the 1920s was built in 1860 to accommodate the merger of two congregations that trace their roots back to 1803. The New York Avenue Presbyterian Church became home to a devout group of 291 worshippers led by Dr. Phineas Densmore Gurley, who was appointed chaplain to the U.S. Senate. Gurley's Presbyterianism was derived from the old-school religion of the Church of Scotland. The new church, only three blocks from the White House, was frequented by many presidents, including—only six months after its dedication—Abraham Lincoln. Lincoln regularly sought the spiritual advice of Gurley, who was present at the president's deathbed and spoke at his funeral. The building's steeple fell during a fierce storm in 1898, and was not replaced until 1929.

BELOW: A nineteenth-century view of the church with its steeple still intact.

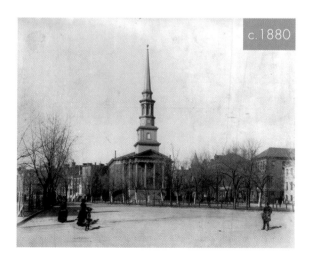

c.1880

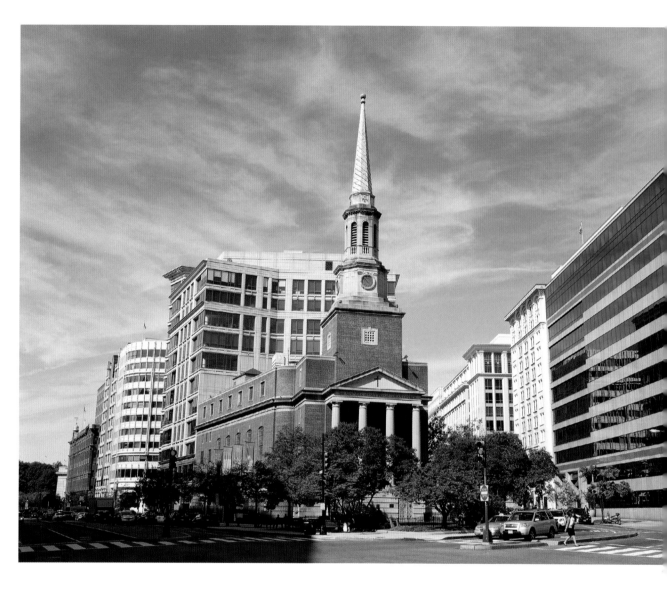

ABOVE: Although at first glance the modern view appears to show the same building, the original church was demolished by its congregation in 1950 and replaced with one that was architecturally similar but twice the size. Harry Truman laid the cornerstone. The portico is less grand, there is an extra row of windows above the pediment, and the plan of the building is flared to make the most of the triangular lot on which it sits. While the church looks like its predecessor, its surroundings have changed beyond all recognition. Downtown space is at a premium and the early residential properties have given way to ranks of tall blocks, including one on Fourteenth Street that adjoins the west wall of the church. But its third steeple and its prominent location ensure that the church remains a distinctive local landmark.

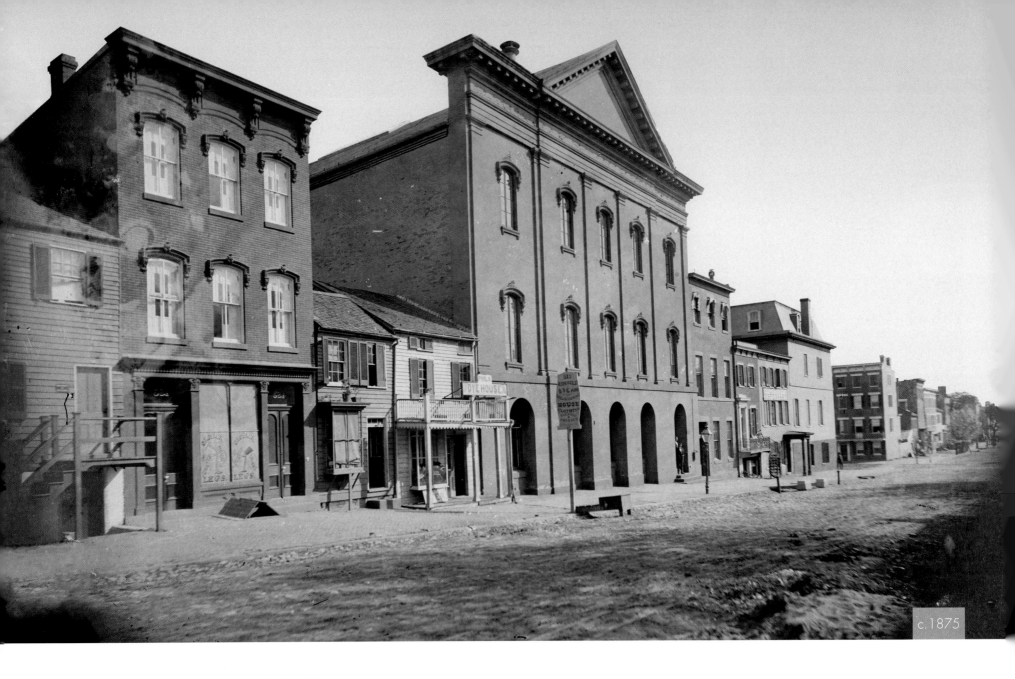

c.1875

FORD'S THEATRE
Scene of the tragic epitaph to the Civil War

ABOVE: Theater manager John T. Ford built his new auditorium in 1863 on the site of a former Baptist church on Tenth Street NW. President Lincoln was a regular patron, and his visit to Ford's Theatre on the night of April 14, 1865, was his twelfth. During the performance, of a farce called *Our American Cousin*, he was shot by actor and Confederate sympathizer John Wilkes Booth. Lincoln was rushed across the street to Petersen's Boarding House, where he died the following morning. As a result, the government bought and closed the theater, compensating Ford to the tune of $100,000 and decreeing that it should never again be used for public entertainment. Instead it found a number of government uses as a warehouse, museum, and office space; ninety clerks were injured or killed when part of the building collapsed in 1893.

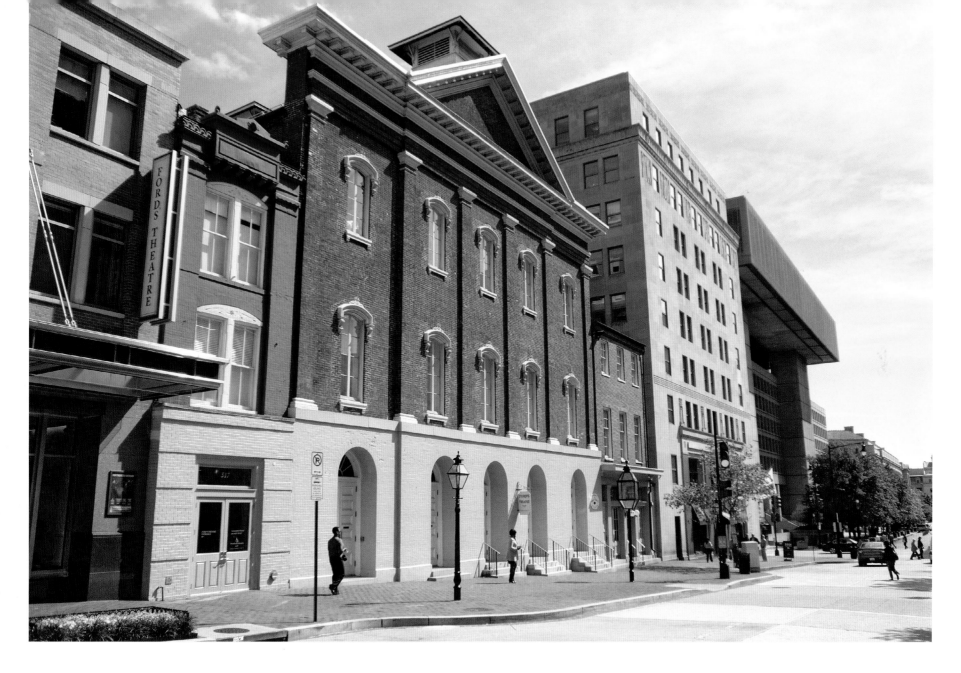

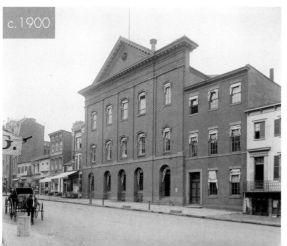

ABOVE: After two decades of cross-party lobbying in the mid-twentieth century, the building was restored as a theater and reopened with a gala performance on January 30, 1968. Among the stars celebrating the launch of the reborn venue were Helen Hayes, Henry Fonda, Andy Williams, and Harry Belafonte. It still operates as a theater today, presenting a program of new and classic drama. The building is now part of the Ford's Theatre National Historic Site, along with the Petersen House opposite it. After further renovation in 2009, it expanded into the building on its left, with improved customer facilities, including a redevelopment of its popular museum; in 2012 it opened a new Center for Education and Leadership next door to the house in which the inspirational president died.

LEFT: To the right of Ford's Theatre was the Central Free Dispensary, which opened in 1871.

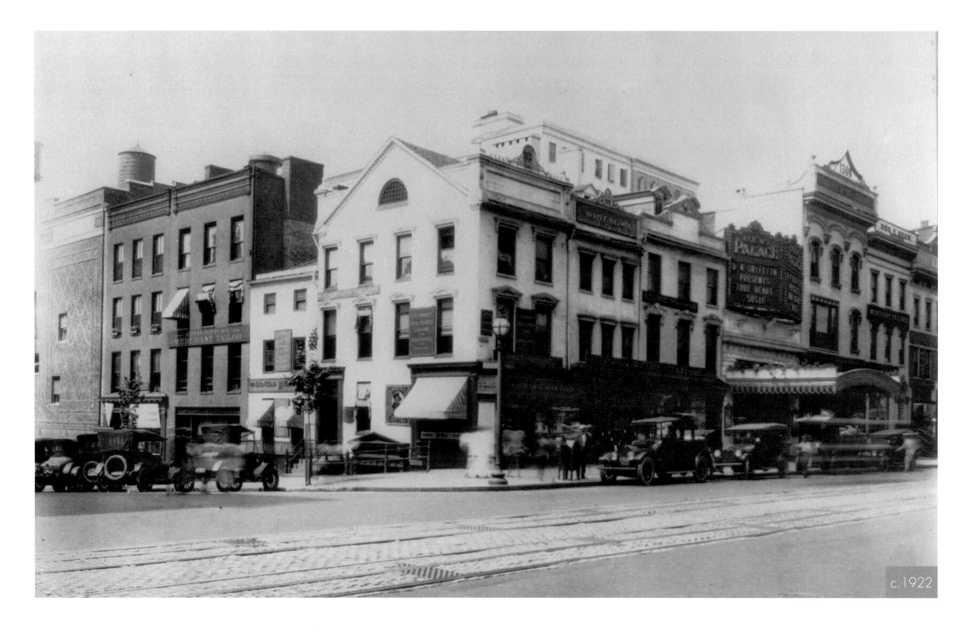

c.1922

THIRTEENTH AND F STREETS

Loew's Palace was a purpose-built movie house that diversified to present live shows

ABOVE: The junction of Thirteenth and F Streets NW, as it appeared in the early 1920s. On the corner stands the cigar store of Richard Hartley, beneath Leipold's Real Estate Loans; to its right is J. C. Wineman, tailor and cloth merchant, with the jeweler J. C. Calahan above. To the right of Wineman is R. T. Cissel, a men's shirt and nightgown maker, above whose store numerous businesses were conducted, including that of fresco and mural painter H. C. Hoether. Next is the building with the magnificent canopy covering the entire width of the F Street sidewalk, from which it's possible to date this image with some confidence. Loew's Palace was erected in 1918, Washington's first purpose-built movie theater, designed by Thomas W. Lamb. By 1926, four years after this picture was taken, the theater, one of three operated by Loew's in downtown Washington, D.C., had acquired a new facade and a huge vertical neon sign.

c.1980

c.1980

ABOVE AND BELOW: By the time these photos were taken for the Historic American Building Survey in the early 1980s, the auditorium, occupying a large lot on Thirteenth Street, had already been demolished. Only the lobby remained.

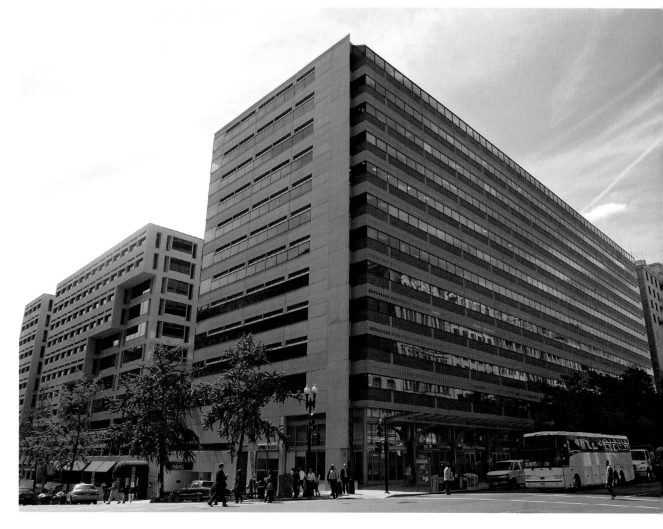

ABOVE: The year 1926 was a big one for Loew's Palace—it not only got a new sign, but began to offer live shows as well as movies, and became the first D.C. cinema to install air-conditioning. It thrived into the 1960s with continuous performances of mainstream films. A robbery and shooting on the premises in 1968 persuaded Loew's to sell the property; from the early 1970s the new owners of the theater ran a program of blaxploitation and kung fu features. Most of the small retailers alongside the theater had been redeveloped many times over by the time it finally closed in 1978. It was demolished a year later. The block still houses a rich variety of stores in the three-level upscale mall of Shops at National Place, which was developed in the 1980s.

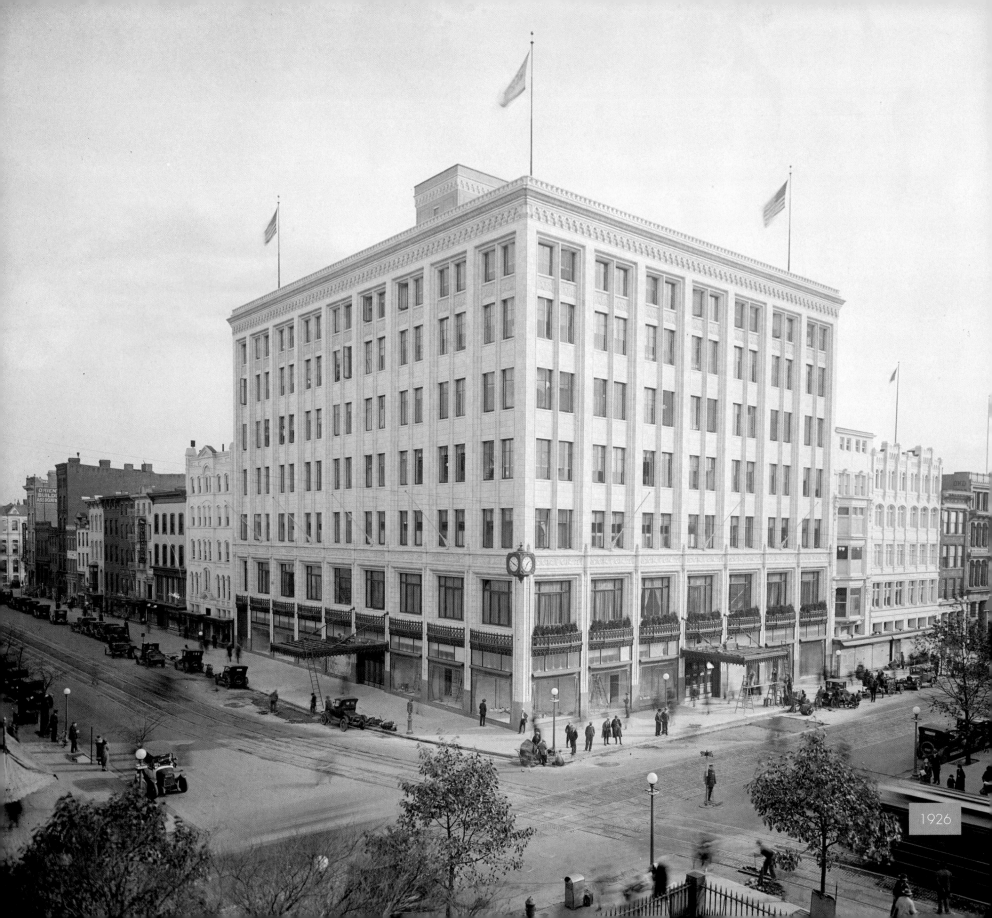

1926

HECHT'S DEPARTMENT STORE / TERRELL PLACE

A department store whose warehouse was as impressive as the store itself

LEFT AND RIGHT: Many department stores opened in the downtown commercial district in the early twentieth century, including the Palais Royal on G Street between Tenth and Eleventh Streets, which later evolved into the Woodward and Lothrop chain; Kann's on Pennsylvania Avenue between Seventh and Eighth; Dulin and Martin at 1215 F Street, which burned down in 1928; and this, the Hecht Company flagship store at the southeast corner of Seventh and F Streets NW. Built in 1926, the Art Deco glass-and-marble cube replaced the company's first D.C. store, which opened in 1896. Samuel Hecht arrived in Baltimore as a young immigrant from Germany in 1845. He scraped a living for many years as an itinerant peddler before opening his first establishment in Baltimore in 1857. The new building was the first department store in Washington with a parking garage and elevator.

BELOW: Samuel Hecht died in 1907, but the Hecht chain remained in the family until 1959. The Washington store survived controversy caused by introducing segregated dining at its lunch counter in June 1951, as Kann's had a year earlier. It was picketed every Thursday and Saturday for seven months until, as at Kann's, the policy was reversed. In 1985, under new ownership, Hecht's moved to a new building at nearby Twelfth and G Streets. The old store stood empty for the next eighteen years but was at last refurbished and reopened in 2003 as Terrell Place. It is named after Mary Church Terrell, a former leader of the National Association of Colored Women who led the antisegregation campaigns at Hecht's, Kann's, and elsewhere. Terrell Place's long-standing neighbor to the south on Seventh Street is now the privately run National Museum of Crime and Punishment.

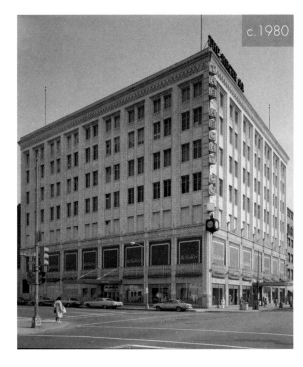
c.1980

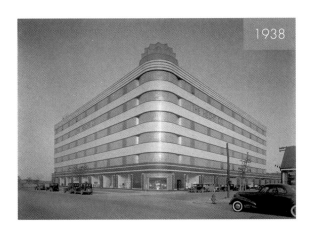
1938

ABOVE: Hecht's was committed to cutting-edge architecture: in 1937 it erected a new warehouse at 1401 New York Avenue NE, designed in the striking Streamline Moderne style by Gilbert V. Steel, which survives and still looks contemporary today.

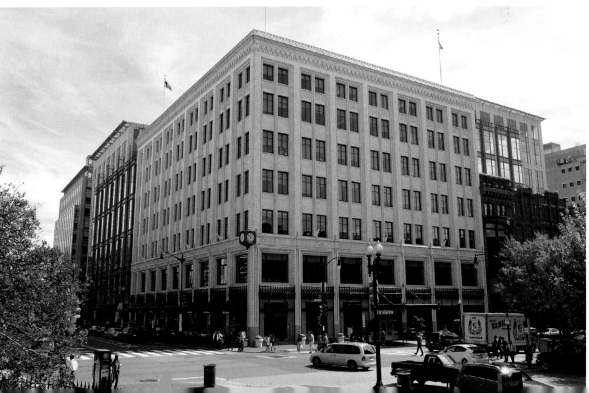

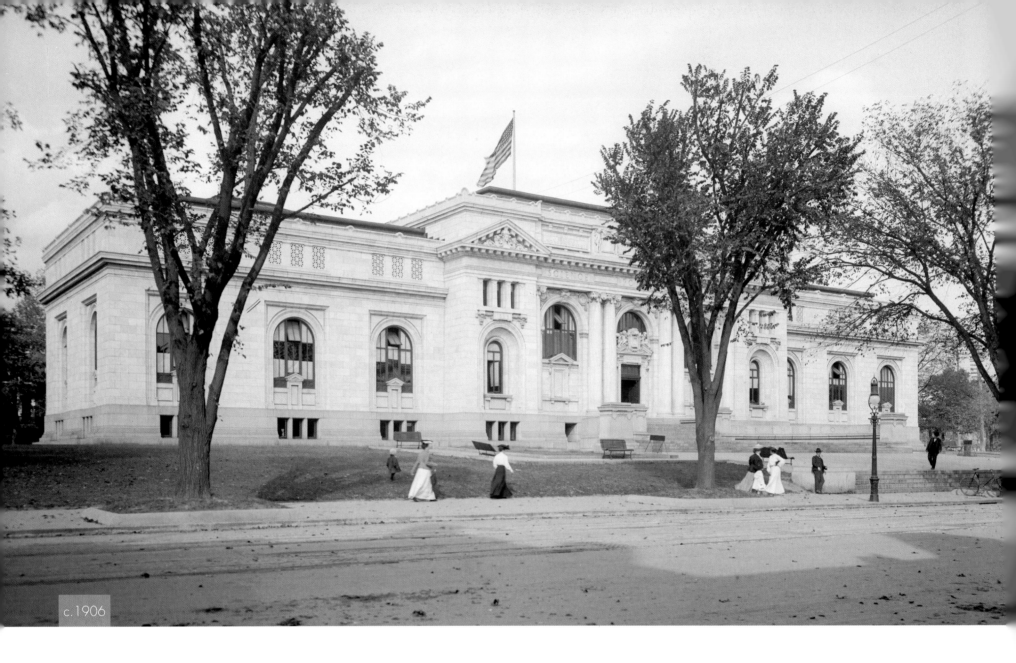

c.1906

D.C. PUBLIC LIBRARY
The grandest of Carnegie libraries, befitting its location

ABOVE: The District of Columbia Public Library in Mount Vernon Square, at the meeting of Massachusetts and New York Avenues NW, was the gift of steelmaker and philanthropist Andrew Carnegie. The grand building was built in 1903 from white marble, on the site of the old Northern Liberty Market. A public library had been established in 1896 after extensive lobbying by Theodore W. Noyes, the editor of the *Washington Evening Star* newspaper. Its original home was in a house down the street at 1326 New York Avenue NW, and the new building served as the central public library for Washington until 1972.

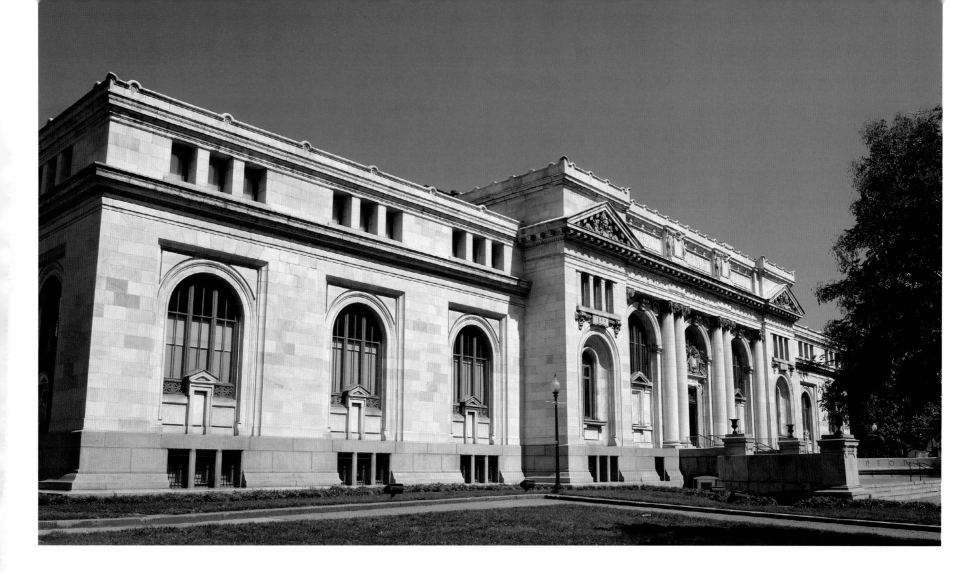

ABOVE: The library succeeded a market, a firehouse, and a building that housed the Walker Sharpshooters.

ABOVE: In 1972 the library moved to new premises designed by one of the masters of modern architecture, Ludwig Mies van der Rohe. Dedicated to Martin Luther King Jr., the new library was Mies's last commission, and he died before its completion. The old building became the Carnegie Library for the University of the District of Columbia, an institution formed by the merger of three local colleges in 1976. It now houses the Historical Society of Washington, D.C. Their attempt in 2003 to create a modern interactive museum in the old Beaux-Arts building foundered because of low visitor numbers, but they continue to mount temporary exhibitions about the city's past.

ANDREW CARNEGIE

It is said that the Carnegie Steel Company in Pittsburgh made its owner the second-richest man in history after John D. Rockefeller. Scottish-American industrialist Andrew Carnegie worked his way up from his first job as a bobbin maker, and he never forgot the value of his early Scottish education as he rose to the top. He endowed his first library in his hometown of Dunfermline in 1883. By the time of his death in 1919, there were 2,509 Carnegie Libraries in Europe, America, and Australasia. Of these, 1,689 were in the United States—almost half of all the country's libraries—and five were in Washington, D.C. Many bore the inscription by which Carnegie lived: "Let there be light."

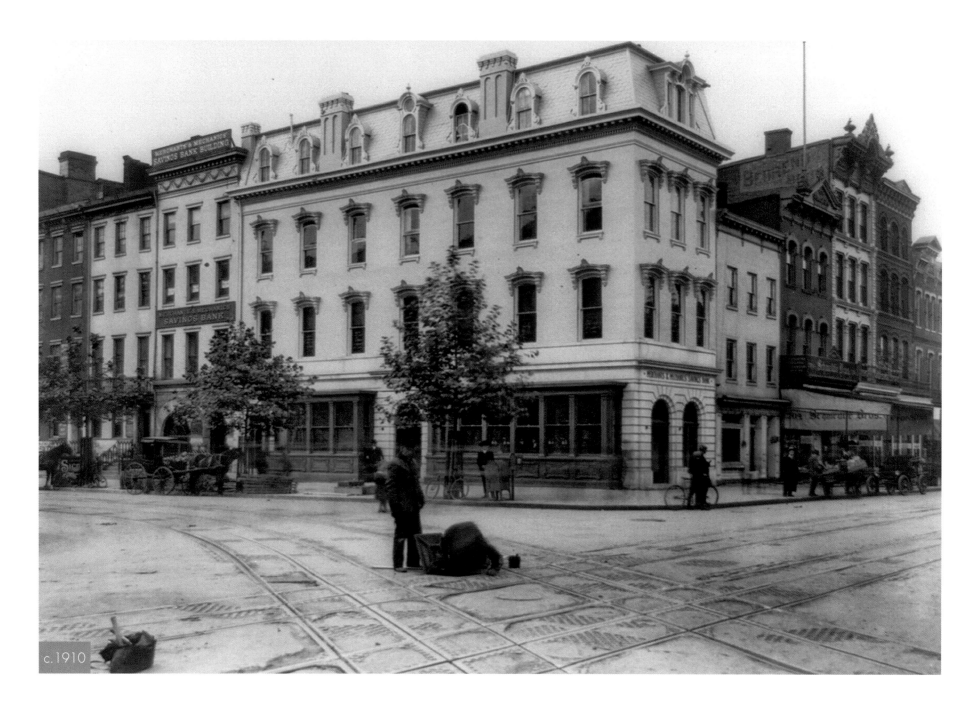

c.1910

SEVENTH AND G STREETS

Enjoying a resurgence in business after lying vacant for many years

LEFT: Across G Street NW from the U.S. Patent Office, the Merchants and Mechanics Savings Bank (M&MSB), located in offices completed in 1865, anchored a block of commercial establishments in the Seventh Street shopping district. It was a handsome building, its mansard roof immediately evoking then-popular Second Empire French architecture. It was a typical scene in 1910, when this photograph was taken and when much of downtown Washington looked like this—a mixture of grand corners and more modest businesses. Seventh and G was a busy crossroads for streetcars, and the two gentlemen in the foreground are working on running repairs for the transportation network's underground electrical conduits. In 1910 modern mass transit still competed for street space with hand-pulled carts, bicycles, and horse-dawn carriages.

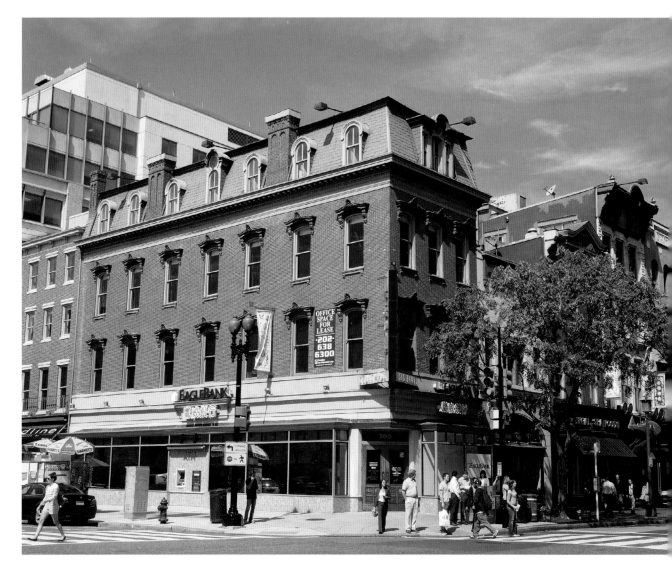

ABOVE: In 1969 the Historic American Building Survey noted: "This brick building is typical of those erected for commercial use immediately after the Civil War. Three stories high plus a mansard roof, it faces east along a frontage of twenty feet (three bays), and south along seventy feet (seven bays)." Loeb's women's wear occupied it at the time.

ABOVE: Although at street level many of the buildings on this corner have been substantially altered over the years, the upper floors along this stretch of Seventh Street are remarkable survivors. The grand stone arches of the old M&MSB building are long gone, and it has seen a variety of occupants: ladies' outfitters the Loeb Company in the 1960s, and later Kent's, a jewelry store that closed down in the early 1990s when the MCI Center opened across Seventh Street. By the end of the century almost the entire block was vacant, but the area has seen a revival led by galleries, museums, and two nearby theaters (Ford's and the Shakespeare). Once again a bank occupies the corner spot, and the three tall buildings on the right of the old photograph are now home to a seafood restaurant.

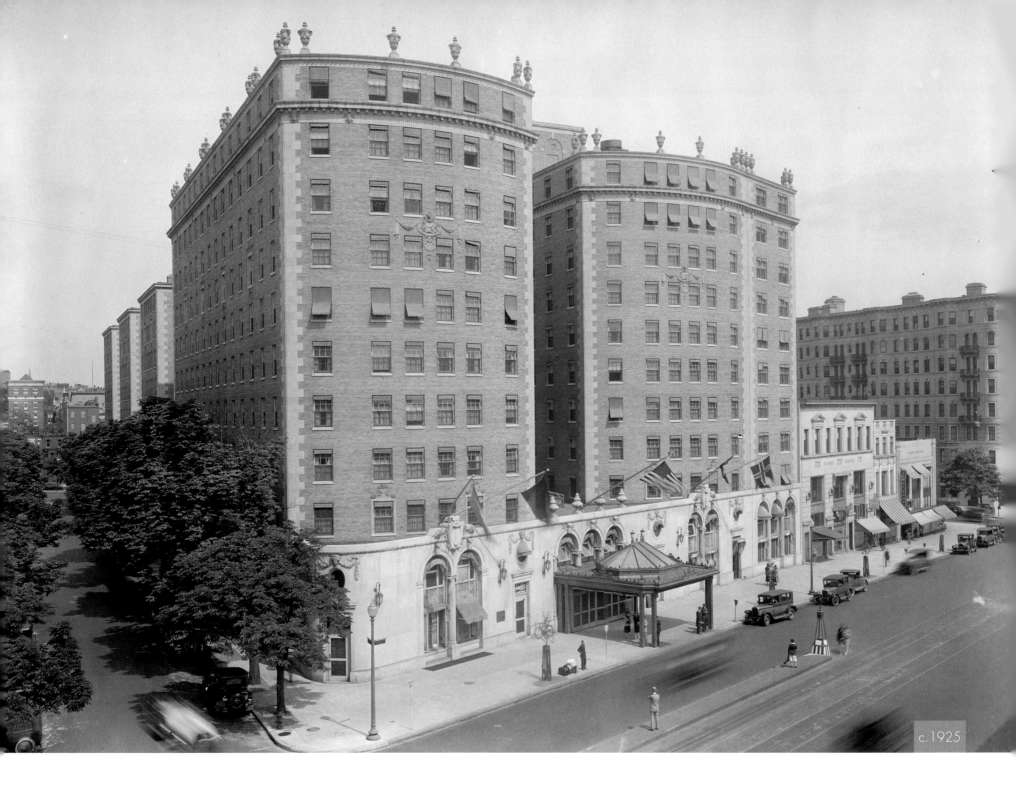

c.1925

MAYFLOWER HOTEL
"The second-best address in Washington"

LEFT: Located on the corner of Connecticut Avenue and DeSales Street NW, the Mayflower Hotel opened on February 18, 1925, with the inaugural ball of President Calvin Coolidge. Coolidge himself did not attend, but the Mayflower has continued a tradition of hosting Inauguration Day balls ever since. The largest hotel in Washington, it was said at the time to have more gold decoration than any building except the Library of Congress. DeSales Street takes its name from St. Francis de Sales, the founder of an order of nuns called the Sisters of the Visitation. The sisters owned the land on either side of the street. Where the Mayflower now stands was once the site of their convent and school, an 1876 redbrick complex in the Gothic Revival style by German-American architect Adolph Cluss. The convent and school were demolished in 1923 to make way for the hotel.

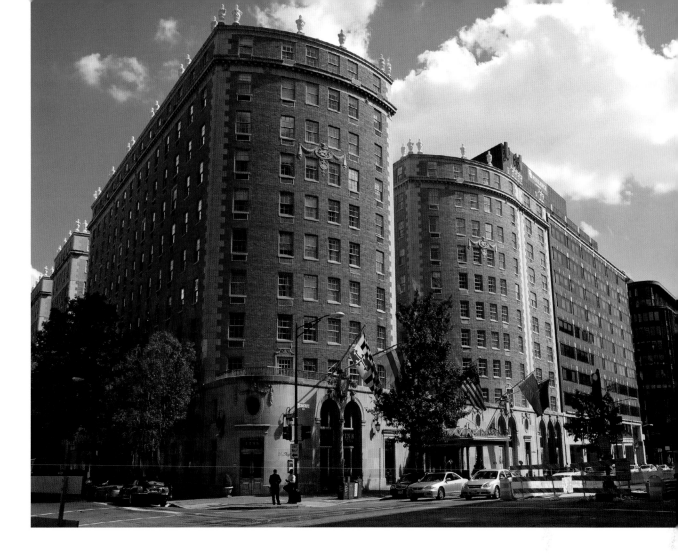

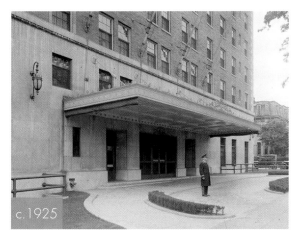

ABOVE: A doorman waits at the rear entrance of the Mayflower Hotel.

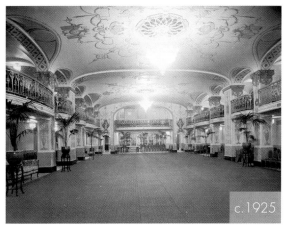

ABOVE: The elegant ballroom of the Mayflower.

ABOVE: Over the years, the fortresslike Mayflower has been the temporary home of many important residents of the nation's capital, including several vice presidents, cabinet members, Supreme Court justices, senators, and representatives. Harry Truman dubbed it the second-best address in Washington after he stayed there while the White House was being renovated. Now the Renaissance Mayflower Hotel and part of the Marriott chain, the hotel's rooms have also seen their share of presidential scandals. With high-powered guests on their doorstep, it's easy to understand why, farther down DeSales Street, the building opposite the Mayflower is the Washington bureau of ABC News.

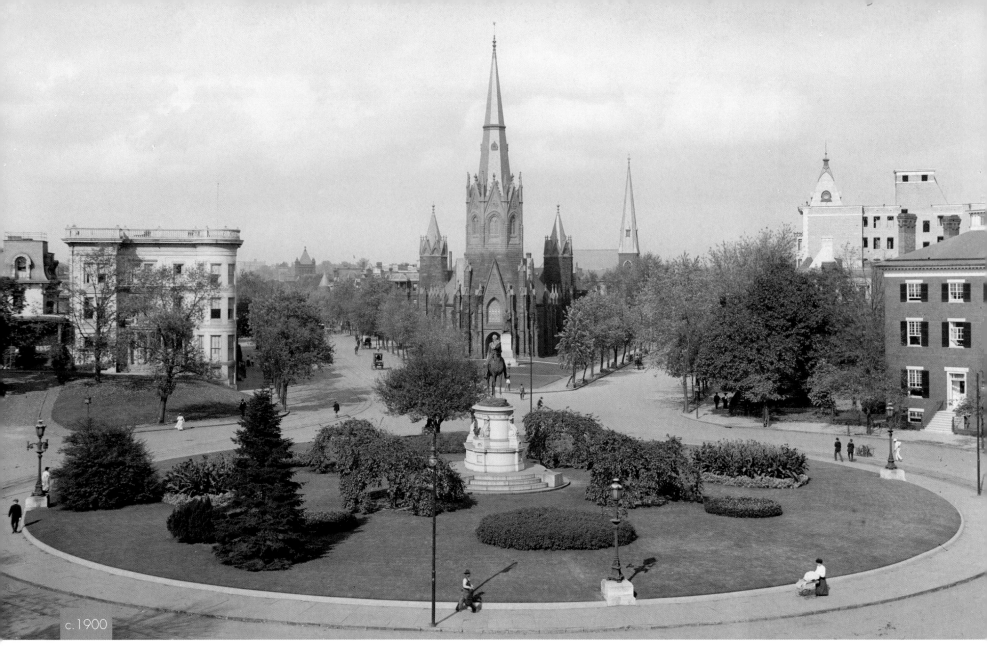

c.1900

THOMAS CIRCLE

Named for the Union general who was nicknamed "the Rock of Chickamauga"

ABOVE: L'Enfant's original plan for Washington designated certain blocks as the sites for monumental public buildings. He also envisaged monuments or statues in every public square, to be erected by the states in recognition of military achievements or leaders who "were conspicuous in giving liberty and independence to this country." Thomas Circle takes its name from the subject of the equestrian statue at its center. George Henry Thomas, sculpted for this site by John Quincy Adams Ward in 1879, was a major general in the Union army. The Luther Place Memorial Church behind the statue, framed by Fourteenth Street and Vermont Avenue NW, was built in 1870 as a memorial to the end of the Civil War. This view was captured circa 1900 from the Portland, the first apartment building in Washington, which was erected the same year as Thomas's statue.

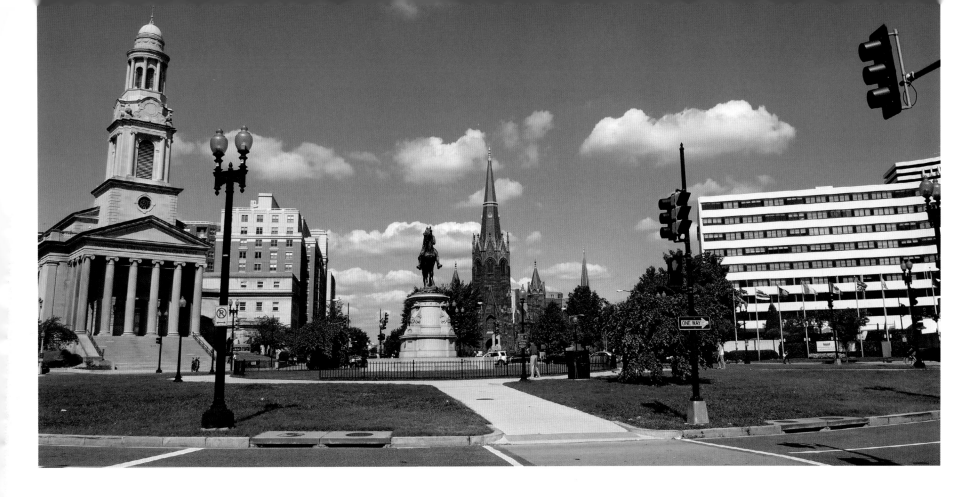

BELOW: Even by the 1920s, the church that now dominates Thomas Circle had yet to arrive, while the Thomas statue was gradually being obscured by the four surrounding ornamental cherry trees.

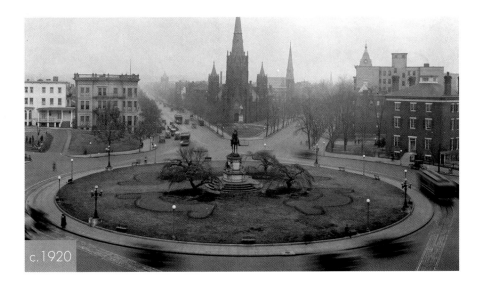

c.1920

c.1920

TREW MOTOR COMPANY / STUDIO THEATER
A dealership at the heart of "Automobile Row"

ABOVE: The Trew Motor Company showroom was located on the northeast corner of Fourteenth and P Streets, at 1501 Fourteenth Street NW. The building was designed by the architectural firm Murphy and Olmstead, in an industrial style with concrete finished in tapestry brick. On completion in 1920, it served as a showroom for the Trew Motor Company, a distributor for the REO and Peerless automobiles. The building later functioned as the Petrovich Auto Repair Shop. The area along Fourteenth Street NW was known as "Automobile Row" for its many car dealerships. The building is designated as a contributing property to the Greater Fourteenth Street Historic District, and was listed on the National Register of Historic Places in 1994.

ABOVE AND BELOW: These photos from around 1915 show the latest top-of-the-line REO automobiles on display in Joseph Trew's dealership. In 1915 REO introduced the famous Speedwagon, which would stay in production until 1953.

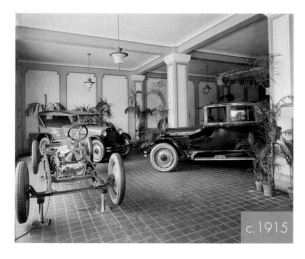

ABOVE: In 1978 the building was acquired by director Joy Zinoman and designer Russell Metheny, who turned it into a nonprofit theater production company. It was renamed the Studio Theatre; the ground level was converted into the 200-seat Mead Theatre, and the upper level was renovated into office space and classrooms. This four-stage complex presents eclectic and provocative plays. The Studio Theatre specializes in productions that emphasize the intimate relationship between the actors and the audience.

1905

DUPONT CIRCLE

Admiral Du Pont's family believed his statue was being neglected, so they took it to Delaware

ABOVE: The meeting of Massachusetts, New Hampshire, and Connecticut Avenues with P and Nineteenth Streets NW was named Pacific Circle in the plans of Pierre Charles L'Enfant. The area boasted only a slaughterhouse and a brickyard until after the Civil War, when grand mansions began to spring up along Massachusetts Avenue NW. Toward the end of the nineteenth century, this district of wealthy villas also included an area known as the Strivers' Section, inhabited by the emerging middle class of African American community leaders. In 1882 Pacific Circle became Dupont Circle, and two years later a statue was erected to Civil War hero Admiral Samuel Francis Du Pont. The admiral was a member of the powerful Du Pont family, whose chemical works had supplied half the gunpowder used by the Union side during the war.

c.1900

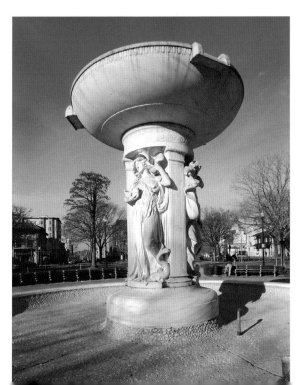

LEFT: Civil War hero Admiral Samuel Francis Du Pont (1803–1865), sculpted by Launt Thompson.

BELOW LEFT: The replacement memorial was dedicated in May 1921, a fountain made from three allegorical figures.

ABOVE: In the early twentieth century the Du Pont family became concerned about the statue's neglect and removed it to Rockford Park in their hometown of Wilmington, Delaware, in 1920. In its place they commissioned Daniel Chester French and Henry Bacon, fresh from their work on the Lincoln Memorial, to design a marble fountain (left) with allegorical figures of the sea, stars, and wind. It was dedicated in 1921, when the area around the circle, particularly on Connecticut, was becoming more commercial in character. The fortunes of the Dupont Circle neighborhood fell in the wake of World War II, and again after the race riots of 1968. It was colonized in the 1970s by a more bohemian population, including Washington's lesbian and gay community. Today the colorful and constantly changing district has gone upscale again, with fashionable shops and restaurants and, since 1997, a weekly farmers' market. It is also the location for numerous embassies, many housed in those early Du Pont mansions.

115

c.1950

WASHINGTON NATIONAL CATHEDRAL
L'Enfant's plan for a great church was ignored for a century

ABOVE: The Cathedral Church of St. Peter and St. Paul, better known as the Washington National Cathedral, sits on Mount St. Alban, one of the highest points in Washington. The inclusion of a "great church for national purposes" had been part of Washington's plan from the start, and in 1791 L'Enfant allocated the land now occupied by the National Portrait Gallery for the purpose. Nothing was done, but a century later the idea of a national church was revived. Reverend Henry Y. Satterlee, Washington's first bishop, drove the idea forward,

and in 1907 President Theodore Roosevelt laid the foundation stone. It had been brought from Bethlehem, symbolically set in American granite, and carved with the text of John 1:14, "The Word was made flesh and dwelt among us." Bethlehem Chapel was opened for worship within the unfinished building in 1912. The construction of the cathedral itself became one of the longest projects in Washington's history; this early view from the east of the apse with its flying buttresses conceals the incomplete nave.

1912

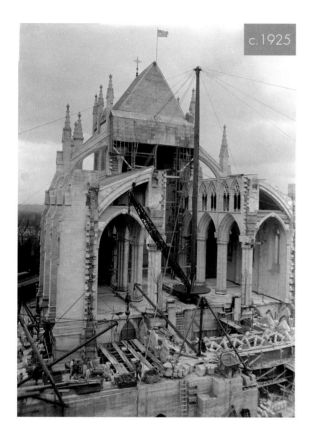

c.1925

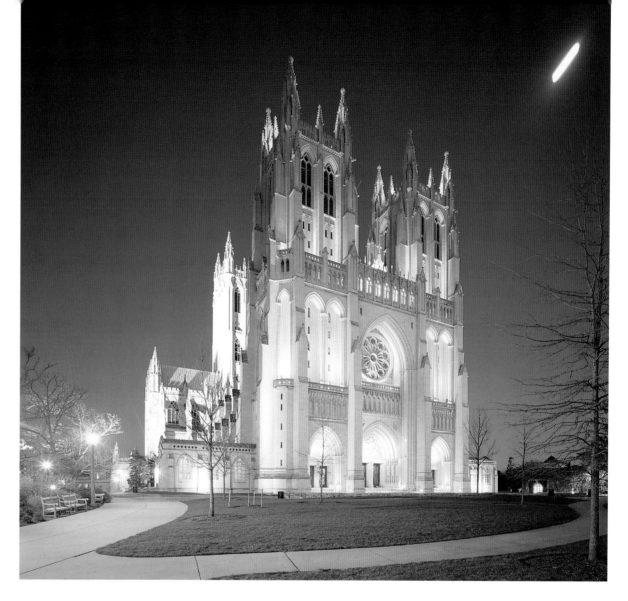

RIGHT: The nave and the rose window of the west front were finally dedicated in a 1976 ceremony attended by President Gerald Ford and Queen Elizabeth II. Not until 1990 was the building considered complete with the addition of the two west towers, making the floodlit view of this modern photograph a possibility. Stonemasons are still at work today. The task of carving the cathedral's Gothic detail has been increased as a result of damage sustained from the 2011 Virginia earthquake. The twentieth-century building owes

ABOVE: Progress on the cathedral was slow; this is a view of construction from April 1925.

LEFT: The Peace Cross at the cathedral in 1912. Behind it and to the left, the Washington Monument is visible.

its fourteenth-century appearance to its British architect, George Frederick Bodley. An important figure in the English Gothic Revival movement, Bodley died only a month after the laying of the Washington foundation stone. But his pupil Henry Vaughan (who died in 1917) and Vaughan's successor, Philip Hubert Frohman, ensured that Bodley's vision was realized. Both Vaughan and Frohman are buried in the cathedral. The funeral services of four U.S. presidents have been held here, although Woodrow Wilson, whose tomb stands within its walls, is the only president to be buried in Washington.

THE ST. ALBANS CONNECTION

The land chosen for the National Cathedral was named after the city of St. Albans in Hertfordshire, England, the birthplace of Joseph Nourse, who owned the plot in the early nineteenth century. It was a bequest from Nourse's granddaughter that, in 1854, funded the first small wooden church on the land, dedicated to St. Alban, a second-century Christian martyr. A more permanent stone structure now stands in the shadow of its grander neighbor, and St. Alban's is a flourishing parish congregation.

1868

SCOTT HALL
A building that has been transformed from Italianate to Second Empire to Gothic Revival

1900

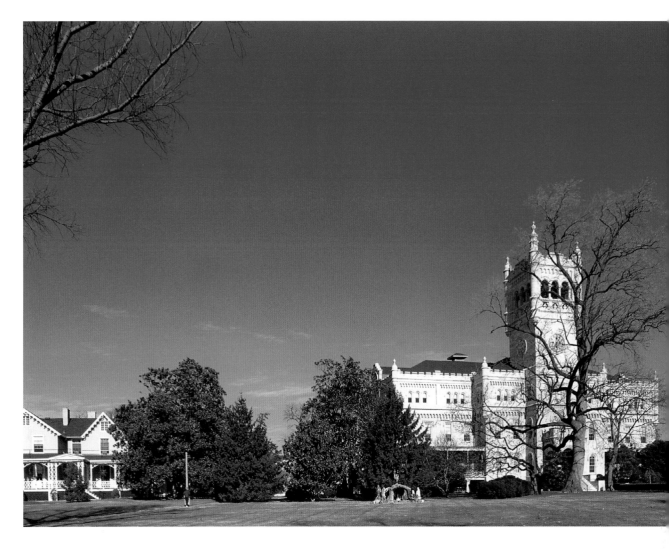

LEFT: In 1851, after the Mexican-American War, Congress approved the establishment of a soldiers' home for retired and injured servicemen. The government purchased a stretch of countryside northeast of Washington from banker George Washington Riggs (who later founded Riggs National Bank), and the first building to be used by the new institution was Riggs's cottage. Riggs—and several presidents, including Lincoln—used to seek refuge there in the summer from the stifling heat and humidity of the city in the days before air-conditioning. Scott Hall was the first purpose-built accommodation on the site, constructed in stages between 1851 and 1868. It was funded by a payment that General Winfield Scott had received from Mexico in return for not ransacking the country. The building was originally completed in the Italianate style but was remodeled with a Second Empire mansard roof in 1868.

ABOVE: Scott Hall's Gothic Revival modifications from 1890 make it look like an entirely different building than its predecessor.

ABOVE: In 1890 Scott Hall's mansard roof was replaced by a more robust third floor of stone. The central tower, which had served as a lookout post during the Civil War, was now completed by a grandiose balcony, as the building was totally remodeled in the Gothic Revival style. It suffered damage during the 2011 Virginia earthquake, the worst U.S. quake east of the Rockies since records began in 1897. The building has been joined by many others in the modern complex now known as the U.S. Soldiers' and Airmen's Home. It is maintained, along with the U.S. Naval Home in Gulfport, Mississippi, by a coordinating organization, the Armed Forces Retirement Home. Almost 1,300 now live on the site that, despite having long since been swallowed up by the advancing suburbs of Washington, boasts its own golf course and fishing lake. The home is a total-life retirement community for military personnel who have been injured or who have served for at least twenty years.

119

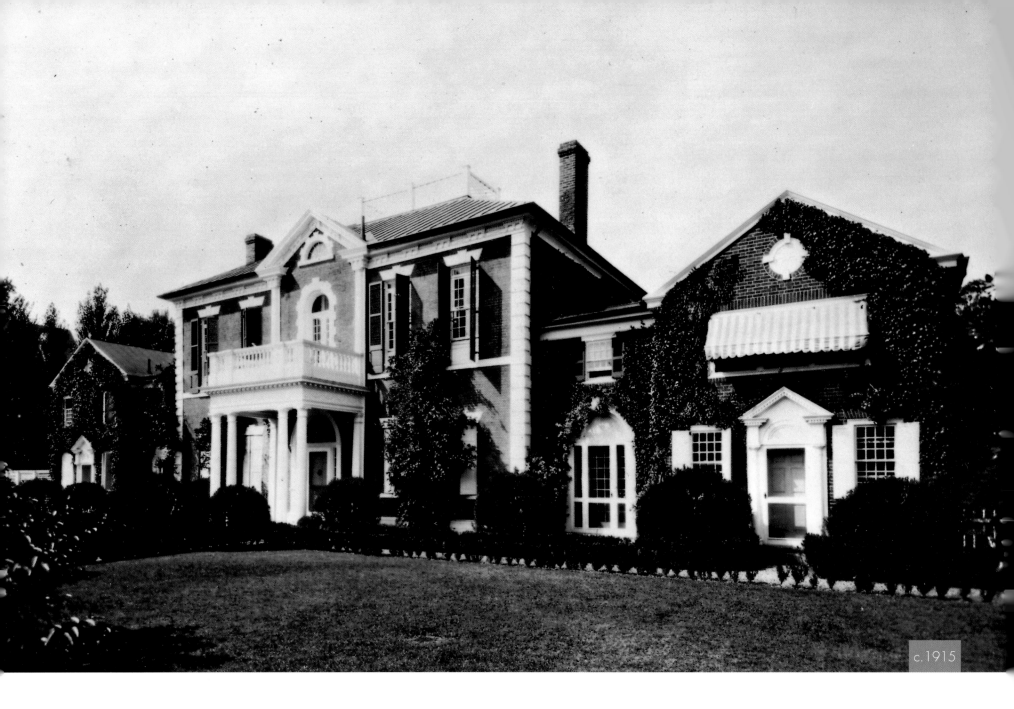

c.1915

DUMBARTON HOUSE
One of the first grand houses to rise on the heights of Georgetown

ABOVE: Built in 1799 by Samuel Jackson and originally called Bellevue, this house was one of the first of what would be many grand houses to rise on the heights of Georgetown overlooking the Potomac. The property changed hands many times before and after the house was built, in the rapid real estate speculation surrounding the founding of the federal city. During the War of 1812 it was owned by Charles Carroll, who evacuated Dolley Madison to this house when the British burned the White House in 1814.

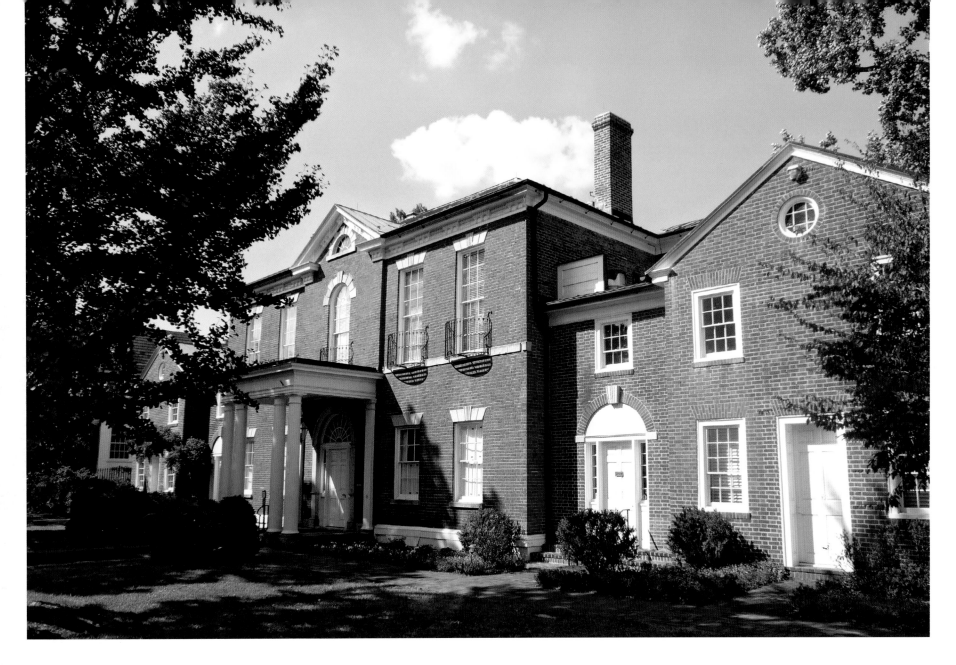

ABOVE: Moved slightly from its original spot in 1915 to allow for the extension of Q Street, the Dumbarton House at 2715 Q Street is now preserved as a museum and the headquarters of the National Society of the Colonial Dames of America.

LEFT: A painting by George Beck entitled *George Town and Federal City, or City of Washington* dates from 1801, around the time that Bellevue (Dumbarton House) was being built.

POTOMAC RIVER
Dominated by the spires of Georgetown University

RIGHT AND BELOW: The sightseeing launch *Bartholdi* steams upriver past Georgetown University in this photograph from the turn of the last century. Founded in 1789, Georgetown was the first Catholic university in the United States. The tall spires on the skyline are those of Healy Hall, the centerpiece of the campus, completed in 1879 and designed in the Romanesque style by Paul Johannes Pelz and John Smithmeyer. The pair were later responsible for the Beaux-Arts design of the Library of Congress. On the narrow north shore below the university, two transportation systems jostled for position. The Chesapeake and Ohio Canal followed the Potomac River for 190 miles, connecting the Washington City Canal to Cumberland, Maryland. Alongside it ran the Washington and Great Falls Electric Railway, a trolley service that never actually reached either destination. But a five-cent ticket took one from Georgetown to Cabin John via the popular amusement park at Glen Echo.

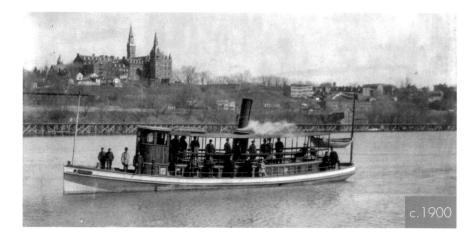

c.1900

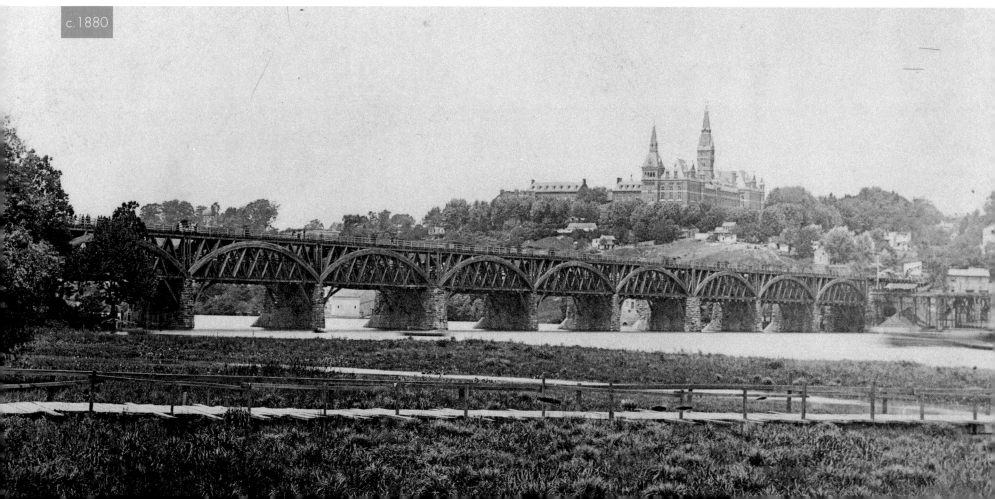

c.1880

BELOW: The Georgetown campus has expanded greatly over the years, although Healy Hall (seen at right in 1904) still dominates the skyline. The large modern building to its right is a library dedicated to Georgetown University alumnus Joseph Mark Lauinger, who died in Vietnam during its construction. Behind the trees along the shoreline, the trolley tracks are gone; a four-lane highway, Canal Road NW, connects Georgetown to the northwestern suburbs. The building in the center at the water's edge is the clubhouse of the Washington Canoe Club, which was formed in 1904 by canoeists who broke away from the Potomac Boat Club a hundred yards downstream. Between the two stood Aqueduct Bridge, shown in the earlier picture, which carried a branch of the Chesapeake and Ohio Canal and later a roadway across the river to Rosslyn. It was demolished in 1933 after the construction of the Francis Scott Key Bridge just to the right of the modern view.

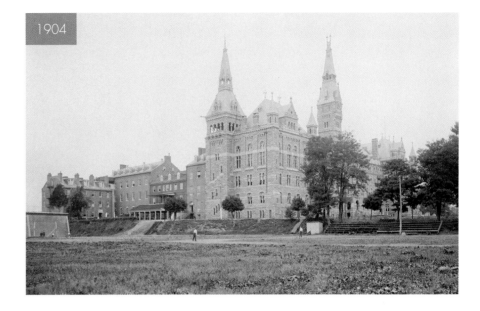

1904

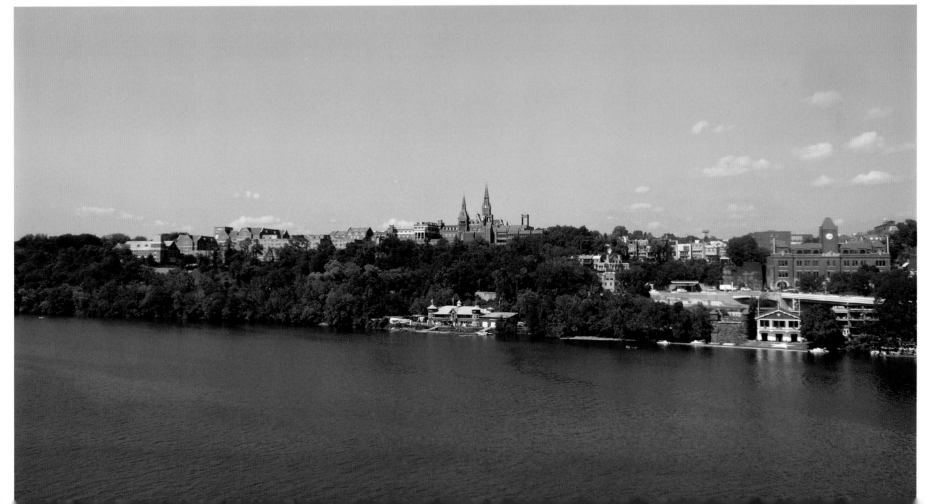

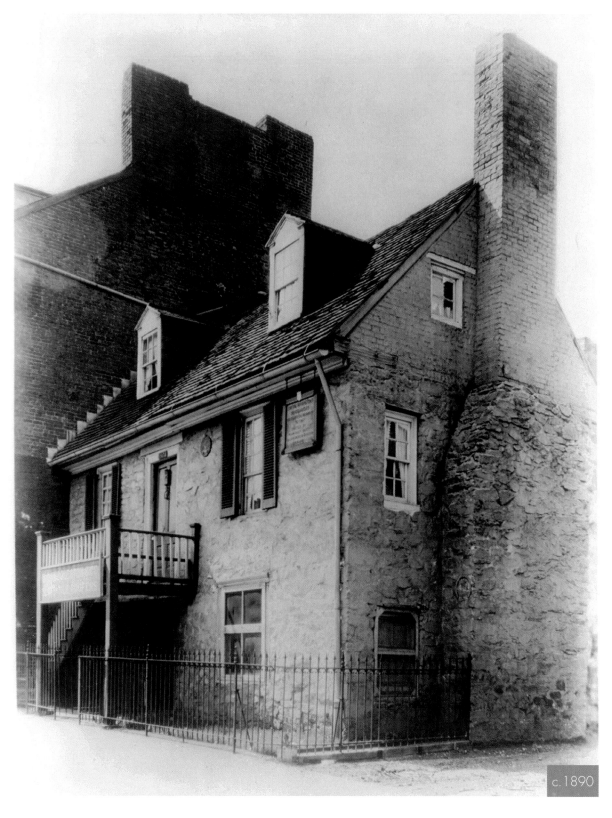

c.1890

OLD STONE HOUSE

A building from colonial days

LEFT: Built around 1765 by cabinetmaker Christopher Layman, this six-room stone house at Jefferson and M Streets NW is regarded as the oldest (and only pre-Revolution) building in the district. The house was originally a single-room structure that served as a carpentry shop and home for Layman and his family, on what was then known as Bridge Street. Layman died soon after the house's construction, and it was sold in 1767 to Cassandra Chew, a wealthy widow who added the upper floors and a kitchen to the rear. A story persisted for many years that the house was the location for George Washington's meeting with Pierre Charles L'Enfant at which the new city's layout was planned. This photo shows clearly the sign that hung for many years identifying the house as "George Washington's Headquarters." This urban myth certainly saved the building from demolition.

RIGHT: For nearly two hundred years, the Old Stone House continued as a private property in residential and commercial use; occupants included tailors, clock makers, and even a used-car dealer. The National Park Service bought the building in 1953. It was part of the George Washington Memorial Parkway until research finally established that Washington and L'Enfant actually met elsewhere, in a tavern run by a certain John Suter. Suter lodged at the Old Stone House, but there is no evidence that either Washington or L'Enfant ever set foot there. Today the building serves as a rare museum to the modest lifestyles of ordinary colonial Americans, so often overlooked in the bigger picture of the nation's history.

ABOVE: One of the restored rooms in the Old Stone House displays a range of carpentry tools from colonial times.

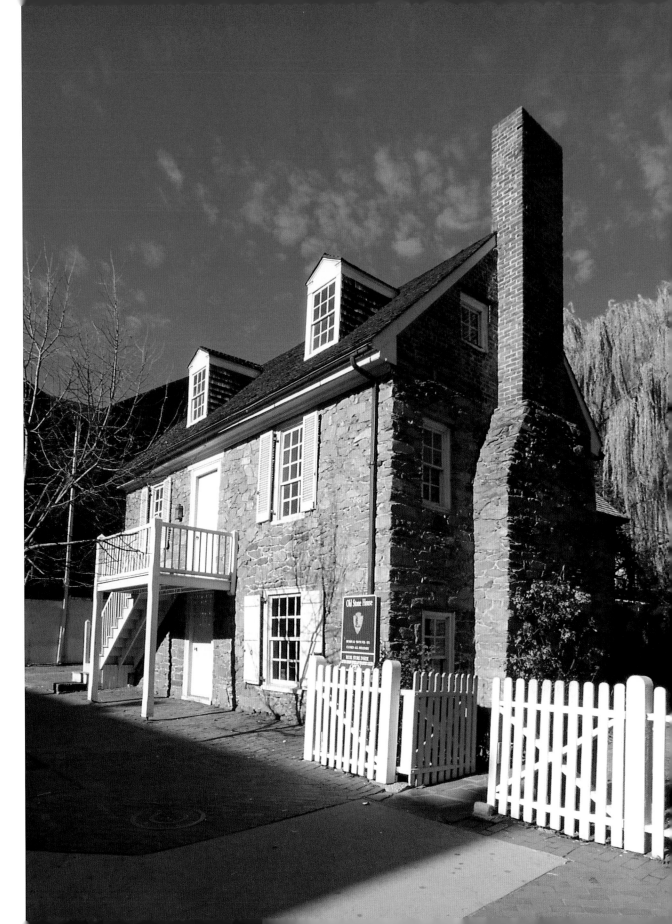

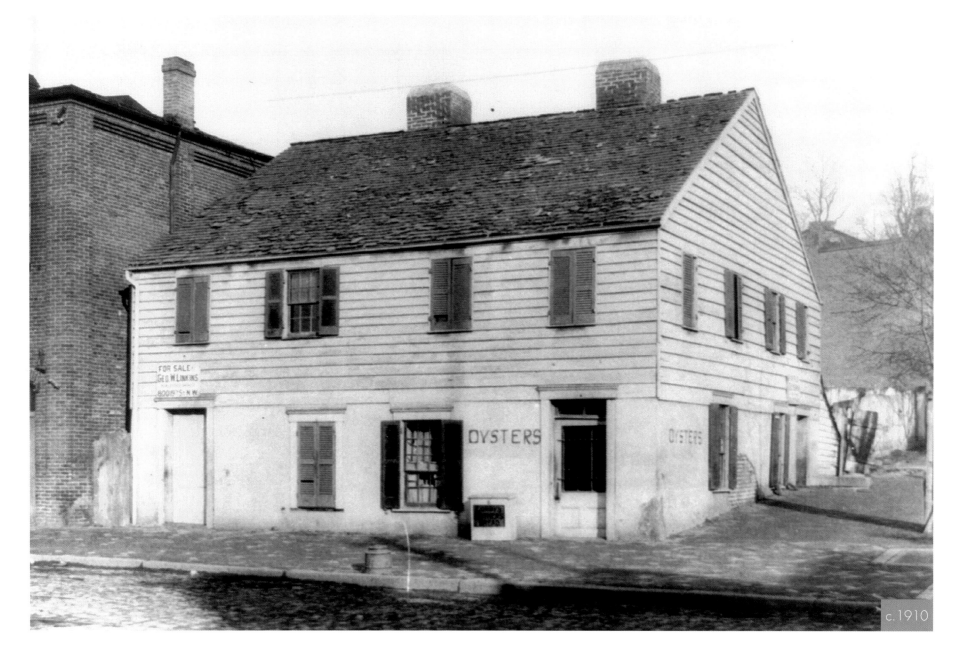

c.1910

SUTER'S TAVERN
The site of a historic tavern that hosted a key meeting in D.C.'s history

ABOVE: On March 30, 1791, the owners of the properties that would become the District of Columbia met with George Washington at Suter's Tavern in Georgetown. They agreed to sell their land to the government for $66.67 per acre and the ownership of half the building lots in the new city. Unfortunately, the exact location of this tavern has been lost to the ages. This particular colonial-era tavern at Thirty-first and K Streets, said to be a leading contender because it vaguely matched later drawings of the building, was demolished in 1931 to make way for an incinerator.

ABOVE: The site now sits in the shadow of the elevated Whitehurst Freeway, built in 1949. The incinerator itself closed in 1971, and as the twentieth century came to a close, the location was part of the last undeveloped plot of land in Georgetown, designated as the site of a $150 million luxury hotel, shopping center, and twelve-screen theater complex. Ironically, the incinerator with its 163-foot smokestack, a source of fumes and derision over the decades, was then the subject of preservation efforts due to its Art Deco architecture.

CABIN JOHN BRIDGE

Linking Washington with the Cabin John Reservoir

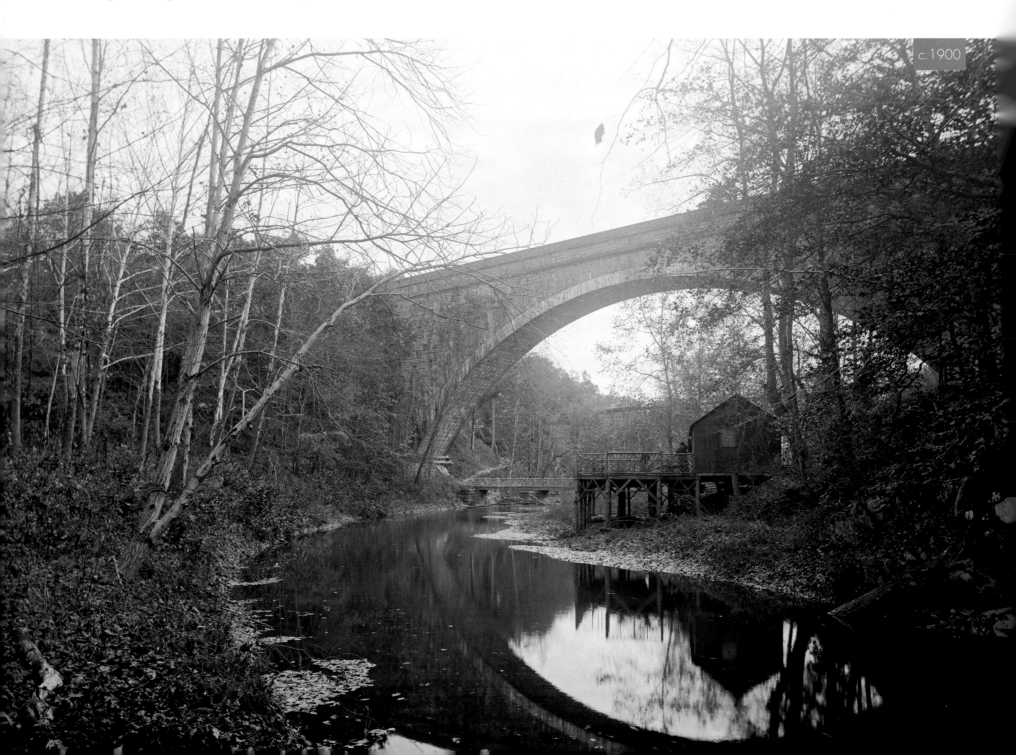

c.1900

LEFT: This massive stone-arch bridge, also known as the Union Arch, was built between 1853 and 1864 by Montgomery C. Meigs as part of the water-supply aqueduct that provided Washington with water from the Cabin John Reservoir. With a clear span of 218 feet, it was the longest stone-arch span in the world for forty years. The photograph dates from about 1890.

BELOW RIGHT: Today the bridge carries one lane of MacArthur Boulevard over both Cabin John Creek and the parallel Cabin John Parkway (atop the tall wall to the left), connecting with the nearby Capital Beltway (I-495). The formerly pastoral location of the earlier photo is now all but inaccessible beneath the parkway and the additional water aqueduct in the foreground.

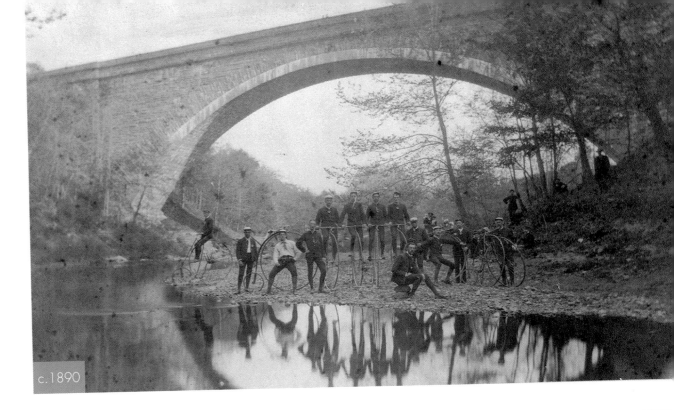

c.1890

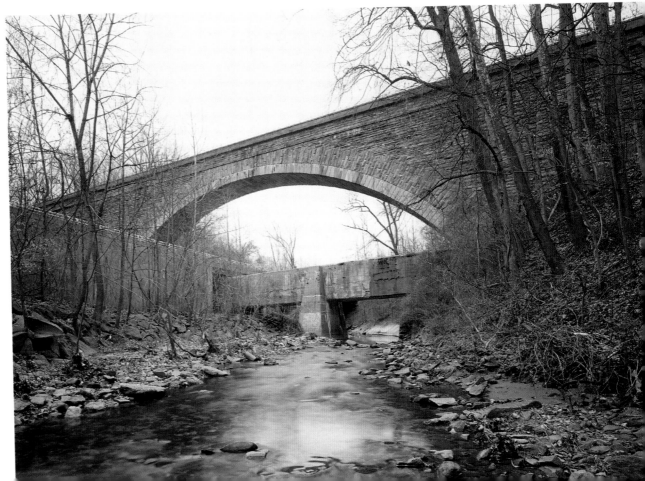

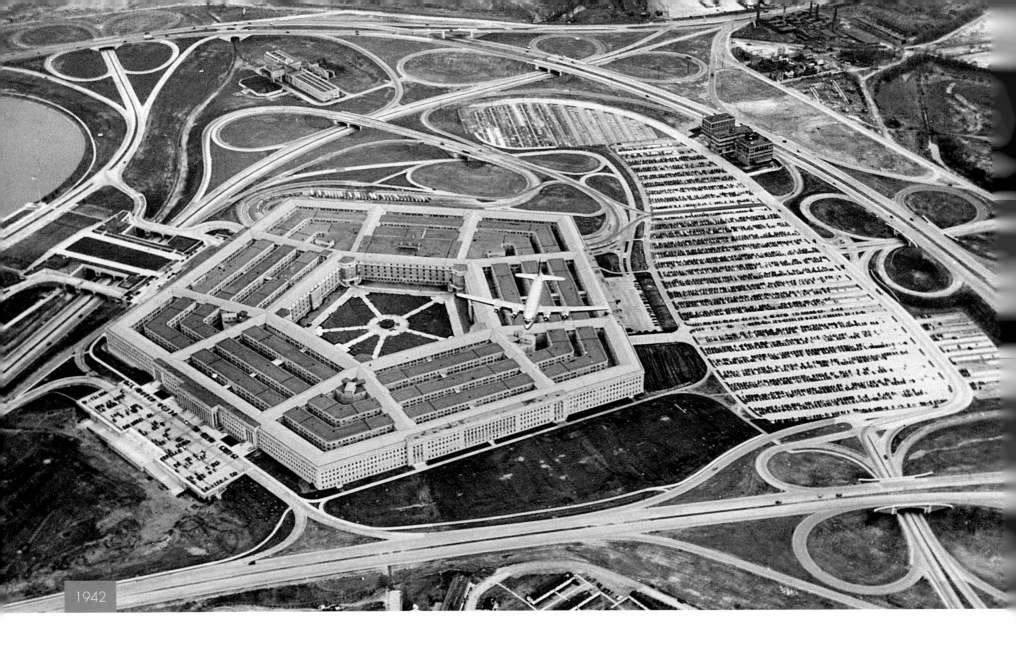

1942

THE PENTAGON
Hoover Airfield was bulldozed to save the view from Arlington Cemetery

ABOVE: In anticipation of America's involvement in the conflict that had broken out in Europe, the U.S. War Department expanded rapidly after 1939. By 1941 it was accommodated rather chaotically in many buildings throughout the capital. A new headquarters for the department was badly needed, and the government chose the Arlington Experimental Farm as a site. The irregular shape of the land dictated a five-sided plan for the new building, but President Franklin D. Roosevelt, who liked the design, felt that its location would interrupt the noble view of Washington from Arlington Cemetery. Instead, the

Pentagon was built over Hoover Airfield, Washington's first airport, which had proven to be inadequate by 1941. Other land was also cleared for the complex, including the slum district of Hell's Bottom. On September 11, 1941, the first ground was broken for the project, which became more urgent three months later after the attack on Pearl Harbor. It was completed in only sixteen months. This 1942 picture shows the design of concentric pentagons, with the surrounding web of roads, ramps, and parking lots still under construction.

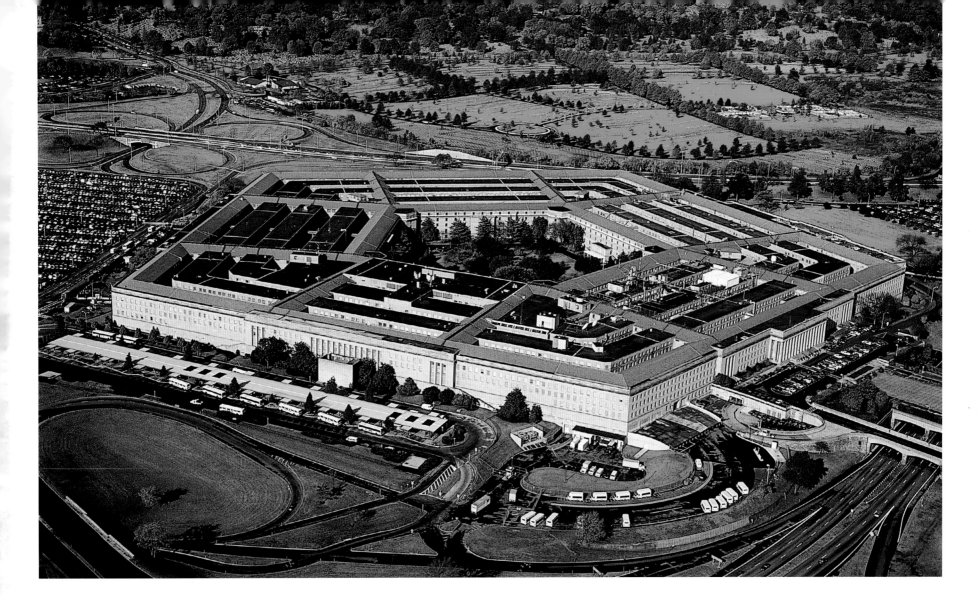

ABOVE: The Pentagon is now the headquarters of the U.S. Department of Defense. Many wars have been fought from its offices, and many protests have been held at its doors. Exactly sixty years after construction began, on September 11, 2001, the nation was shaken when terrorists hijacked American Airlines flight 77 and flew it into the western side of the Pentagon. All sixty-four passengers and crew on the plane died, along with 125 employees in the building. The death toll on the ground would have been much higher but for a major refurbishment program that was already underway; only 20 percent of the offices destroyed in the attack were occupied.

The renovations, which included structural reinforcement, improved security, and more comfortable working conditions, were completed in 2011. As part of the rebuilding, a small chapel was added at the point where the aircraft struck. The Pentagon is the largest office building in the world and houses around 28,000 military and civilian employees. It has over seventeen miles of corridors, but because of its self-contained ground plan, it is said that one can walk between any two points within it in less than eight minutes.

LEFT: A view showing the full parking lot at the War Department in January 1942.

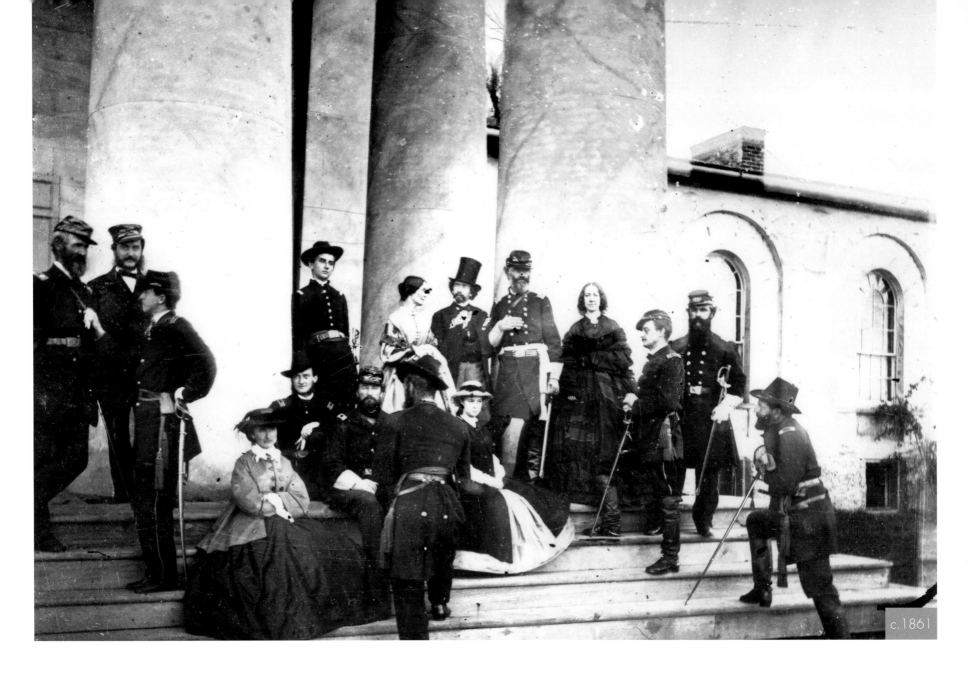

c.1861

LEE HOUSE / ARLINGTON NATIONAL CEMETERY

After the Civil War, General Robert E. Lee's home became the site of Arlington National Cemetery

ABOVE: The land that became Arlington National Cemetery was originally the property of General Robert E. Lee's wife, Mary Anna Custis Lee, who inherited the estate from her father. The general resigned from the U.S. Army in 1861 to serve as a Confederate commander in the Civil War. When a new military burial ground was deemed necessary in 1864, the Union side resolved to punish Lee by confiscating Arlington for the purpose. By refusing a payment offered by Mrs. Lee's agent, the government engineered a charge of nonpayment of taxes against General Lee, and bought the land cheaply in lieu. This photograph shows Union soldiers on the steps of Arlington House, the Lee family home, which they occupied soon after the start of the war. It was built in 1802 in a classical Greek style to the plans of English architect George Hadfield.

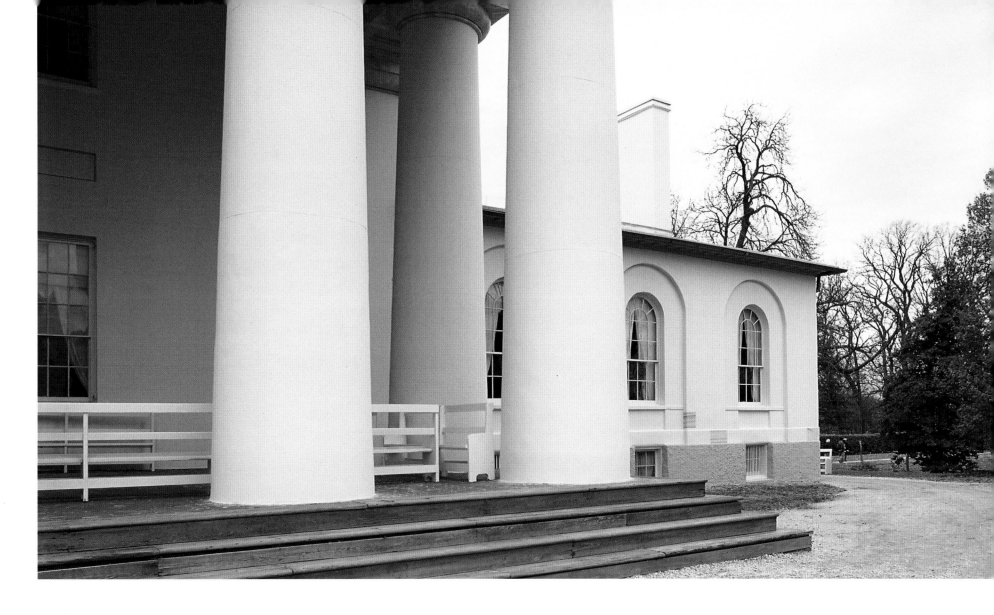

ABOVE: Robert E. Lee and his wife chose not to contest the seizing of their home and lands, but after the general's death in 1870 his son George Washington Custis Lee (himself a Confederate major general) sued the U.S. government for the return of the property, despite the fact that it already contained several thousand graves. In 1882 the U.S. Supreme Court finally awarded him the estate on the grounds that it had been confiscated without due process. The following year, he sold it back to the government for $150,000. Arlington is now the largest and best known of over a hundred national cemeteries, the final resting place for over 300,000 servicemen and their relatives. Arlington House has, unusually, been twice copied in other buildings. Canterbury School in Atlanta, Georgia, is a full-size replica erected in 1919. A smaller scale version named Arlington Hall was built on the grounds of Lee Park in Dallas, Texas, in 1939. The original has been preserved and restored by the National Park Service as the Robert E. Lee Memorial.

LEFT: This 1864 print by Andrew J. Russell was taken at the side of the portico at Arlington House, and shows Federal troops guarding the property.

1933

AIRSHIP *AKRON* OVER WASHINGTON
A reminder of the U.S. Navy's brief experimentation with airships

ABOVE: The airship *Akron* was one of the few American contributions to aviation's short-lived experimentation with rigid lighter-than-air flying craft. Built in 1931 in the Ohio city after which it is named, it was still flying in early 1933 when this photograph was taken and when its sister ship the *Macon* was launched. There had already been safety concerns about such dirigibles since the fatal crash of the *Shenandoah* in 1925. The *Akron* was lost at sea with seventy people on board on April 4, 1933, not long after this flight over the

Lincoln and Washington Memorials, having clocked up less than 1,700 flying hours in its twenty months. The *Macon* also crashed, off California's Big Sur coast in 1935. Although U.S. airships used nonflammable helium gas, the newsreel images of Germany's hydrogen-filled *Hindenberg* bursting into flames in 1937 consigned the age of large-scale airships to history. The Arlington Bridge on the right, completed only a year before this photo was taken, was built to link Washington directly with Arlington National Cemetery.

134

ABOVE: Much of the airspace around Washington D.C. has been off-limits to civilian aircraft for many years due to security concerns. These concerns were further heightened after the terrorist attacks on September 11, 2001. However, military jets routinely patrol the skies over the city. The eastern end of Arlington Bridge is guarded by two large bronze equestrian statues by American sculptor Leo Friedlander. Installed in 1951, the statues are called *Sacrifice* and *Valor*, and are known together as *The Arts of War*. The Old Post Office Tower and the dome of the Capitol, to the left and right in the earlier view, are still visible from across the Potomac, the result of a city ordinance that prohibits the construction of anything taller than the Washington Memorial. Over the decades since the airship age, the view of Washington from Arlington's Washington Boulevard has been softened by trees planted along the city's shore and in the grand green expanse of the National Mall.

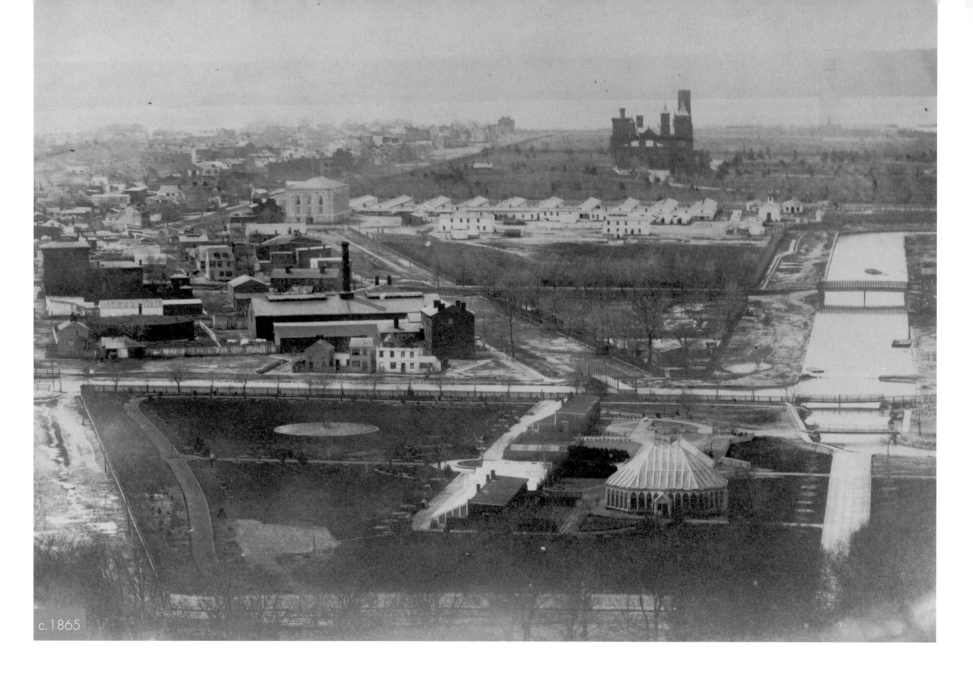

c.1865

VIEW FROM THE CAPITOL

A panorama of the changing landscape of the National Mall

ABOVE: This nineteenth-century view from the Capitol looks out toward the Potomac River. Most notable are the medieval-style towers of the Smithsonian Castle behind the soon-to-disappear Washington Canal (see page 84). The Washington Monument lies unfinished, its construction halted at 152 feet after the funding ran out. The Smithsonian Castle overlooks the Washington Armory, an 1855 neoclassical structure built for the storage of weapons for the

militia of the District of Columbia. To its right stands Armory Square Hospital, a collection of about a dozen wooden structures built during the Civil War. Each ward was a miniature hospital with its own surgeon, nurses, and orderlies. The Botanic Gardens are located next to the Washington Canal. The octagonal greenhouse, designed by Thomas U. Walter in 1859, housed the hundreds of specimens brought back from the Pacific expedition of 1838–42.

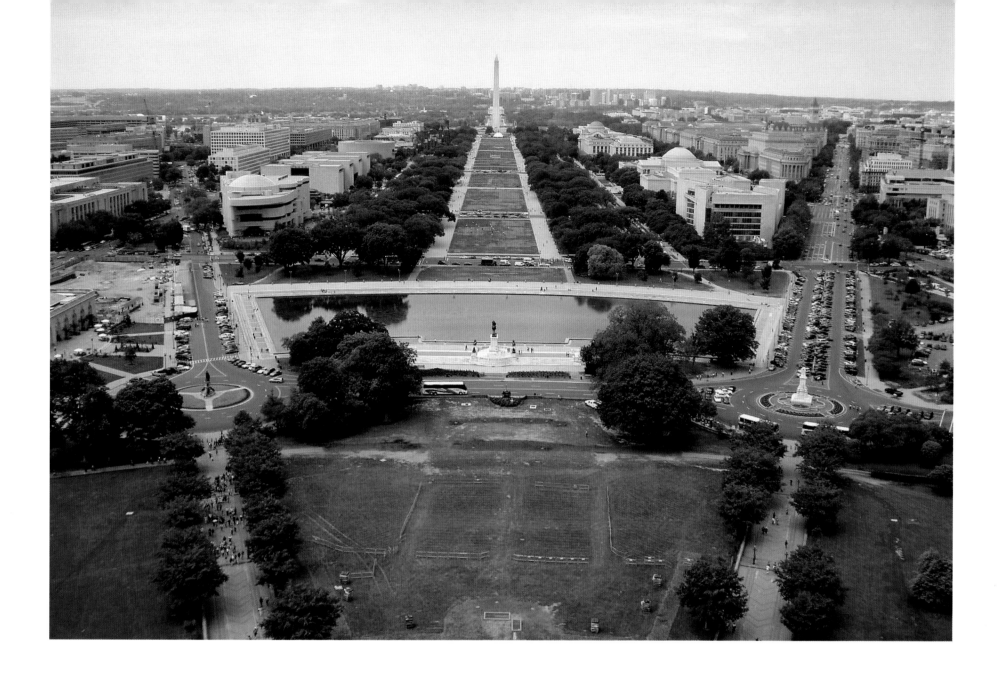

ABOVE: After the Civil War, the armory served as storage space for the Smithsonian collection, and was finally razed in 1964. Since 1976 the site has been occupied by the National Air and Space Museum of the Smithsonian Institution, home to the largest collection of historic aircraft and spacecraft in the world. The museum is surrounded by the yellow structure of the National Museum of the American Indian, opened in 2004, and the Hirshhorn Museum and Sculpture Garden, an art museum founded in 1974. The Washington Canal was eventually paved over and became (in part) Constitution Avenue. The greenhouse of the Botanic Garden was enlarged in 1867, and later razed in 1932. This demolition opened a vista to the Washington Monument, completed in 1884, and the Ulysses S. Grant Memorial, dedicated in 1920. Between Fifteenth Street NE, Constitution Avenue NW, Pennsylvania Avenue NW, and E Street NW stands the Federal Triangle, with the distinctive redbrick rooftop of the Old Post Office and the neoclassical structure of the National Archives. The ten buildings within the Federal Triangle are all part of the Pennsylvania Avenue National Historic Site.

c.1915

VIEW FROM THE WASHINGTON MONUMENT

ABOVE: This view from the top of the Washington Monument provides an unrivaled panorama of the city's history. In the distance on the left, the Aqueduct Bridge connects Rosslyn to Georgetown, from which Virginia Avenue NW stretches toward the humblest of Washington buildings in the foreground, the old Lockkeeper's House. Its grand neighbor across Constitution Avenue is the Pan-American Union Building with its distinctive three-arched entrance. Beside that to the north are the headquarters of the Daughters of the American Revolution.

To the north, past the lot now occupied by the American Red Cross Headquarters, lies the second home of the Corcoran Gallery. The broad curves of the Ellipse south of the White House complement the infinite straight line of Sixteenth Street to the north. To its west, the Second Empire style of the old State, War, and Navy Building makes an interesting architectural contrast with the Beaux-Arts classicism of the U.S. Treasury Building to the east.

139

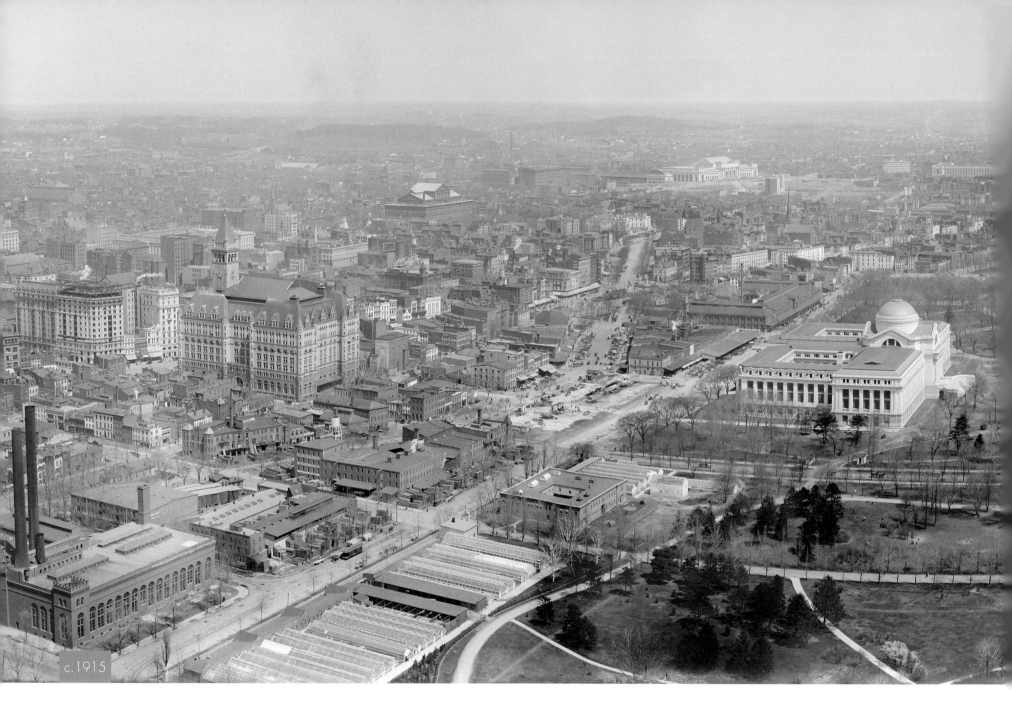

c.1915

VIEW EAST FROM THE WASHINGTON MONUMENT

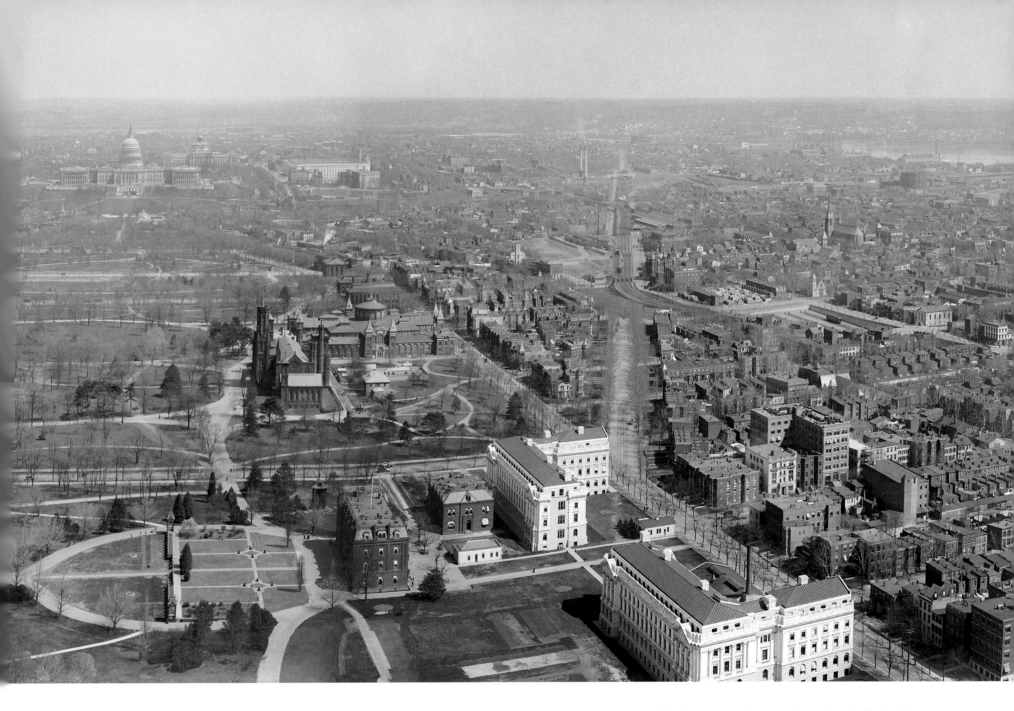

ABOVE: The view east from the Washington Monument toward the domes of the Capitol and the Library of Congress changed considerably as the plan for the National Mall was implemented. Already gone in this circa-1915 view are the tracks of the Baltimore and Potomac Railroad, which proved redundant after the construction of Union Station, seen here to the left in the hazy middle distance. Between the station and the Capitol stand the first Senate offices, now known as the Russell Building, built to relieve overcrowding in the Capitol. On the left of the Mall, the tower and Gothic facade of the Old Post Office rise above the

jumble of low buildings, which have yet to be redeveloped as the Federal Triangle. The plant with the chimneys in the foreground is appropriately now the site of the U.S. Environmental Agency's offices. Facing each other across the Mall are the dome of the Natural History Museum and the towers of the original Smithsonian Institution. On the right, the approach along Virginia Avenue SW leads to the two wings of the U.S. Department of Agriculture Building, completed in 1908—the central block, which replaced the smaller, isolated building aligned with the Smithsonian, would not be added until 1930.

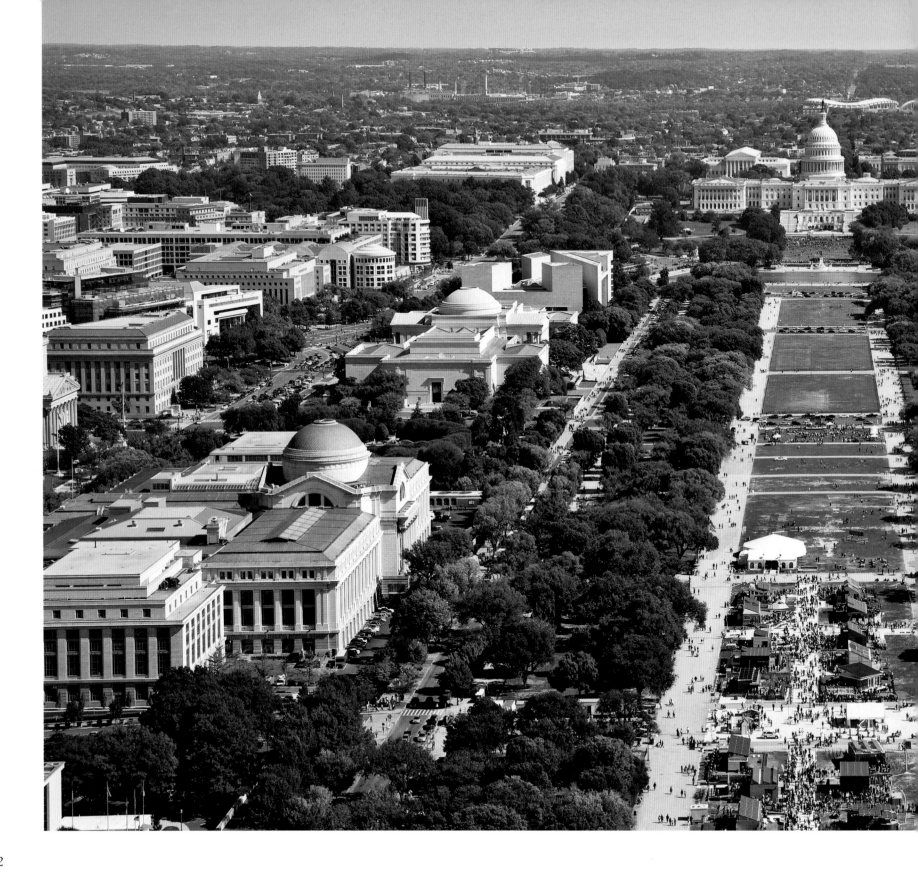

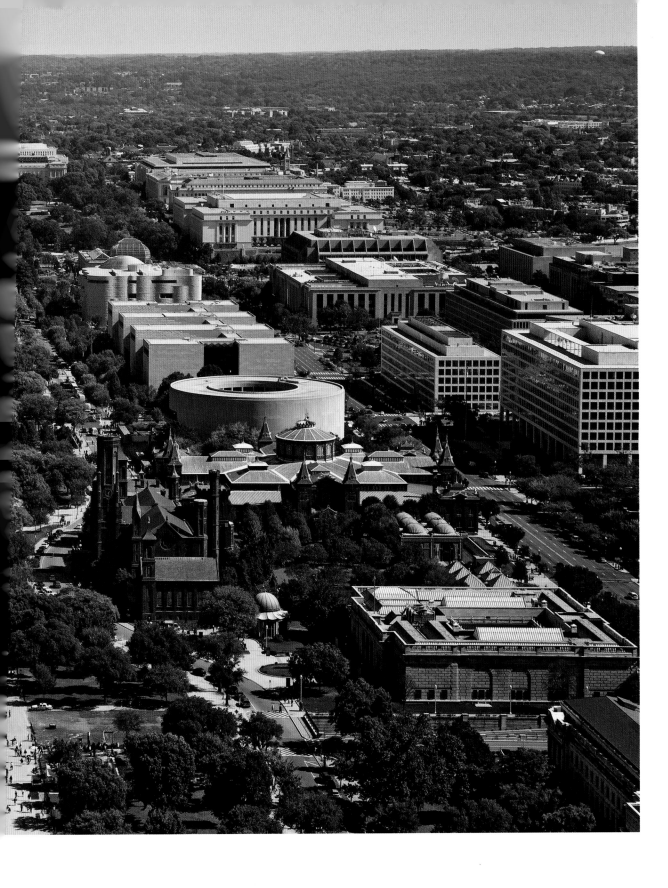

VIEW FROM THE WASHINGTON MONUMENT

LEFT: Today the view along the Mall is more majestic than ever, its grandeur emphasized by the pedestrian avenues that parallel Madison and Jefferson Drives. A full complement of monumental institutions along either side now defines the approach to the Capitol. On the left behind the National Museum of Natural History are the original National Gallery of Art (1941) and its modern East Building (1978). The Gothic Smithsonian Institution on the right is now flanked by the Freer-Sackler Gallery (1923) and the Arts and Industries Building (1881). Beside it, the circular Hirshhorn Museum (1974) displays late twentieth-century art; behind that stand the National Air and Space Museum (1976) and the National Museum of the American Indian (2004). Behind the dome of the Capitol can be seen the undulating roof of Robert F. Kennedy Memorial Stadium.